Ask Me Again
Tomorrow

Ask Me Again
Tomorrow

a life in progress

OLYMPIA
DUKAKIS

with
Emily Heckman

 HarperLargePrint

A Division of HarperCollinsPublishers

HarperCollins books may be purchased for educational,
business, or sales promotional use. For information, please
write: Special Markets Department, HarperCollins
Publishers Inc., 10 East 53rd Street, New York, NY 10022.

Epigraph quote used by permission of the Nikos
Psacharopoulos Estate.

FIRST HARPER LARGE PRINT EDITION

Designed by Elliott Beard

Printed on acid-free paper

HarperCollins books may be purchased for educational,
business, or sales promotional use. For information, please
write: Special Markets Department, HarperCollins
Publishers Inc., 10 East 53rd Street, New York, NY 10022.

Library of Congress Cataloging-in-Publication Data is
available upon request.

ISBN 0-06-018821-9 (Hardcover)
ISBN 0-06-055813-X (Large Print)

03 04 05 06 07 ❖/RRD 10 9 8 7 6 5 4 3 2 1

This Large Print Book carries the
Seal of Approval of N.A.V.H.

for my children and their children

Now I know, I understand . . . that in our work—acting or writing—what matters is not fame, not glory, not what I used to dream about, it's how to endure, to bear one's cross and have faith. I have faith and it all doesn't hurt so much, and when I think of my calling I'm not afraid of life.

From Anton Chekhov's **The Seagull,** translated by Nikos Psacharopoulos

Introduction

I never wanted to write a book about my life. When I was first approached by a literary agent, I told her I wasn't interested. I didn't want to dredge up all the personal history that I had already spent much of my life rehashing—in conversations with my husband, my friends, my therapists, myself. I felt I had nothing new to learn or to teach. But as the idea of doing a book insinuated itself in my thoughts, I grew more and more attracted to the possibilities. I couldn't resist taking one more look back.

When I play a role on stage, I tell the same story night after night, but each time, I see and understand a little bit more of who that character is. In order to write the story of my life, though, the only script I had was "Olympia" and what a chaotic, angry, loving, contradictory character

she turned out to be. But as the events of my life began to unreel in my mind, I recognized that I had an advantage now I'd not had in the past: I had the vantage point of **distance**. Looking back through the prism of time and experience, I went over and over the events of my life, trying to identify the narrative threads that have made me who I am; trying to understand the forces that have made me Olympia Dukakis, Greek-American, mother, actress, wife, trying to make a coherent story out of all of it. There were times I wanted to quit, but as I began to unravel the past and examine where I came from, several themes revealed themselves. The biggest one turned out to be the one that made this book-writing process so difficult at times; here I was, trying to define who I am for the reader and realizing that one of the main themes of my life was to defy definition.

Much of what I've done in my life, many of the decisions I've made, has been a reaction to ethnic and gender bias. I've spent a large part of my life rejecting the definition of what a Greek-American, and what a woman, was supposed to be. I'd set out to define **myself,** not fall into the role others wanted to define for me. I'd done it from as early as I can remember; first with my

parents, then as a schoolgirl, later as an actress and wife and mother.

The life I've chosen to lead bears very little resemblance to what has been expected of me in all those roles. I'm a poster child for the bad Greek daughter—there are no Greek Orthodox bishops holding up my picture and nominating me as a role model. As a woman, I never fit into the prescribed parameters of "proper" behavior. As an actress, I've made choices that led me directly **away** from the fame and fortune acting is supposed to bring. As a wife, I refused to be stifled by the rules that society says wives are supposed to follow. As a mother, I made mistakes, but I'm happy to say that my three grown children like spending time with me, I believe, because they see me as a human being as well as a mom.

It's not always easy to stay true to your own definition of yourself. There's a lot of pressure from the outside world, telling you to be like everyone else, don't rock the boat, take the easy way out. When you fight that, you naturally put yourself on the outside, and I spent a lot of my life feeling like an outsider. When I was younger, I took this as an indictment, but I grew to understand it was not just the road I'd carved out for myself

through sheer stubbornness, it was the only road I wanted to take. In the year 2000, I played one of the most demanding roles of my career in Martin Sherman's one-woman show, **Rose.** There is a line in that play that has always resonated with me, because, perhaps more than any other, it is a reflection of my own experience: "Maybe there's a joy in not belonging."

Women still stop me in the street to yell, "I know who I am," which is the line Rose Castorini says in my break-out role in **Moonstruck,** when rebuffing a pass from a younger man. I love the strength of character it took for her to say that. I love that she believes that to be true, and that it's the thing that keeps her true to herself. But I am not Rose Castorini. When I finally agreed to write this book, my editor suggested that should be the title. "But I **don't** know who I am," I told her, "that's just the point." Because the "who I am" keeps changing, evolving—it's inevitable. We are constantly gathering—or stumbling upon—new information that, if we allow it to, will change our understanding of the past and point us in new directions for the future. The sand shifts constantly. Our life stories have a logic all their own—they

meander this way and that. Their logic is the logic of the spirit as it seeks to know itself, as we seek to work and love.

What I think about my life keeps changing. At twenty, I thought one thing. At thirty, I thought another. And forty, and fifty, and so on. Each decade, sometimes each day, has brought its own revelations. If you want to know who I am today, I'll tell you. But you better ask me again tomorrow. . . .

Ask Me Again
Tomorrow

Prologue

In the late 1980s, something truly unexpected happened to my family and me, something I never thought I'd see in my lifetime, something my father could only dream about. In 1988, my name became a household word. I don't mean just in Montclair, New Jersey, where I lived at the time. And I don't mean within the theatrical community (a community in which I'd been an active member for thirty years). I mean the name Dukakis became known all across the United States! Even around the world, thanks to an acting award and a presidential election.

For me, it meant being recognized for the role I'd played in the movie **Moonstruck.** For my cousin Michael, it meant being on the ballot as the Democratic candidate for president of the United States.

It was hard for me to grasp that two first-generation Greek-Americans had made it in this incredible, public way. I became—literally almost overnight—no longer what I'd always considered myself to be: a hyphenated American, living between two cultures and constantly trying to balance the many contradictions forced on us, trying to bridge a divide in ways that kept us on our toes and sharpened our senses. It also meant having to live as a kind of second-class citizen. Now we Dukakis progeny had broken through a barrier of ethnic discrimination that had been, at times, vicious, unforgiving, and isolating. But living in the hyphen, or as an "outsider," also had its benefits. It gave us all a degree of freedom that we each, in our own way, tried to capitalize on: we weren't expected to conform (how could you when you didn't look like everyone else and you spoke a foreign language and you had a name that no one could pronounce?). In the minds of our nonimmigrant classmates and playmates, we were the "other," and it was our job to figure out how they lived and not vice versa; how to "belong" within a context defined by the majority around us. Instead, Michael, my brother, Apollo, and I, and all the other Dukakis cousins—

Stelian, Arthur, and Strat—seized our standing as outsiders and became what our parents had hoped we would: hardworking American citizens.

For me, the process of assimilation has been the lifelong process of allowing this line, this hyphen, to blur and soften. It hasn't been an easy process, nor has it been simply about assimilating culturally. It's been about learning to embrace the influences of my family and my heritage without letting them limit, hurt, or hinder me from becoming a better person, a better actor, a better mother, wife, and citizen. It has been about allowing my heart and my mind to open to new influences that will help me embrace life and all of its contradictions, instead of run from them.

It's only now, at a relatively late time in my life, that I can even begin to articulate what it meant for my parents to come to this country and to raise children who became successful here. It's a complicated ideal, this notion of being successfully assimilated, and it had such a profound effect on so many aspects of our lives. It determined, for example, how much personal gratifi-

cation my parents would delay so that they might provide us children with more opportunity, more education, more freedom than they had. And though they tried to shield us from the limitations that were put on them by the outside world, particularly in the form of ethnic bias, they were never really successful. This was something my generation had to figure out for ourselves. We had to figure out how to be good Greek daughters and sons while also becoming Americans. There were so many competing ideals of what was valued, what was honorable, what was right. The world was fraught with contradictions and the best we could hope for was not to be undone by them. Learning how to grasp and use the lessons of this great paradox has been the source of more consternation, more joy, and more growth than anything else in my life. I was taught, by example, to stand tall in the face of fear, not to shy away from obstacles, to believe in myself—even when I felt utterly defeated inside. I was encouraged to strive to be authentic, to become an American without betraying my Greek heritage; to become the authentic Olympia Dukakis, warts and all; to take on the obstacles that came my way, learn as much as I possibly could from them, and then move on.

I've been overlooked or unfairly treated, but just as often, I've been rewarded and honored in very unexpected and public ways, and even acclaimed, as I was so lavishly in 1988 for just that one part I played.

Chapter One

The spotlight that shined on my family in 1988 started on what was a typical February morning—typical except for the TV crew sitting in my living room.

A couple of days before, I'd gotten a call at the theater where I worked. It was **Entertainment Tonight (ET)** and they wanted to know if they could come film "my reaction" when the Oscar nominations were announced. There was some talk that I might be nominated for my part in **Moonstruck,** but I thought wanting to film me on the off chance I might be nominated was an odd request, and I laughed when I told Bonnie Low-Kramen about it. She was the head of publicity for the Whole Theatre in northern New Jersey, a nonprofit organization I'd been very involved with for the last eighteen years. Ten cou-

ples—including my brother, Apollo, and his wife, Maggie, and my husband, Louie, and me—had been founding members of the company and Bonnie had, by then, been working with us for a number of years. She thought the **ET** idea was great. "Just think," she said. "You can plug the theater on national television. It will be great publicity for us." As a not-for-profit organization, we were always scrambling for money, so any publicity was truly helpful. I asked her, when she set it up, to have **ET** come to the theater so that we'd have the opportunity to get a good shot of the exterior of the building and our sign. However, they didn't want to interview me at the theater. They wanted to tape this at my home, at eight A.M. sharp, just as the nominations were broadcast live from Los Angeles at five A.M. I was disappointed by this but determined to figure out some way to promote the theater anyway.

On the morning the nominations were to be announced, I was up early, doing routine paperwork for the company and taking care of things around the house. I had already helped my mother, who was living with us by then, get dressed and have some breakfast.

I also let our dog, Sandal, out the back door for his morning dash over to our neighbor's yard, which, for some reason, he'd recently decided was the only place he could relieve himself. This was probably the greatest stress in my life at that moment, as our neighbor, who was always having his breakfast at the picture window that spanned his kitchen at the exact moment Sandal needed to go out, was threatening to sue us. Things had gotten pretty ugly between us, but I couldn't worry about that today. I had to get Sandal back into the house and see if Louie needed help with the coffee and bagels; we had a crowd to feed.

Some of our friends and neighbors began showing up, as well as some of our colleagues from the Whole Theatre. I remember being vaguely annoyed as the techs from **ET** began dragging cameras and lights into the house—I didn't want them to scratch the floor or bang the furniture. I started to feel that the whole thing was a ridiculous mistake and neither Louie nor I had time to play host to a bunch of strangers with heavy equipment.

But apparently, **ET** knew something we did not because sometime between eight-thirty and nine, there was my face, on the television, and I'm looking around my living room watching my fam-

ily, friends, neighbors, and this film crew jump up and down. I was nominated! For Best Supporting Actress for my portrayal of Rose Castorini in **Moonstruck.** Louie was cheering and my mother, who still couldn't believe that I was actually paid to act, was beaming. Everyone was just so high. I think I must have been, too. I don't really remember.

What I do remember is that the phone started ringing off the hook after that. People wanted to interview me and, in particular, find out how it felt to be an overnight success. An overnight success? Either the media really believed this was the case or they just thought they would get more mileage out of the story if they presented me as the heroine of a slightly twisted Cinderella story because I was also a **middle-aged** overnight success. True, I was in my fifties at the time and **Moonstruck** was only my fourth movie, but what most people, especially those in the film industry, simply did not know was that I'd been working as a professional stage actor and director for thirty years. So much for overnight anything.

As the reality of the nomination set in, I did start to feel like this was some kind of fairy tale. What **did** happen overnight was that so many people became interested in my work, including

what I had done in New York and with the Whole Theatre Company as both director and actor, and everything I had done before then—all of it. Small tremors began rolling through my life and me—but they weren't unpleasant. Something good was happening and I was the belle of the ball, albeit one with three kids, a naughty dog, and a big mortgage. Not to mention a mother who called my dining room home.

There were interview requests and job offers. Suddenly my asking price went up. I'd signed on for **Look Who's Talking** before the nomination, and one of the first calls I got was my agent telling me that the producers would up my salary if I actually won the Academy Award. I was beginning to like this.

It was Norman Jewison, the director of **Moonstruck,** who told me to take every call, do every interview. Sure, talking about the movie would bring people into the theaters and he knew that, but he was really telling me to seize this moment and promote myself. I took his advice to heart and spoke to everyone who called.

Then I got a call from the New York Film Critics Awards to tell me I had won their award for Best Supporting Actress and to please bring anyone I wanted to the award's ceremony. As it

happened, we were, as a family, just emerging from a decade-long crisis, and we badly needed a reason to celebrate. So Louie and I and our three grown children, Christina, Peter, and Stefan, dressed up for the big night out.

It was a wonderful evening. I remember seeing this look of satisfaction on my children's faces, a look of recognition when they realized that what I did, day after day, and the work their parents were engaged in that was so different from any-thing their friends' parents did, had value.

I was also nominated for the Golden Globe Award. Jewison, who was now certain I'd win the Oscar, was equally sure that I wouldn't win the Globe, because the Globes are awarded by for-eign critics and **Moonstruck** was a quintessen-tially American film. Just as I had earlier with **ET,** before the Oscar nominations were announced, I realized that attending the Globe Awards would give me another chance to promote the Whole Theatre, so Louie and I flew out to L.A. I had no idea what to expect, but I was curious to see how this would unfold.

And then the damnedest thing happened—I won the Golden Globe, which was more than a bit unnerving, as I had absolutely nothing pre-pared to say. I was so convinced I wouldn't win

that I had worn an old dress from my closet back home, and had not bothered to have my hair or nails or makeup done professionally. Those little tremors I had started to feel back in New Jersey began to intensify.

For the first time in a long while, I found myself thinking about my career, which was something that I had not thought about consciously for years. All of the attention I was getting was lovely, of course, but I was more than a little confused about why it had come at this point, and with this role, which, to my mind, was not the greatest part I had ever played. On the contrary, and quite honestly, I had taken the part of Rose Castorini largely for the money it would bring in and for the chance to work with the director Norman Jewison. The script was excellent, but the character of Rose was a familiar one to me. Maybe it was the ethnicity—I had played a lot of Italians— but I felt comfortable with the character. What excited me was how beautifully the part was written, not the challenge of the role. I found it difficult to accept all the acclaim this one role had brought me. I had played so many great parts on stage and I felt that if I claimed only this role as my greatest success, I would be turning my back on all the other parts. I remember telling one

of my friends, the great stage actor Austin Pendleton, about how confused I was by the attention I got for my work in **Moonstruck,** and he said something so wonderful to me that I've never forgotten it. He told me that he saw all of my work in Rose Castorini. I understood, for the first time, how sometimes we are rewarded for our efforts long after we've given up any expectation for external gratification or the need to be recognized for this or that particular piece of work. I had always focused on the process and aspired to do the work for the work's sake. I had, thankfully, over and over again during my thirty-year career, held to the belief that the work itself would provide its own gratification. I was stunned by how brilliantly this moment shone, how it seemed to come from out of left field, with no warning. And, truth be told, it took me awhile to get comfortable with the attention, with the impact it had on my life.

I did not become an actor in order to become famous or rich. I became an actor so I could play the great parts: the Greeks, Chekhov, Shakespeare, Molière, Racine, Arthur Miller, Eugene O'Neill, Tennessee Williams, and Brecht. My dream, since college, was to have my own theater company and travel to the capitals of

Europe performing the classics. What I wanted was the chance to inhabit great characters whose yearnings and passions opened up for me a way of seeing the world and would help me to break free from the limitations I had struggled with that came not just from the world around me, but from the world within me. I had discovered that the stage gave me a safe arena in which to express my emotions. It was a place with firm enough boundaries that I could take emotional and psychological risks there. It was also a place where I could be physical, sexual, and spontaneous. It was the place where I felt the most alive.

One of the things I had to learn, over and over again, as an actor and as a person, was to resist the urge to be competitive, to moderate my continued drive to always want to win. This is another reason why winning the Oscar when I did confused me in some ways. I had finally learned to be less competitive, less combative with the world, and so it was more than a bit ironic in some ways that I found myself "winning" this award at all. But the pleasant tremors I had experienced since my Oscar nomination signaled to me that for the first time, really, I was at a place in my life where, despite the bills, the pressures of the theater company, the demands of my family—

despite all of it—I finally felt comfortable enough with who I was as a person to just let myself enjoy this time.

It was hard to believe, but all the signs around me said I truly was a contender. A favorite even, if one were to believe the odds the bookies in Vegas put on my chances. I even started to think that Jewison might be right and that I had a very good chance of winning. So, unlike the Golden Globes, I decided to prepare for my next trip to Los Angeles. For the first time in the twenty years that I'd lived in Montclair, I finally went into the most upscale dress shop in town, where I bought a black dress. Bonnie, meanwhile, booked a hair and makeup artist in Los Angeles to help me dress and prepare on Oscar day.

Entertainment Tonight decided they wanted to continue filming me throughout the Oscar process, and they were very generous with making sure that I had whatever I needed. A limousine was sent to take Louie and me to Newark Airport for the flight to Los Angeles. The much-loved and respected Governor Thomas Kean of the state of New Jersey was there to send us off, and there were fifty or so fans lined up at the terminal bearing GO OLYMPIA! signs. Even the local news station had someone there covering this

"event" for the eleven o'clock news. I remember walking through the airport and feeling, at least for that moment, that I truly was a favorite child of the state. I was incredibly moved by this unexpected show of support.

Once we got to L.A., I really started to feel the whole thing was unreal in some way. Just a few weeks before, I had been clipping coupons and shopping for bargain jeans, while working ten- to twelve-hour days at the theater. Now I was checking into the Four Seasons and being told I had "signing" privileges (which meant I could have whatever I wanted with a quick flick of a pen). We decided, Louie and I, why be shy now? So we threw a cocktail party and then a champagne reception for our L.A. friends and we kept our energy up by getting massages, eating great food, and enjoying every luxury that was offered.

By the time the concierge called us on the evening of the Oscars to say that our limo was ready, Louie and I were so excited we actually ran down the hall to the elevators. We couldn't wait to get to the ceremony.

Our car joined the parade of limos that made a slow-moving procession to the Shrine Auditorium. At one point we came to a complete stop and heard a knock on our limo door. It was Jon

Voight; he had been riding in the limo behind us and it had broken down. Would we mind if he rode with us? We decided this was the perfect time to open the bottle of champagne that was chilling in a silver bucket in the backseat.

When we pulled up to the red carpet, I was stunned by what we encountered. There was an exuberance bordering on pandemonium. The party had apparently already started. It's as though all these grown-ups had suddenly reverted to being children who were just told adult swim was over and it was okay to jump back into the pool—tux and all. I'd only experienced this level of celebratory abandon one other time in my life: when I was host to fifteen seven-year-old boys at a birthday sleepover. Outside the theater, there were literally hundreds of photographers all yelling "Olympia! Olympia!" and my head would turn involuntarily every time I heard my name. I was stunned by all the lights and the attention, and it dawned on me that I had no idea how to do this. How were we supposed to walk through this tangle of photographers as though it were the most natural thing in the world? I decided the best thing to do was to simply follow the lead of the people in front of us, and so we made our way down the red carpet and into the auditorium.

• • •

All of the nominees were seated together in the center section. We had barely—and I mean barely—sat down when my name was called. "And the Oscar goes to—Olympia Dukakis!" I instinctively leaned into Louie and kissed him and he immediately slumped over, sobbing. It was almost as if he had absorbed the emotional impact of the moment for both of us, because I was able to get up and walk to the stage with this incredible feeling of calm. Of being present. The one thought I had was, "I wish Daddy were here to see this." My mother, of course, was watching all of this on TV, back home in Montclair.

When I held that statuette in my hand and felt the weight of it, I hoisted the Oscar aloft and cried out, "Okay, Michael! Let's go!" This was not something I had planned to say, but my cousin Michael was making a bid to become the Democratic nominee to run for president of the United States, and that golden statuette felt like a baton in my hand. I felt as though I had run the first leg of a very important race and it was time to hand off that baton to Michael so that he could run the second leg. It seemed absolutely natural to do this in that moment. I felt as though I were floating on a current of ancestral energy—the en-

ergy that had blessed and cursed me for five decades—and that now heralded what our parents had worked so hard for.

After the show, I was hooked up by satellite to Michael, who was celebrating Oscar night back in New York City at Grand Ticino, the restaurant featured in **Moonstruck.** We talked and laughed and cried. Neither of us could even begin to imagine that for the next six months, our name would literally be everywhere. We had fulfilled the aspirations of our parents and had validated—for ourselves, our cousins, and all of our ancestors— that what our parents believed in and cherished most mattered. Our parents had set a course for us, based on their absolute belief in the American Dream, and we had navigated that course and it took us where they had dreamed we could go.

I remember looking out at Louie then and he was still crying.

Even at that moment, I couldn't help but wonder what would have happened if I had taken the well-intentioned advice that was heaped on me thirty years before and had changed my name. Believe me, I had seriously considered doing it, because I was discriminated against time and time again because my name—because **I**—was so ethnic. It would have been a hell of a lot easier to

get acting jobs if my name were Day instead of Dukakis, but then I wouldn't have had the satisfaction of seeing the family name—my parents' name—displayed so visibly during that time.

Almost before I got off the stage at the Shrine Auditorium on Oscar night, I was initiated into the very rarefied world of "Hollywood Insider." For the first, and maybe the last, time, I was able to glimpse how the system really worked. How those who lived inside the industry defined success. On one level, it was stunning to have such an intimate look at the "system," but on another level, it was disheartening to understand the implications of how it all worked.

But I had no time to dwell on this or anything else now. I was whisked off the stage and I remember flashbulbs going off, and reporters, and getting back into the limo and heading off to Spago with Louie, my brother, Apollo, his wife, Maggie, and their son, Damon, who were now living in Los Angeles.

First there were the interviews. They started taking place immediately after I'd won and before I could even get back to my seat to watch the rest of the show. The atmosphere around the inter-

view room was simply a more organized and civilized version of the preshow media frenzy that I'd already dealt with while walking down the red carpet. But I no longer felt paralyzed: I felt more like an actor who is called upon to deliver a short, improvised monologue, over and over again. I was asked to stand in front of a special Oscar-night backdrop and hold my Oscar in a particular way that would ensure that it was captured to its best advantage in each picture. "Olympia! How does it feel to be an Oscar winner?" "Did you know you'd strike gold with this part in **Moonstruck**?" "How does it feel to be an overnight success?" "What are you going to do next?" "What was it like to work with Cher?" When it seemed that I'd given someone the two-second sound bite he or she was after, the next interviewer stepped up.

Then, before I knew it, we were driven to Spago, where I was congratulated by people such as Robert Altman, Audrey Hepburn, Shirley MacLaine, and Mel Gibson. This was definitely fun, but there were weird aspects to this attention, too. I can't recall anything particular from that night, but Louie remembers an odd encounter. He saw an old colleague coming our way, an actress he'd appeared with in a long-

running play. She approached us with her arms outstretched and blew right past Louie and threw her arm around me and smiled for the camera. It was as if Louie, whom she'd come to know quite well, just didn't exist. At least not when there was a photo-op for her with a bona fide Oscar winner!

Though this struck both of us more as funny than anything else, it was an example of the kind of disingenuousness that was part of the Hollywood insider game that was often rude and disrespectful.

I'm still amazed at how I finally came to play the role of Rose in **Moonstruck.** Most of us would call this "luck." But luck only works if you're prepared when the opportunities present themselves. For me, it started with being cast as Soot in the Christopher Durang play **The Marriage of Bette and Boo.** Nora Ephron caught that performance and she recommended me to Mike Nichols, who was directing the movie version of her novel **Heartburn.** I was cast, but somehow, none of the scenes I was in ever made it into the final cut. But Nichols liked my work and cast me in the Broadway production of **Social Security** by Andy Bergman, starring Ron Silver and Marlo Thomas. The night before the audition, I worked all night, reading the script. I

liked it but I was convinced that I couldn't do the part. She was an eighty-year-old Jewish woman—what could a fifty-year-old Greek actress do with that? After reading all night, the next morning I told Louie I was going to cancel the audition. He said, "Let me see that script." He read for a moment, then looked at me and said, "Go in and do your mother."

I got on the bus to New York City and read all the lines with my mother's voice in my head. When I got to the theater, there were half a dozen other women—all older, and perfect-looking for the part—waiting to audition. I thought, Okay, I'm here, let me do my mother—and they all laughed at my lines. I thought, Well, I'm not going to get the part but I'm giving a damn good audition. Later that afternoon, they called and told me the part was mine.

Unbeknownst to me, the director Norman Jewison came to see the show twice. He was casting **Moonstruck** and cast me as Rose Castorini without ever having me audition for the part. Later he told me that when he saw me on stage, he knew that I had the right "comic timing," and that was enough for him. He wanted me for the role of Rose.

January 1987 found me in Toronto filming

Jewison's movie. **Moonstruck** had an excellent script by John Patrick Shanley (who received the Oscar for best original screenplay). It opened during the Christmas season of 1987 and was met with immediate buzz. In January 1988, I was invited to introduce the film at the Sundance Film Festival, which was then (and still is) the preeminent festival for independent filmmaking, and the rest, well, as they say, is history (or more accurately, my story).

After we left the Oscar party at Spago, we went on to two other star-studded parties, and Louie and I finally stumbled back into our room at the Four Seasons at about four A.M.

The next few days continued to be an exhaustive round of interviews, get-togethers, and smaller celebrations. All I remember is that I didn't have the right kind of wardrobe for these events, so I bought one good pair of black pants and a black sweater with blue stripes. This became my favorite interview uniform. When the hype died down and the interviews ended, I finally looked at that battered old sweater, said thank you, and threw it out.

There was one event in those first few days back

from Los Angeles that actually came close to matching the rush of exhilaration I felt on stage when the Oscar was handed to me. The town of Montclair, New Jersey, threw a parade when I returned and it was wonderful. The mayor presided over the afternoon and even had a replica of my Oscar to hand to me in front of the entire town. The parade route came up Bloomfield Avenue, the main street that runs the length of Montclair, and traffic was backed up as far as the eye could see. I stood with my family, the mayor, and other local dignitaries on a platform that was set up right in front of our theater company. I remember wanting to take advantage of all of this attention and funnel it directly into the theater. For fifteen years Louie and I, and everyone else involved, had spent every free moment of our lives trying not only to raise money for our nonprofit theater but to raise its profile, too. We wanted to build an important theater and educational outreach program, and we wanted to let the world know we existed. Standing on that platform, seeing all those cars backed up and all those people lining the street, I saw potential donors, subscribers, and theater lovers. I wanted to capitalize on all of the attention I was getting, to seize the moment, take advantage of the opportunities this would bring

us, and make sure that the theater benefited as much as possible from this moment of exposure. I wanted to be smart about it and not squander anything that would help us. **Entertainment Tonight** was there again, cameras rolling, capturing it all on tape.

Artistically, the theater was thriving. We were at the top of our game in terms of the quality of the plays we were performing, and our subscription base was growing steadily, but it was difficult to meet our budgets because of the never-ending battle to secure grant money and federal dollars in an ever-darkening climate for not-for-profit arts organizations. It seemed like every dollar that we used to be able to rely on now took twice the effort to secure. Sometimes I felt like Sisyphus, eternally pushing that boulder up the hill. It was hard to maintain the cash flow we so desperately needed to stabilize the company. This was not just exhausting; it was heartbreaking as well. But the staff and the board of directors did not give up; we simply kept trying harder. I continued to show up, every day, determined to keep the company going. The life of the glamorous Oscar winner began to recede when I took on the role of produc-

ing artistic director for the theater after surviving a political tussle that had erupted. It was time to get back to work.

In spite of all there was to do at the theater, I couldn't ignore those tremors I had felt when I won those awards for my work in **Moonstruck.** They had signaled a seismic shift that had taken place in my life. Even as I went back to work at the Whole Theatre, immediately engulfed by the stress of struggling for funding and the political battles raging about how to run the theater, the effects of my Oscar win were reverberating in my professional life.

For the first time in our married life, Louie and I were able to pay off our credit cards (including the first year and a half of my daughter's college tuition), and we realized that, with some good choices on my part, we might even be able to pay off our mortgage. After nearly thirty years of working together to keep our family afloat, this was some relief.

Calls came and scripts arrived regularly for the first time in my career. I had become so used to hustling for every job, for every opportunity, that it was hard for me to relax and enjoy the idea that

now, work would be coming to me. Or at least I hoped it would. I'd had too much experience to think that the good times would last forever. Nothing is ever as easy as it seems, and though I certainly enjoyed the professional recognition the Oscar signified, it took me a very long time to get comfortable with the idea that I was no longer an outsider. That I was now on the inside and that I'd have to contend with a whole new set of challenges and opportunities. I'd have to prepare for the challenges that would accompany this whole new world of contradictions that was opening up in front of—and within—me.

I remember shuttling back and forth to Boston a lot in 1988, especially during the months right after the Oscars, in order to help my cousin Michael, who was then governor of the state of Massachusetts. I liked being involved in his intensifying campaign. It was a great opportunity to see a true public servant such as Michael in action, and it was a great excuse to get together.

Louie and I would arrive at the Dukakis campaign headquarters and watch Michael move from the phone, to one person, to another, then back to the phone with a measured grace. He handled everyone with a high level of efficiency and respect that really impressed me. I had the

great honor of introducing Michael at a number of gatherings, including the Democratic National Convention in Atlanta. I remember how moved I was hearing the name "Dukakis" said over and over again. It made me want to acknowledge all the Greeks that came before this who had been a part of our lives and meant so much to us. I found myself reciting a very personal roll call of my own that day, as I invoked the names of our fathers, our grandfathers, grandmothers, aunts, and uncles. As though calling their names would reach them somehow and they could see and hear what their lives had contributed to.

Despite the fact that Michael ultimately lost the election, these were great days for us, for everyone in our family. It still astounds us all how 1988 became our "family" time to truly shine—I called it the year of the Dukakii—the moment when the Dukakis flame truly flared in recognition of all who came before us and for all those who would follow, because it wasn't just Michael and me, children of immigrants, who broke the surface and rose to such professional prominence. It seemed as though that year we all flourished and had reached a point of excellence in our work.

One of the great highlights of that period for me was introducing Michael at the Democratic

National Convention that was held in Atlanta, Georgia, just months before the November election. I had made a short film about him and that was shown first. Then I stepped out onto this gigantic platform that overlooked the convention floor. The room was a sea of bouncing placards that read DUKAKIS FOR PRESIDENT!, and Neil Diamond's "America" was blaring from speakers that surrounded the enormous hall. Then a chant rose up—"Duke! Duke! Duke!"—and it built until I stepped up to the microphone, when it erupted into applause and cheers. To be cheered like that, for my cousin Michael, for the name we shared, was like facing all the audiences I'd ever played to all rolled into one.

It had helped me to take my mind off of my own future to turn my attention and focus on Michael's bid for the presidency. It was also a wake-up call when my Oscar was stolen—right out of our kitchen. This little larceny also illustrates how naive I could be when it came to handling the press. I found myself reading interviews I gave and cringing when I saw my words in print and thinking, "Did I really say that?" I made a few gaffes where I neglected to thank someone or I

came off sounding arrogant when I thought I was just being emphatic. But somewhere along the line, when asked where I kept my Oscar, I told the interviewer that it was still in my kitchen, where I had left it after coming home from L.A. Around the same time, our insurance broker suggested to Louie that we should have my Oscar insured. "You never know," he said. "There could be a fire or an earthquake or something." Louie thought about it and had a rider attached to our home-owners' policy that insured my statuette for ten thousand dollars. About a week after the interview ran in our local paper, someone broke in and took the Oscar, but left the plaque that had my name on it! The thief, for some reason, figured it would be more valuable on the black market without being identified as belonging to me, and so had taken the time to take the plaque off and leave it on our kitchen counter. We reported the theft to the police department and then Louie rang up our insurance company. Sure enough, a check for ten thousand dollars arrived within weeks. Louie called the company that made the statues and we got a replacement—for fifty-six bucks! I screwed on the original plaque with my name, and I had my Oscar back, safe and sound.

• • •

Right after the convention I got a call from my agent about a movie called **Steel Magnolias,** written by Robert Harling. It was set to go into production, and Herbert Ross, the director, had one key part still to cast and he wanted to meet me.

Ross was staying at the Waldorf-Astoria in New York, so I took the Number 66 bus in from Montclair one afternoon. At the front desk I asked for Mr. Ross. Without even looking up, the concierge said, "Go right on up to his room. He's expecting you." "Okay," I thought as I got into the elevator, "this isn't so bad." I rang the bell on Ross's door and a voice called out, "Come on in!" I walked in to find Herb Ross naked, faceup in the middle of the floor of the suite, with only a strategically placed bath towel covering him. A Japanese masseuse was straddling him, working away with intense concentration. I just stood there, unsure of what to do, when Ross simply rolled over and said, "Oh. It's you, Olympia. The desk said it was Lee [Radziwill, his then girl-friend]. I'll be with you in a minute." I looked around for a place to sit while the thought ran through my head that maybe this was yet another

run-in with the "casting couch," and I remember thinking, "Is this still how this is done, even at my age?" The thought made me laugh out loud.

When his massage was over, Ross, now wrapped in a bathrobe, and I had our meeting. I liked him immediately. He offered me the part of Clairee, a recent widow in the town of Natchitoches, Louisiana, where this true story happened. But first, he asked to hear my southern accent. "Not good enough," he said. "You'll have to learn a plantation accent." He wanted me to sound like what an upper-class southern woman would sound like. Sometime in the middle of rehearsals, prior to shooting, Dolly Parton turned to me and said, "I can't stand that accent. I've listened to it all my life and I can't stand it."

With a finalized "deal," I looked forward to soon heading off to Natchitoches to join Shirley MacLaine, Sally Field, Darryl Hannah, Dolly Parton, and the then-unknown Julia Roberts for filming. This was a big-budget affair—six enormous Winnebagos—way beyond the scale of **Moonstruck.**

What I liked about Clairee was that in her quiet, subtle way, she was willing to take on life's challenges and contradictions and be transformed by them. Though my character was no longer a

young woman, and she had recently lost her hus-
band, she was struggling to find her way back into
a meaningful new life by buying a radio station
and making plans to travel to New York City.
Clairee had a razor-sharp sense of humor that
took the truth, as she saw it, to the outer limits of
decency; in some ways, she was not unlike Rose
Castorini in **Moonstruck.** Both these women
knew who they were, in a very basic and essential
way, and made the commitment to honor that
person. To be authentic and to not view them-
selves solely through the lens of male perspective
that had, in their own lives, so limited them.
Whenever I had the chance to play a part that
went into this territory that short-circuits pre-
tense, insecurity, and especially the limitations
placed on women by the outside world, I
grabbed it.

I recall feeling very at home on that set. I en-
joyed and admired the women. Darryl Hannah is
a bright, intuitive, aware, and politically active
woman. Sally Field is probably the most disci-
plined film actor I've ever worked with. Shirley
MacLaine, well, let me tell you, she's as high-
spirited and generous as she seems. I remember
sitting with her between takes one afternoon, and
she looked over at Julia, and she turned to me and

said, "She's got it. The camera loves her. She'll be a big star someday." And Julia! She was really being put through her paces by Ross; she'd come on board the movie with absolutely no formal training and held her own with a crew of very experienced women. I admired her for hanging in there and turning in a fine performance, despite Ross's constant needling. Dolly Parton held herself with such simple dignity and was sincerely generous with her fans. I determined that I would try to follow her example.

The only hard part of this job for me was being away from home and the theater. Whenever there was a break, I'd call Louie and the kids and they'd fill me in on what was going on back home in Montclair; they kept me posted on how my mother was faring. I'd talk with the theater staff about what was going on there and we'd brainstorm over the phone about raising money and other theater issues, but it was a little hard to try and run a theater long-distance.

Once shooting in Louisiana was over, I dove full-time into fund-raising. I was not above deceit in my quest for additional funds for the theater. I was told that a cat food company was offering celebrities five thousand dollars to allow their cats to appear in its annual cat calendar. I thought,

"Hell, let's do that." There was one problem: we had a dog, not a cat. The woman in charge of marketing at the theater had a cat, and she offered to loan him to us for a day so that they could shoot the calendar. The morning of the photo session, we shipped our dog, Sandal, off to a neighbor's (no, not the one right next door; even living alongside a bona fide Oscar winner hadn't diminished his threat to sue us), and the marketing director brought her cat over. I quickly named him Baklava—the name of a Greek pastry seemed appropriate. Baklava, of course, didn't respond when we called him, and he was understandably skittish and ill at ease, with so many strangers in such strange surroundings. He certainly wasn't used to having so many lights and cameras focused on him, and I tried to explain to the cat company people that this kind of attention always made him, well, distracted. When we had him just about settled down, my mother happened to wander through the living room and took one look at poor Baklava and asked, "Where'd that cat come from?"

Everyone froze. The cat people looked nervously from me to Louie and back again. "She often forgets things," Louie whispered reassuringly, as he gracefully steered my mother into her bed-

room before she could make another perfectly lucid remark. We were able to shoot the commercial, and the theater saw some relief that week.

I had ridden the Oscar wave of goodwill back to Montclair and into the arms of my family, my community, and my work, but most important, I had gone home to the arms of my mother, which, for so many, many years, had seemed closed to me. Now she was living in my house and I had a chance to get to really know her, woman to woman, in a way I never had before.

When they had placed the Oscar in my hands on the stage of Shrine Auditorium, I had thought about my father because I knew exactly what his reaction would be—it would have been completely unconditional and straightforward. He would have wept for joy. My mother's reaction, though, would be far more complicated. It would certainly mean as much to me as my father's reaction had, but I knew her response would be more ambiguous and more emotionally loaded. It would be far too easy to say that my mother, at nearly ninety years of age, was simply weighed down by what pop psychologists like to call "emotional baggage." My mother's reaction

would be informed by so much more than that: it would be colored and shaped by the influences of her cultural and emotional history in ways that had confounded me for most of my life. My father, who had always been much more of an optimist than my mother, would have taken my win as affirmation of everything that he believed in and aspired to. My mother, on the other hand, would not be able to enjoy my win without also fearing that there would be some kind of loss lurking behind it, that there would be, if we were not careful, a price that we would have to pay for such good luck. I was finally at a place in my life and in my relationship with her where I was beginning to understand the complexity of her reaction to me and to this kind of success. I wanted to know her, to accept her, and be able to embrace her, at last, with an open heart.

My mother was eighty-seven years old when I appeared in **Moonstruck,** and she had been living with Louie and me for a couple of months at that point. She and I were finally at a point where we were enjoying a relatively companionable relationship after many years of terrible, terrible tension between us. I knew that she was pleased with me, but I also knew that she'd never directly express what she was feeling, that she'd never be able to

simply be happy for me. Her happiness would be tempered by a kind of foreboding, a reluctance to believe in the goodness of life that she couldn't help but express, and it was this that I had processed as a lack of faith in me personally, that had hurt me so deeply when I was growing up. She had always been leery of what she perceived to be good luck or easy success. And though this may have been a trait shared by many Greek women, my own mother had more reason than most to expect tragedy to come in the middle of joy, even despite the fact that, by nature, she had great appetite for life. She had what Greeks refer to as the quality of **kefti,** the spirit of exuberant living. She could be playful, passionate, spontaneous, the life of the party. The truth be told, **kefti** was at the core of her being, but it was often hidden or muted as a result of the scars she carried following experiences she'd had that were tragic and devastating. It took me the better part of my own life to even begin to understand how much they affected who she was and how she coped with the world around her—especially with me.

With my Oscar win, my mother had her own moment in the spotlight, whether she wanted it or

not, when she became the subject of interviews herself. **Entertainment Tonight** filmed her reaction to my win on Oscar night and she was interviewed by several newspapers in the days that followed. Talk about the camera loving someone! She enjoyed preparing for these appearances and she felt comfortable commenting on my success. When she was asked if she'd always known that I'd become a movie star she replied, "No. I never thought she was pretty enough!" I think this completely stunned the interviewer, but it didn't shock or surprise me. To her way of thinking, one had to be a great beauty to be a true movie star. She was also trying (as any good Greek mother would) to ward off the "evil eye" on my behalf by tempering all that praise. Appearing in any way proud or arrogant would court disaster. The gods must not be tempted to second-guess or rescind the goodwill they had just bestowed on us all.

She took my brother, Apollo, aside and shook her finger at him, urging him to warn me: "She'll get a big head." She believed the gods were watching. If you dared to consider yourself on an equal footing with the gods, they would strike you down. She'd illustrate this by smacking one hand against the other—**boom,** they'd come down and take it all away. How you handled good fortune or

success could be dangerous, and my mother wanted Apollo to remind me of that, to make sure I avoided disaster by staying humble. Here I was, fifty-seven years old, and she was almost ninety, and she was still trying to protect me.

Thanks to experience, I knew how to handle failure. I knew how to withstand it, what I could learn from it, and that it would pass. I didn't know how to handle this kind of success. What about all those fine actors and actresses I had worked with in the theater? Why should I have this Oscar success and not them? They had paid their dues as well. As satisfying as the role of Rose Castorini was, I had played far more challenging roles—why all the recognition for a role that felt as comfortable as this one? I felt unable to enjoy this acclaim until I realized there was as much to learn from success as there was from failure.

Chapter Two

During the couple of years that followed the Oscars, we were finally able to collectively let go of our breath, which we had been holding for so many years because of various setbacks, professional and personal.

In some ways, the structure of our daily lives didn't change that much: we were all busy, the children with their school and their friends, and Louie and I with our work, especially at the theater. What had changed was that now the structure of our family life was made a bit more solid, reinforced by the financial buttressing the Oscar brought us.

I was busier than ever at the theater. A couple of years earlier, I had taken on the job of producing artistic director, in what was a rather difficult and politically charged time of upheaval among the

board and staff. We had always made decisions based on a shared vision of what we were trying to create. We hit a point in the 1980s, though, when this basic vision for what the Whole Theatre was, what it should be, came into question. At that time, I was artistic director, in charge of overseeing the creative side of the theater. The producing director was in charge of the business and fund-raising side of things. He wanted to stage more commercial plays on their way to Broadway. He convinced some board members that this would solve the economic problems of the theater—which were very real. However, their solution meant changing the artistic signature of the Whole Theatre. I wanted to be part of a theater that produced plays that dealt with issues important to the human condition, plays that could change the way people see their lives, plays that confront how we see ourselves and what we make of our existence.

The purpose of commercial theater is to make money. The purpose of a not-for-profit theater such as ours is to enhance the quality of life in the community—and the community consisted of the theater artists who worked there and the members of the audience. Part of serving the commu-

nity meant keeping the price of the tickets afford-able, which meant constantly hustling up the money to deal with the deficit, always a prob-lem with not-for-profit. There were those who thought that we'd be able to make more money if we became a "trial run" theater for shows that as-pired to make it on Broadway, who believed that positioned in this way, we could accept monies from commercial producers interested in seeing their shows developed at lower costs, and we would not have to exhaust ourselves always look-ing for subsidiary support. I couldn't see us be-coming some sort of a minor-league theater that would serve as a farm team to a major-league outfit that produces and mounts commercial Broadway shows. These were not the kind of pro-ductions I, and many of my colleagues, aspired to be involved with. I became the de facto leader of this side of this tense and heated debate. After many months politicking behind the scenes, the board of directors determined to protect the orig-inal vision of the theater. The current producing director was asked to vacate his position. The board of directors then decided that in order to avoid such conflict in the future, they would cre-ate a single position that would oversee both the

business and the artistic sides of the company. I was asked to take on the newly created job of producing artistic director.

This was a huge step for me. I could not and would not give up my roles as actress and director. I knew the job of artistic director was demanding because I'd been doing that already for almost ten years. In that position I was responsible for selecting the season's plays, putting together the team—director, designer, and actors—for each play, and choosing the special programs we'd put on outside of the season's roster that were part of our community outreach efforts. In addition to all the hiring and firing of directors, designers, and actors, I was responsible for stage management and for all set, costume, and building crews. I had support staff of about twenty or twenty-five people. Adding the role of producing artistic director to that seemed overwhelming. I didn't think I could do it and I wasn't sure I wanted to. It meant an intense and ongoing involvement with the board of directors, constant efforts to raise money, daily interaction with marketing and publicity, and creating budgets.

I came very close to turning the job down, but before I did, I met with the department heads and told them how I felt. Then I asked them if they

thought I could do it. By the end of the meeting, we figured out a way to structure the new arrangement. It meant changes for everybody— they all had to take on more responsibilities and work very closely with one another. There was no more "we" and "they."

I went home and, still undecided, told everything to Louie. He said, "What the hell—give it a shot." The next day I accepted the job that consumed most of my time and energy for the several years leading up to the Oscar, and for several years after that.

The first major decision I made as producing artistic director was to rethink how the company was organized and begin a major restructuring of the business offices. This reorganization was prompted by my inheriting, from the outgoing managing director, a whopping deficit of three hundred thousand dollars, and discovering that our balance sheet was in far worse shape than any of us had known. I had to act quickly to turn things around. I hired a consultant to come in and help me analyze the effectiveness of the existing structure of the theater. We quickly realized that the theater would benefit by being run quite

differently than it had been, and so I reorganized the management and created a more team-oriented, democratic organization that gave people a chance to identify problems—working in pairs or small groups to think through solutions for those problems, and then presenting those ideas to the rest of us in a more relaxed and open environment. This would cut down on how much time people had to spend building a consensus every time an issue arose; it would help all of us to think and act more decisively and reduce the amount of paperwork and time it took to communicate with each other. Most importantly, it would generate an atmosphere that encouraged more risk-taking where there was far less of a threat of reprisal if an idea didn't work. It fostered a kind of entrepreneurial way of thinking that really seemed to reinvigorate all of us.

By early 1990 we were finally in full gear: our subscription base was at an all-time high; we were in the midst of our most ambitious fund-raising drive ever and had already raised $1.25 million toward a goal of $2 million—which would then be met by a matching grant from the state of New Jersey. But then misfortune struck: our chief fund-raiser and a member of the board of directors suffered a heart attack and had to withdraw

from his duties. We were in the middle of our most ambitious fund-raising drive ever, left without the person who had been most involved.

We were blindsided again when we lost three sources of funding at once—federal, state, and corporate. These sources simply fell away, due in part to a weak national economy and new federal and state budget constraints, but more directly as a result of a terrible domino effect that started with a "scandal" involving the National Endowment for the Arts (NEA). When a small group of artists that included Robert Mapplethorpe, the photographer known for his bold photographs that shocked and disturbed conservatives, were denied NEA fellowships that year, they protested and started a controversy that pitted the NEA against the conservative senator from North Carolina, Jesse Helms, who no one has ever mistaken for a lover of experimental art. He had made cutting federal funding of the arts his personal crusade, and the Mapplethorpe scandal was perfect timing for him, but deadly timing for us.

We were just then involved in our own mini-scandal, having recently mounted a production that caused a controversy, even in our part of the world. It was a play called **Spare Parts,** very

funny and moving, about two lesbians who talk a male friend of theirs into helping them have a baby. I remember well the discussions we'd have on how to market and publicize this show, and I found myself vetoing all of the well-intentioned suggestions for marketing the play in a way that would not cause our subscribers any discomfort. I just wasn't comfortable with euphemisms like "It's about a new kind of nuclear family": if our patrons didn't know up front that they'd be coming to see two lesbians figuring out how to get their hands on some sperm, I didn't want them to find out once they were comfortable in their pre-paid subscription seats.

Then the state of New Jersey, like just about every other state in the union, was hit by the fall-out from the NEA controversy and cut their arts grants budget. It was as if we had, after two decades of holding our seawall, been hit by a perfect storm that we just never saw coming.

When we lost our grant money, the board immediately asked me to slash the next year's budget in any way that I could. I reduced our rehearsal time from four weeks to three weeks (I knew I could count on our professional crew to get the work done), but that wasn't enough. They wanted me to cut the salaries of all the staff who

were already working ten hours a day. Even worse, the board wanted me to systematically let go the most senior, and therefore best compensated, members of the core staff in order to bring in entry-level people, at much lower salaries, to fill these posts. This is something that I simply would not do. These were the people with whom I'd worked closely for many years, and for the last four years they had supported me in my dual role as producing artistic director. I couldn't have done that job without them. It was because of their encouragement and hard work that I had been as successful as I was, and I just couldn't do what the board wanted me to. I suggested they bring in someone to replace me.

By this time, the board members, who had always supported me as well, were totally dispirited. The theater was carrying a deficit from previous years and now we'd lost three major funding sources. The board refused to replace me; they said it was either fire staff or close the theater. When they told me that, I just said, "Well, close the doors."

After almost twenty years, the end came swift and sure. Just like **that,** the Whole Theatre Company was gone.

Three short years earlier, when I came back to

Montclair from L.A. after the Oscars, the main street leading up to the theater had been jammed with traffic and supporters. Now, though northern New Jersey had benefited so much from our presence, and for such a long time, the community around us fell oddly silent. In the end, this was just another piece of that damn storm that made the whole end so final and so terribly inevitable. So many good people would be out of work! I was luckier than most of the staff and crew; in the last couple of years, thanks to my higher profile, I had been turning down work for the first time in my life. I knew that my family would be okay. But I knew that some other people would not be. I wrote glowing letters of recommendation for anyone who requested one and I passed along any job leads that I could, but this didn't manage to assuage my feelings of failure—there should have been something I could have done to avoid this ending and save the company.

In April 1990, for the first time in the twenty years since Louie and I had left New York City, I woke up in the morning with nowhere to go, no one to see, and no deadline to meet.

For all that time, I had been at the theater and in my office by nine A.M. I spent my days managing a staff of dozens; making endless fund-raising phone calls; meeting with this or that board member, actor, designer, or director; or rehearsing my part in our next production. For the first day in a long time, my calendar—my life—was wide open.

I found I had time to have breakfast at home—not on the run. I could sit at the kitchen table and read the newspaper; I even had the time to do the crossword puzzle. But I lived with a world-class puzzler who insisted my inability to spell meant I should keep my hands off **his** puzzle (not to mention his special pencils).

After about a week of this leisure time, I was standing in the middle of the kitchen, looking around, and realized that the house, though clean, had been neglected. Things that needed repairs had gone unnoticed. Doorknobs wiggled, hinges groaned, three-way lightbulbs were now only one-way in the too few lamps in the house. I didn't have a full set of anything—silverware, glasses, dishes, pots and pans. I took a tentative step toward the dining room, then stopped myself when I realized that I kept referring to this room as the dining room, even though it had been my

mother's bedroom for several years. I felt like Rip
Van Winkle waking from a long sleep—or, in my
case, what was more like an endless all-nighter.
Looking around me now, I determined to take an
inventory of the entire house. I began to make a
list of everything that needed to be either re-
placed or repaired: I took note of the cracked or
mismatched dishes, every creaky latch and door
that I had been silently complaining about for
years, and every lousy throw rug that was still un-
derfoot but that I'd been swearing for years I
would someday burn.

Then I called Bonnie Low-Kramen, who
had been the publicity manager at the theater.
She'd been the one to persuade me to have
Entertainment Tonight over for breakfast be-
fore the Oscar nominations were announced. In
the couple of years since the Oscars, she had
taken on a great deal of responsibility as her or-
ganizational and business skills had blossomed.

She had helped me pack my desk, just days be-
fore, and as I was loading my belongings into the
trunk of my car, she'd hugged me and said, "You
need me. So call when you're ready." For two
years, Bonnie had been handling my schedule,
my calls, and all of the mail that had come for me
at the theater. I really had no idea how much

work she did solely on my behalf there, but I knew it was essential. Now I found myself thinking about our last conversation; I picked up the phone. Bonnie, like the rest of us, had been unemployed now for a week. The phone rang twice before I heard her cheerful hello.

"Olympia! Enjoying your break?" she asked.

"I'm not sure 'enjoy' is exactly the word," I replied. "What about you?"

"Aside from looking for work in this dismal economy and applying for unemployment, I'm fantastic. What's up?"

And then I just blurted it out.

"You were right. I need your help," I said.

Without missing a beat she replied, "Okay. Let me just pull a few things together and I'll come over."

Just like that, and without knowing exactly what I was doing, I unofficially opened and incorporated Olympia Inc.

When I look back on this time now, I realize that bringing the business skills I'd developed at the Whole Theatre closer to home and into my non-professional life was something I could—and should—do. It was finally time to focus on my

own career with the same kind of professional attention and care as I had the running of the theater.

After almost twenty years of dealing with the rigors of keeping a not-for-profit organization afloat—especially after the last handful of years as producing artistic director—maybe I had matured enough and learned enough to make my own work my number-one priority and put myself and my career first. I was now stepping forward to focus on my own life. I was excited by this, and also terrified. It meant that I wouldn't have any excuses to fall back on if I didn't show up. If I didn't give myself the kind of care and attention I needed.

Taking this step meant that I deserved to take myself—and my life—seriously. I'd always taken my work **very** seriously from an artistic point of view, but now, thanks to my experience in running the Whole Theatre, and thanks to the kind of acknowledgment I got from winning the Oscar, I felt more confident to put myself forward and ask for certain considerations, reach out for certain parts, and even to make demands that a few years earlier I would have been too intimidated to make.

One of the skills I'd learned running the theater

was how to be a good negotiator. I still left the actual deal making up to my agents, but I now had a lot to say. I knew what I wanted—a flexible schedule that left time for me to spend with my family, more money, better accommodations—whatever it was that was on the negotiating table, I had an opinion. My longtime agent, friend, and now manager, Gene Parsagian let me have my say. But there was more to this Olympia Inc. business than just the negotiations I found myself in. I had to look at my career as a whole, rather than in parts.

The first thing to decide was where to put the office, what we laughingly referred to as our "national headquarters." Peter, my middle child, was living back at home while he finished college. He had moved up to the third floor. Christina—my eldest—was now living in New York, and we used her bedroom as a guest room when she wasn't home visiting. Stefan had moved into Peter's old room, where he stayed when he was home from college, leaving his old room empty. That, I realized, would make the perfect spot. We purchased all of the basic office equipment. We had two desks, a phone with two lines, a computer, copy

machine, and fax—all our toys were in place. We made a list of priorities. First up? Louie and I had been putting it all together on gut and need, on a month-to-month or, more often, day-to-day basis. At the time, it was the only way to do it, but now, I realized, it was time to rethink the way I ran my own business—the business of Olympia Inc.; I had to create a means of tracking money that came in or went out of "the business." This meant designing financial statements and flow charts and learning to look as closely at my own bottom line as we once had the theater's.

Next we decided to tackle the house. We made a list of everything that positively had to go and a list of everything we needed. Not only did I have the time to look around and see what was needed, I actually had the cash in my pocket to get it fixed or replaced. We went into a combination feng shui–shopping frenzy over the next several weeks and spent a lot of time in the local mall, in which I hadn't set foot for about fifteen years. I couldn't believe the size—and the din.

With Bonnie navigating our way around all this commerce, we bought lamps, rugs, mirrors, desks, silverware, and new pots and pans. It felt good to finally be able to dress up our old 1890s Georgian-style house and make it feel like a place

where you wanted to put up your feet and stay awhile, and not, as my daughter, Christina, liked to describe it, like a Greyhound bus station. It felt good to finally be able to stop running long enough to actually let myself feel at home.

Amid all the excitement of putting my new game plan into action, the closing of the theater remained a complicated thing for me. On the one hand, it was difficult to have to give up the day-to-day friendship and fellowship I had enjoyed with the staff. It was especially hard to say goodbye to Rosemary Iverson and Warren Ross, two board members who had both been such good and patient mentors to me. Warren was the president of an insurance company in town, and I used to go to his office whenever I needed to speak to him. Instead of picking up the phone or making an appointment, I'd just show up, at the back of the building where he worked and where his office was located. I'd stand on the small patio and Warren would always step out and talk to me as if nothing were more important than the crisis I was then facing. I remember we would take long walks around the park together, and he would coach me on how to approach problems

strategically and how to work with various personalities on the board.

Rosemary was just as important a friend. During the time she was president of the board, the theater had been in one of its ongoing spots of financial trouble, so I called her up and told her what a precarious place the theater was in. After listening attentively, she said, "Well, maybe there'll be a miracle!" Three days later a large check came in from one of our longtime benefactors in support of our educational outreach program. Apparently our conversation had gone straight from Rosemary's lips to God's ears! This money kept us going for awhile, but in the end, of course, it wasn't enough to save us. Her advocacy of the theater helped sustain my efforts for years. I still miss working with her, but she remains one of my closest friends.

It is only now that I can see that the closing of the theater was more than just the ending of this part of my professional life. It was also the end of a dream, a desire for a community. The Whole Theatre was not only a successful artistic endeavor, it had become an important part of all the northern New Jersey communities we served. One of the things we were proudest of was our educational program, inspired by the Living

Stage in Washington, D.C. We had started a second company at the theater called the Thunder and the Light, which worked with various populations in schools and institutions. Using theater and acting techniques, students were deepening their feelings of self-esteem, directly affecting their reading, language, and math skills. It was hard to see that program come to an end.

During my childhood, my mother had invoked a proverb that she often repeated, which seemed to me to be a kind of curse. She used to say, "When one door closes, another door closes." Hearing this had always made me angry, resentful that my mother stuck to a needlessly bleak view. Why couldn't she occasionally buy into the American notion that if you were optimistic enough, every time a door closed at least a **window** would open? Why couldn't she believe that sometimes you could somehow make your own luck? I was at a point in my life, both professional and personal, where I was in charge and would have to make my own luck. I was starting a new phase of my life and was determined to learn everything I could about who I was, what was truly important to me, and how I could make it happen. Acknowledging

this, I suddenly realized how deeply I had internalized my mother's belief that good fortune was always tempered by some kind of misfortune and misfortune was the only thing one could count on. I had ingested this bleakly pragmatic philosophy and it had become a part of my outlook on life. That had to change. I wanted to understand how and why I had so internalized this point of view. Sometimes, in order to look forward, you have to look back.

Chapter Three

My mother's family emigrated from the Mani region of southern Greece to Lowell, Massachusetts, in 1907, when she was six years old. Her family came from a very rugged, rural part of the country, known for its olive groves and the strong work ethic of the local people. They worked in the groves and lived in small stone houses that had one or two simple rooms. There was no possibility of moving up the economic ladder there, of gaining any sort of meaningful toehold and improving one's socioeconomic standing. What these people had was a voracious appetite for hard work and a set of ethics and values that centered on a rigid code of honor that kept them insulated from the world at large while firmly cementing their familial bonds. Those who chose to emigrate to America came because it offered

them a place where their hard work would be re-
warded, where they would be able to improve
their circumstances in life. And Lowell offered
them a place where they could, at the same time,
maintain their Greek values.

The town of Lowell had been a mecca for
Greek émigrés since the 1880s, and by the time
my brother and I and all of our cousins were
born, it had become known as "the Acropolis of
America." Greeks came to Lowell because it was
a factory town with plenty of available jobs. Early
arriving Greeks had established a very active and
visible cultural bulkhead, which provided an
added incentive for the newer Greek émigrés who
were streaming into America via Ellis Island to
settle in Lowell. In this small New England city,
these émigrés would find the kind of community
support they needed to begin the process of as-
similation. By 1930, there were forty thousand
Greeks in Lowell, mostly living around a part of
town known, simply, as "the Acre." The Acre, and
the rest of Lowell, and the other towns surround-
ing it, were just like many other small cities across
the United States that had flourished in the years
following the industrial revolution, but which
were ultimately hit hard by the Great Depression
that came after the stock market crash in 1929.

Alexandra Christos, or Alec, as my mother was called, was the youngest of seven: two brothers and five sisters. In Greek families, the sons would take on the responsibility of keeping a watchful and protective eye over their siblings, particularly their sisters, to ensure that the family's honor was upheld at all times. While Alec's brothers worked the family's one fruit pushcart and her older sisters worked in the local cotton mills all day, she went to school. All of the adults around her worked sixteen-hour days and contributed their earnings to the family savings, which allowed them to build their family business from a single fruit cart to a general store, which led to a drugstore, and which culminated, finally, in the acquisition and management of tenement buildings in and around the Acre. In just a few years, the Christos family became well established and prosperous in the Greek community of Lowell. The amount of energy, conviction, stamina, and above all the hunger for success it took to achieve this kind of success so quickly were enormous.

But the story of the Christos family's early days in the United States was not a cliché of immigrants overcoming hardship nor was it a stereotypical rags-to-riches tale. On the contrary, the Greek émigrés were people of great appetite, not

just for work and the betterment of their families; they also had great appetite for culture, and the arts, and good food and drink, and they were always happy to celebrate, whether it was a wedding, a christening, or any other holiday or family event. They had a joie de vivre—that spirit of **kefti**—that was perfectly suited to taking full advantage of the opportunities America offered. They would make their dreams come true without sacrificing their ability to enjoy life, and one another.

My mother, because she was the youngest in her family, was able to attend school instead of going right to work. She was the only girl in her household to ever attend school, and she was one of a small handful of Greek girls to graduate with a high school diploma. She was a self-taught pianist and had a knack for drawing and painting. She was even awarded a scholarship to attend art school, but, given the times, this was impossible. As the daughter of a good Greek family, she was expected to marry well and make housekeeping and raising her own family her number-one priority. Women could and did work outside the home, but Greek women and girls were not encouraged to have a social life outside their small community. Their social interactions were limited

to those that centered on family and friends: going to church, being involved in community organizations, socializing with other Greek children.

Greek women and girls were encouraged to be active in the community as long as they did not do so at the expense of their familial responsibilities. My mother was blessed with an inordinate amount of **kefti,** which made her a family favorite. She was playful and bold: she would sing, play practical jokes on people, and she was a great mimic. She was, within the context of her family, what we might call a party girl, and she would dance and celebrate whenever the opportunity arose. But she was always mindful to keep her actions in check so that they would never embarrass her family's honor. In short, she was comfortable with her family's set of ethics, and she was respectful of the Christos family belief in honor. In the early roaring twenties, for example, my mother wore trousers and smoked—but never in the presence of her brothers or father. She knew the latest dances—the Lindy and the Charleston—and she had her hair cut in a flapper bob, just like the movie star Louise Brooks. But she never acted out in defiant ways, never questioned that she must follow her older brother's

lead in all things. Her small rebellions, if that's what they were, always took place in such a way as to never challenge her Greek family ethic. She was, in turn, doted on by her adoring older siblings and her parents, who surrounded her with love and a sense of abundance. (She once told me that she remembered how her father would stock their cellar with giant wheels of feta cheese, barrels of olives, and casks of wine so that the family was always prepared for an impromptu celebration.)

It wasn't until she was out of high school that she set foot in the cotton mills of Lowell, and then it was only because she wanted to feel what it was like to earn something by virtue of her own hard work. She only lasted in the mill for a few short months; she lost the hearing in one of her ears due to the deafening roar of the cotton processing machines.

Though my mother was an aspiring musician and artist, she had to be careful about becoming too proficient in these creative endeavors in one very important—and very Greek—way. It was perfectly all right for a girl of her time to work alongside her brothers and her father, and study hard and achieve success in school. But women and girls were not encouraged to pursue these ac-

tivities at the expense of their primary responsibility, which was to tend to the home and family. The fear was that any movement away from the Greek home, participation in "American activities," was to be carefully monitored. This meant my mother was not permitted to have a social life that did not revolve around the family. She was not permitted to interact with Americans, especially American men, and she was allowed to spend time with Greek men only under the watchful eye of her brother Fred, and even then, only at family gatherings. In this way, her life in Lowell was tied to the life her family left behind in Mani—it was marginalized in many ways. She lived, quite by choice, in the Greek style that her family re-created here. It was all about family pride and honor. Always.

I remember my mother telling my brother and me one story in particular that always struck me hard but that I didn't understand for a long time. The ending, in particular, was upsetting to me. It went like this:

"There was a beautiful young woman who lived with her family and worked in the olive grove," my mother would always begin. "One summer, this beautiful girl fell in love with the overseer's son. In a moment of passion, she slept with her

lover. When her family found out, her parents sent for her brother to come home from America. When he arrived, he went straight to the house and got a rifle. Then he went into the olive groves in search of his sister. When he found her, she was high in the branches of a tree, picking olives. He called out her name and when she saw him she immediately yelled, 'We're going to get married,' but without a moment's hesitation he pulled the gun from behind his back and shot her dead."

At this point in the story, my mother would clap her hands three times—once for each crack of that rifle. Then she'd end the story by saying:

"And then she dropped like a fig to the ground."

When I was roughly the age of the girl in the story—probably fifteen or sixteen—I realized that this was a parable about the Greek familial honor that pervaded my mother's upbringing, and that by behaving in a way that disgraced her family, this girl had left her brother—her own brother—with no option but to kill her and so erase the dishonor she had brought upon the family name. I also learned that this was no fairy tale at all—this had actually happened to a girl back in my mother's village in Greece.

• • •

My father, Constantine Stelianos Dukakis, was born sometime around 1899, into a family of Anatolian Greeks who lived in Adramit, Turkey. His father had emigrated there and become a successful merchant. My grandfather was originally from the island of Mytilene, which was known in ancient times as the island of Lesbos—a place dominated by, revered for, and even feared because of its feminine energy. By the time my father was born, his father had become relatively wealthy and owned the "best" house in town. My father spent his childhood enjoying the benefits of this wealth—the finest education available, horseback riding, and sailing boats in the Aegean Sea. One of the elements that contributed to his family's success was their ability to master the art of living as "outsiders"—in fact, they had thrived on it, much as my own family did later in Lowell. My father wore the public mask known as the "Anatolian smile," which appears to the viewer as a face that exudes trust and openness, when in fact it is quite the opposite. It is a face that hides all bitterness and suffering, a face that maintains hope in the face of defeat. A face of contradiction. It is a device of protection, of survival. In some ways, it is

not dissimilar to the enigmatic smile of the **Mona Lisa.** It's a face of neutrality, of apparent acquiescence. It allowed this minority group of Greeks to thrive in a hostile world . . . until the Ottoman Empire began to crumble at the turn of the twentieth century when the Young Turks rose to power and started their reign of terror against the Greeks, Armenians, Assyrians, and Jews who had been at the center of commerce and culture in the region for nearly five hundred years.

My father came to America in 1914, when he was fifteen years old. By then young men were being conscripted into the Turkish army, and my grandfather had already allowed his two eldest sons to leave Turkey (though they did not fulfill his wishes and go back to the Greek mainland: one went to America, the other to Russia) in order to avoid conscription. The genocide launched by the Young Turks was brutal. In the middle of the night, my grandfather got word that he and his family would be slaughtered if they did not flee immediately, so the next morning, he, my grandmother, my father, and my father's sister, my aunt Marina, grabbed the few jewels and coins they could hide on their bodies and made their way to the sea, where boats from Mytilene were to arrive to take Greeks to safety. For some

reason the rescue boats were delayed, and by the time my father was put on board, he was deathly ill with a life-threatening virus. While crossing the Adriatic Sea, he was given last rites. It was always considered a miracle that he survived the journey from Turkey to America.

My grandfather, whose home back in Adramit, Turkey, was now the home of the newly installed mayor, never recovered from having to abandon the business he had so carefully built. After building a successful life in Turkey, he arrived in this country with no money, no status, and no work. In 1918, he and his eldest son, Arthur, died, victims of the great influenza epidemic that swept the globe following the First World War.

When they got to Lowell, my father and his brothers were forced to take any kind of work they could find, so my father took a job in a munitions factory. That lasted only six months, however, as my father watched men lose limbs, eyes, and their lives whenever there was an explosion in the factory—which happened often. My father had always had a deep love for education and had already mastered three languages and wrote essays on politics, social issues, and the classic arts.

He felt that he would only succeed in America if he were educated. Thanks to the generosity of his brother George, he was able to finish high school in Lowell. From there he went on to Boston University, and he continued to study there off and on for the next decade as he pursued a law degree. To make ends meet, he ran a printing business, first with a partner, who, I learned later, had embezzled profits from the business and run off with them. I recall my father beginning his business again, solo, when I was a young child, after we had moved into the house once owned by my grandparents. Over the years, whenever he could pull the tuition money together, he would go back to school. It was only years after his death that I discovered he had actually continued to pursue his law degree, and eventually, in 1937, at the age of thirty-seven, he was chosen by his fellow law school classmates to be the class day orator for their commencement ceremony. This was a high honor—but my father never mentioned it. It was only after he had died that I finally understood how determined he had been when he first came here—how tenacious he remained in the face of obstacles, and how hard it was for him to get that degree.

My father, or Costa, as he was known at home

and around the neighborhood, was a true believer in the democratic process. There were liberties and opportunities available to him here that he never would have had access to in Turkey or if his family had gone back to Greece. These liberties included access to free education and free libraries; the ability to speak out in public; and the ability to organize and create unions that would protect workers and laborers. He loved everything about the democratic political system, especially the right to voice one's dissent publicly—something that Anatolian Greeks certainly could not do in Turkey. And he loved it that he, indeed everyone, was entitled to this kind of voice, this kind of visibility, this kind of expression, regardless of whether you were born here or not.

His life, like that of so many others, especially the immigrants who were just finding their footing here, was derailed by the train wreck that was the Great Depression. By the time my father had finished his law degree, the country was nearly a decade into the Depression, and the bonds that had been forged by hard work and the desire for the same success that had formed among various ethnic groups were now in tatters. The willingness to lend a hand to someone of another ethnic

group, to help them succeed, was gone. For my father, a Greek, passing the bar exam in the late 1930s proved impossible, but I never fully understood why. My mother insisted that it had to do with the Irish, who held so much political power then and so held power over the courts and the legal system. I don't know if this is true, but I do know that it had to do with his ethnicity, though this is something my father would never acknowledge in public or private. (That Anatolian smile stayed in place until the end of his life.)

Years later, at my mother's wake, an old friend of hers told me that my father was not the first man my mother was involved with. Apparently she had been seeing a young Greek-American doctor who was well regarded in and around the Acre, but this man betrayed my mother in the worst way— by behaving dishonorably and disrespectfully toward her. It seems that while he was seeing my mother, he was also having an affair with a non-Greek woman—an American. When my mother found out, she had no choice but to stop seeing him.

My father had heard about this vibrant young woman named Alexandra Christos and had seen

a snapshot of her. He used to come "hang around the soda fountain," as my mother would say, at the Christos family store, which my mother was now managing. Though he visited frequently, in the hope of striking up a relationship with her, my mother proceeded very cautiously. She'd already been burned once and was guarding her heart.

In those days, my father was the living embodiment of what successful assimilation looked like. He was not only a college graduate and a young man pursuing a law degree, he was also a proud and active leader of the local Greek community. He founded the Lowell Plato Society, the goal of which was to promote the higher aspects of Greek culture among the newly arrived. For my father, this meant actively cultivating and living by the highest standards of Greek society as he saw them, which included being very well educated, being socially conscious, being politically active—and being a good family man.

He was also something of a Renaissance man—an avid reader of Greek mythology, the great Greek plays, and history. During the Second World War, he even put on plays to raise money for Greeks who were involved in the war effort. I recall that he was always speaking out in public, always actively fighting for the man in the street,

which meant all the Greek-Americans in our corner of Lowell. He was a handsome man—some would even say dashing—who was always well dressed and well spoken. I imagine that he had more than a few female admirers himself, and he certainly would have been perceived as an excellent catch.

One of the hardships my mother had to endure during her young life occurred while she and my father were courting. She was actually sued by her older sister Amelia and Amelia's husband to gain control of the Christos family estate. My mother had not only taken care of her ailing parents until they both died but she had continued to run their businesses. Because she had such a good head for numbers and had been so involved in the family business for so long, her parents had taken the rather progressive step of naming her as executrix of their estate. My aunt Amelia (who lived up the block from us while I was growing up) was convinced that my mother was withholding insurance money from remaining family members. What was probably true was that it humiliated Amelia that her husband, the surviving male of the family, was not named executor. My father, though not yet technically a lawyer in the eyes of the state of Massachusetts, supported my

mother in her legal battle against her sibling, and in the end, my mother prevailed; by then they were in love.

On September 5, 1927, Alexandra Christos, orphaned daughter of one of the wealthier Greek families in Lowell, Massachusetts, married Constantine Dukakis. It was my mother's twenty-sixth birthday. Four years later, in 1931, I was born.

Chapter Four

During the early days of my parents' marriage, they ran what was left of the Christos family business together. My father would take care of the buildings they owned, making sure that the apartments they rented were in good repair, and my mother, much to the horror of her sister Amelia, who thought it "whorish" behavior, would go door-to-door each month to collect the rent from their tenants.

Initially, my mother had no housekeeping skills. My grandmother Olympia (my father's mother) told me once that she watched my mother wash out a chicken cavity with soap and water before stuffing it! My **yia yia,** who lived with us when I was young, took my mother under her wing and taught her to cook the Anatolian Greek dishes that my father grew up on and loved so much.

She took care of me when my mother started to work for the WPA. I spent the day with Yia Yia except for lunchtime, when my mother would race home to nurse me.

By the time I came along, most of their real estate holdings were lost to the Depression. Once tenants started defaulting on their rent, my parents were unable to make the mortgage payments, and the bank foreclosed on all of their properties in Lowell, except the house my mother grew up in (which my parents rented out) and the house my aunt Amelia lived in, both of which were on Claire Street.

The Depression was difficult for both my parents, but particularly for my mother. She once told me that during a terrible freezing winter, when I was a baby, she didn't even have a quarter to put into the meter to keep the electricity on and she was terrified that rats would come out if the apartment were left in darkness. She was so frightened of the rats (which were plentiful at that time) that she resorted to burning her mother's funeral candles so that we would not be without light. This was anathema to her, having to take drastic measures like this simply to keep her child safe, and it took a terrible toll on her, even prompting her, at one point, to attempt suicide.

She told me that it was only because she didn't want me to be without a mother that she held herself back.

I gave my mother trouble from the beginning. My breech birth nearly cost my mother her life. The damage to her uterus and vagina were so severe that her doctor warned her never to have another child and that, for the sake of her own health, she should not even try.

Five years later, my mother went against the doctor's advice to have my brother, Apollo. She later explained to me that she didn't want me to be alone in life.

These were two gestures I didn't understand until I was nearly grown myself, but looking back, they illuminate for me the true depth of her love—and the irony that in the first instance, my existence was what kept her alive, and in the second, the risk she took for me could have killed her.

It was around this time that we moved back into the house my mother grew up in on Claire Street. We rented out the second floor and we took over the first. Because her pregnancy was life threatening, she had to stay in bed after the first two months. I recall these times with great fondness, because for the next seven months, I had my fa-

ther and my **yia yia,** who I adored, all to myself. Yia Yia fed me sweetened yogurt with bread and laughed at all my antics. My father, unlike my mother, was very affectionate and loving and I felt safe in his embrace.

I had just turned six when Apollo was born. I remember how they held my new brother up to the hospital window for me to see. Later, I complained to my father, "All that trouble and he's so ugly?" My father laughed and assured me that his looks would improve, and they did. Apollo had red curly hair and the sweetest smile and disposition. Within months I loved him and was showing him off to the neighborhood. I would take him out in his carriage and insist everyone look at him. I was so proud—by now his older sister was smitten.

In Lowell, I grew up largely in the streets, which was not uncommon back then. All the children in the neighborhood would gather together and play games like dodge ball and tag and roam the streets in minigangs. There was a social order to our playgroups that was dictated by race. The Greek kids stuck together, of course, and we played with the Italian or Armenian or Jewish kids in town. Our group didn't include Irish, English, or other kids of northern European de-

scent. Our interaction with the "white" ethnic kids involved group-to-group clashes or one-on-one sparring. In time, this street life could get really rough. We were constantly on top of each other, constantly provoking and harassing each other. It was a very physical way of interacting, and it meant that if you were on the outside, you'd better stay on your toes and watch your back.

In the winter, we all used to drag our sleds over to this one hill that would become littered with kids and sleds after a heavy snow. I remember a day, when I was about eight, and the sledding was just perfect. Whenever I got to the top of the hill, I'd look down and see this one boy watching me, waiting for me to get on my sled. Every time I was midway down the hill, he'd leap out, jump on top of me, and knock me off my sled. Finally, I'd had it. When I made it to the top of the hill after yet another ambush, I saw him lying on his sled on his belly, laughing with some of his friends. I seized the moment. I leapt onto my sled, made my first uninterrupted run of the day, and then jumped off my sled, ran over to where he lay, and pummeled him as hard as I could in the middle of his back. I kept waiting for him to turn over and prepare to fight me, but he just lay there with

the wind knocked out of him. Then he burst into tears. Crying was serious. It was something none of us ever did—especially not in front of the other kids. I knew that it meant that I'd be in trouble.

I immediately went home, walked straight through the kitchen, right past my mother, and into the bathroom. From the safety of the bathroom, I heard the doorbell ring. The boy's mother wanted to know if my mother knew what I'd done. I cringed behind the bathroom door, dreading what I'd hear, but my mother's reply astounded me. It's not that my mother condoned my behavior or defended my actions—she simply listened patiently and then told the other mother, in a matter-of-fact voice, "I never get involved in what my daughter does on the street. That's her business."

In my mother's eyes, defending myself against a bully was right and appropriate and in no way dishonored our family—so why should she interfere or punish me? In her mind, my behavior actually showed that I was willing to fight for my own honor, and therefore the honor of the family. Her response reminded me of a story she once told me about her own mother: her uncle was in love with one of the neighbor's daughters, and since her parents would not give their consent to

their marriage, he had "kidnapped" his love, which was a ritual that was not uncommon in her region of Greece. This girl's mother, angry beyond belief, came to my grandmother's house and started pushing and shoving her, demanding that her daughter be returned. My grandmother was so affronted by this physical intimidation (their son had chosen his bride and they would stand by his decision) that she bit this woman on the breast! From the first time I heard this story, I was always impressed with how fiercely she was willing to defend her family, and I felt I came by my own fierce stance toward life naturally.

My mother's unwillingness to intervene on my behalf was quite empowering. I actually had to use my own judgment, my own wits, without fear of reprisal. Whether I was laughing with abandon during a game, facing off during a fight, or running home scared to death that some Irish or French kid would catch up with me before I made it to our door, I felt particularly **intact** back then. Complete unto myself. I felt like I was the right person, in the right time, in the right place. That I was Olympia Dukakis, through and through.

There is a Greek myth that speaks to this time

in the lives of young girls. It is the story of the Greek goddess Artemis, who was the mistress of animals and the protector of women and children. She was also an expert huntress and could bring sure death with just one pull of her bow and arrow. She was free-spirited—unconstrained by husband or household duty. Her independent stature was fortified by her reputation as a virgin, and she would lash out at those who mocked her independence.

There is a moment when all young girls have Artemis in them, when they view themselves as their own person, unviolated by any outside definition imposed on them. At that age, it's an unconscious sense, but it is one that allows them to embrace who they are. There then comes a time when girls become aware that others may view them differently, as sex objects, for example. That outside definition alters their feeling of intactness and changes their view of themselves. But at that age, thanks to my mother's support, I felt free to roam our neighborhood and be myself—even as I had to do battle in the streets. I knew who I was, and I defended being a Greek-American with every cell of my being. I continued to enjoy this strong sense of self well into my teens, despite the

fact that by then I knew, because I was Greek and female, I would always be aware of ethnic and gender bias. They were real and a part of life.

Until the time I was ten years old or so, I don't recall experiencing gender bias in a way that felt damaging to me. It wasn't until I got a bit older that I became aware that boys and girls were held to different standards and expected to follow different sets of rules. I became aware of how difficult staying within the confines of these roles was. The roles were defined by entitlement, and entitlement was defined by gender. I might not have been able to articulate it then, but I surely recognized that boys were entitled to **initiate,** while girls were entitled to **nurture.** Boys were entitled to **action** and girls were entitled to **emotions.** I instinctively rebelled against being told who and what I could be.

The families of both my parents came to this country because they believed that the hardships they might have to endure here would be made up for by the kind of opportunities that had not existed for them back home. Those opportunities included economic prosperity, education, and to be part of the political process. The idea they

would have a say—**a vote**—in how things were run, was something they considered a privilege. We firstborn Greek-American Dukakis children were raised by people who took nothing for granted. We were encouraged and motivated to keep our eye on the ball and work toward the rewards of the American Dream, despite the obstacles we would encounter. The day I registered to vote for the first time was so momentous, when I got home and told my father, we both cried.

We were raised in a culture that prized work ethic and the forgoing of immediate pleasure for long-term rewards, and the value of service. **Giving** something back to the community was a welcomed responsibility. We were taught by our parents' example to honor the idea that "much is given so much is expected of you." This was no dead proverb that we were flogged with. Instead, we learned by the actions of the adults around us: our parents and other leaders of our community. The best way to express the gratitude you felt for the hand that had reached out to help you was to, in turn, reach out to another.

My father established several organizations that promoted Greek culture in Lowell and Boston, and my mother was very actively involved with women's groups, she sang in the Arlington

Philharmonic, she helped organize benefits for various causes, and kept her home with the pride of a good and dutiful Greek wife and mother. She understood that her primary role within the tradition she grew up in was to showcase her devotion to her husband and their children. Though my parents could not have been more different temperamentally and stylistically in many ways—they were probably a classic example of opposites attracting—they certainly shared the very traditional Greek values of honoring family and community above all else.

My mother, as I've said, was blessed with a charisma that we Greeks refer to as **kefti.** If there were a celebration of any sort, she would become the most animated—and often the most sought after—person in the room. I heard stories from my aunt Katherine and my mother about the parties thrown at my grandparents' house when the Christos girls were young. They would dance and sing, recite poems, act out stories, mimic people, and play their instruments and games under the adoring, watchful eye of their protective brothers. Within the confines of the home, surrounded by family, my mother and her sisters were encouraged to be as fun-loving as possible.

I even remember one Easter when my mother

and father promised to take me up the street to Amelia's for the traditional midnight Easter celebration. When I woke up at about eleven, they were gone. I got dressed and slipped out of the house and went up the road to my aunt's house. When I got there, I opened the door and saw my mother and her sister Amelia dancing with glasses of ouzo on their heads! They were singing and snapping their fingers. When my mother saw me standing there, she broke away from the dance and came over to me, scooped me up into her arms, and exclaimed to the room how brave I was to come up the hill, by myself, in the dark. I was seven years old.

I loved being around when she and her friends would gossip about this or that neighbor. My mother was a great mimic with perfect comic timing. She'd have her friends in stitches with her dead-on impersonations. Then she'd read the coffee grounds in her friends' coffee mugs and tell them their futures. Once she told a woman she was going to have a child, and the woman jumped up yelling, "Who told you? Who told you?" No one had told her—my mother had read it in the cup. I was convinced this ability to see the future was in the blood and I probably had it, too.

My mother had mastered the skill of knowing

when she could let down her guard and live a little, and when she had to "tighten up" and keep herself in check. She had become a terrific cook and housekeeper and she took enormous pride in both, as any good Greek wife would. But she never taught me the skills my grandmother had taught her: money was so tight and food so precious that she never let me make dinner because she knew that if I made any mistakes there wouldn't be anything else to eat. She also never taught me to sew, though she herself had been trained as a seamstress by the Works Progress Administration (WPA) and sewed for a living at various times, and she also made most of my clothes (which I hated; I wanted "store-bought" clothes, which for me represented being truly American). Fabric was just too precious and she didn't have any reserves should I ruin the little that she had. The tasks she did assign me—cleaning up in the kitchen, sweeping the floor—were ones I hated. Consequently, I learned to hate following her orders. I could never just obey her like a good Greek daughter, such as she had been; I'd constantly question her and fight with her over anything she asked me to do. I'd give her so much lip and attitude that it brought out her worst fears. When a daughter begins to disobey her par-

ents, she ceases to be a daughter; she becomes an enemy. If I rebelled against **her,** the next step would be that I would rebel against the code of behavior meant to protect my honor and the honor of family. That's what she worried about, and well she should have. My rebellion was against that very attitude. I didn't **want** to be the ideal of the good Greek daughter. I didn't want to align myself with a code that would keep me in the house, the way she was kept in the house. This unwillingness to align myself with her in this particular way frustrated and enraged her, thwarting her efforts to mold and shape me into something she wanted for me but that I didn't want to be.

I can see now that my mother and I were not just divided temperamentally, we were also becoming divided culturally. She knew that her primary role was to uphold her honor and maintain her identity as a Greek woman, while her only daughter was out in the streets of America fighting to figure out what and who I was meant to be, which was anything but a good Greek daughter.

The irony was that even as I fought inside the house to become an American, on the streets I was battling to defend my Greek heritage. I had trouble being one type of person out of the house and "out in the world" and then becoming a dif-

ferent person when I got home. The schism be-
tween these two roles was too wide for me to nav-
igate as a child, and I found myself resisting my
mother's expectations of me at every turn. I was
the girl who, out on the street, never backed away
from a fight or a challenge. I'd take on anyone. I
refused to leave this willfulness, this aggression, in
the schoolyard, so I spent a good amount of time
being "in trouble" at school. I'd get sent to de-
tention or have to sit with my face to the wall. It
was the same way at home: it was as though I
were expected to split in two, to somehow leave
my street persona outside and, once I stepped in-
side the house or school or church, become this
other Olympia, the good Greek daughter. I wasn't
going to do it, so my mother and I clashed, again
and again.

As a child, I couldn't see the whole woman my
mother was. It wasn't until many years later that
I understood how deeply mistrustful of life she
had become following an event of monumental
loss that happened when she was twenty-four
years old.

One summer evening in 1925, the Christos
family was celebrating the upcoming marriage of
their fourth daughter, Gladys. After the engage-
ment party, my mother piled into the family car

with nine other people, including most of her siblings, their spouses, and the bride and groom-to-be. My uncle Fred, the eldest Christos son, was driving. It was a wet and rainy evening, and as the car was crossing a narrow railroad bridge, slick from the heavy rains, Fred lost control and plunged over the bridge and the car tumbled into a steep ravine. My mother and her older sister Katherine were the only ones to survive the crash. Eight others, including the bride and groom-to-be, were dead.

My mother, who lost consciousness but who was otherwise unhurt, was hospitalized for a week. By the time she was released from the hospital, her siblings who had died in the crash were already buried. The tragedy had crushed both of my grandparents. They had lost both of their sons, two of their five daughters, two sons-in-law, a daughter-in-law, and a son-in-law to be. Two of their grandchildren were now orphans. My mother's father, almost overnight, started showing signs of dementia, and her mother suffered a stroke. As the youngest, and as the only surviving daughter who was not married and did not have children, it was my mother's responsibility to care for her ailing parents.

To say that my mother's life was changed for-

ever due to that trauma would be a terrible un-
derstatement. One minute she had been in the
midst of a joyful family celebration, and the next
she was returning to an empty home ravaged by
tragedy and to her parents, who could no longer
care for themselves.

She was thrust into the position of overseeing
her family's finances and businesses. On top of
this, she suffered from survivor's guilt that crip-
pled her in very profound ways for the rest of her
life. As she once told me, "After that accident my
heart never opened again. Never." It didn't dawn
on me until years later how literally she meant
this.

My mother, given everything she had gone
through herself, was nothing if not a realist. She
knew that she could not make my life as the child
of immigrants any easier by intervening in the
drama of my daily life outside of our home.

What she really wanted was for me to show
both her and my father the respect of a dutiful
daughter. She wanted me to show her that I took
the call to honor seriously, and this meant being
constantly on guard. Because she knew how un-
expected events could destroy life's happiness,

she needed, desperately, to try to **contain** my very willful personality, and the harder she tried, the harder I resisted her.

As I got older, and more willful, and it became clear that my mother could not figure out how else to get through to me, our relationship took on a terrible physical quality. She began to keep an arsenal of weapons stacked up in the corner of the kitchen, and whenever she felt that I was pushing the envelope too hard, straining too far from her and in any way igniting her fear that I would shame her, she would grab a stick, a spoon, or a switch and she would come after me with a ferocity that was terrifying. She needed to master the situation completely—and before my father came home. Otherwise her failure as a mother would be exposed.

I could never predict what would trigger one of these outbursts of hers. If I tried to be obedient in a way that I thought would appease her or please her, she might snap in anger; or I could walk into the house, completely unguarded, and she would grab me and slap me and just as quickly let me go. Or we would begin to have words and she would lunge toward me and slap at my face. She would exhort me to cry and I would look her right in the eye and refuse to shed a tear, refuse to

feel shame. I stood my ground; she never saw me cry.

I realize now that my mother resorted to this behavior because she feared that I would become less of a girl and more of a woman before my time, which could so easily bring dishonor to our family name—like that girl in the olive tree. She was afraid that I would **become** that girl. She simply had no other skills to fall back on to do what she believed she had to do to fulfill her own role and to protect me from dishonoring the family, and, ultimately, myself.

For both my parents, their early years as a married couple with children, particularly during the first part of the 1930s, were tough. Both of them worked outside of our home. My father, aside from his printing business, finally got a job at Lever Brothers in Cambridge, in the quality control department. My mother worked, too, first for the WPA, which Roosevelt had established to create jobs during the worst of the Depression, and occasionally at various department stores around town. Many days, they would still be at work when I got home from school. (My grandmother would take Apollo to my uncle George's house

and watch over all three of her grandsons while Uncle George and his wife, Aphrodite, went to work.) There would be a sandwich left for me in an icebox that was kept on the side porch, meant to tide me over until my parents got home for supper.

My father deferred to my mother in matters concerning running the household and disciplining their children—specifically, me. I never once heard them argue or have words. My father never came to my defense when she came after me physically. On the other hand, my mother never disagreed with her husband, especially not in front of the children. Part of her job was to cultivate in Apollo and me a sense of absolute loyalty and respect for our father. Looking back from an adult perspective, I'm sure my mother suffered from the guilt that plagues so many women who work outside the home. I think she was so afraid that I'd stray in some way because she couldn't keep an eye on me, and do her duty as a good Greek mother, that she often resorted to desperate measures in a bid to control me. I don't recall my mother ever being as aggressive with my brother, Apollo. Perhaps, because he was a boy, and because he was the baby, she simply didn't see him as being at such "risk" for ruin.

Though her use of physical violence as a form of discipline was the most fearful aspect of the relationship I had with my mother when I was a child, it certainly wasn't the only way she interacted with me. This is why my relationship with her was so complex and confusing to me for so long.

Underneath the anger was another mother whose artistic, poetic nature would sometimes emerge. She wanted my brother and me to experience a certain beauty in life. She wanted us both to embrace the natural world, to feel the ground beneath our feet and the sun on our backs. While other people would put up their umbrellas or run under cover during a summer thunderstorm, my mother would take us outside and encourage us to put our faces into the storm, to taste it, drink it in, become fully engaged in it. For that, I'm eternally grateful to her.

She also loved to sing, and I remember her voice filling the house with Greek songs, particularly songs about love and loss. She could also make us all laugh. She would come home from an afternoon out with her friends and she'd regale us at the dinner table by sharing any slightly scandalous story she may have heard about the neighbors. I remember how my father would brighten

up when my mother began one of these riffs, when she would let us see her wicked sense of humor. He would tell her to stop, to be kind—but I could tell that he really didn't mean it: he loved her spiritedness.

One of my favorite memories is the days when she found enough money for all of the trains and buses it would take, and she would pack up Apollo and me and all our gear and take us out beyond the urban beaches to an unspoiled, exquisite spot on the Massachusetts shore. It was a place too far out for most people, so it remained beautifully uncrowded. We would leave the house very early, and by the time we got to the beach, it was time to eat. We'd unpack our lunch, enjoy the sun and sand, and swim all day. We would dig for clams, search for shells, and swim in the ocean. When the afternoon sun began to drop, she would put warm clothes on us and we would sit together, watching the light change and the sun begin to set. By then we were usually the last ones on the beach. It was as though she didn't want us to miss a moment of the day, a moment of the beauty that all the transitions of the sun could show us. Finally, when dusk was beginning to settle, we would catch the last bus back to Boston and start the long trip home.

My mother also served as my introduction to the movies, which she loved. From time to time, despite the poverty we endured during the Depression, my mother and I would go to the movies together. She was passionate about every aspect of the art of moviemaking: the storytelling, the acting, all of it. She could impersonate anyone and was herself a terrific actress with the ability to tell a great story. She was my first acting teacher. Her self-dramatizing and temperamental personality often frightened and provoked me, but that was never on display those nights we'd go to the movies together. I recall with great fondness those times we spent alone. After the show, she'd be completely energized and animated, so turned on by what she'd just seen that we would walk arm in arm, down the middle of the deserted winter streets, and she would talk to me as though I were her best friend in the world. She would talk about the story and imitate the stars perfectly while acting out various scenes. These were rare times when she was free of the worries brought on by the Depression. Because I often felt estranged from her—I tended to be defiant, contradictory, and argumentative with her—these trips to the movies remain imprinted on my heart as the times in my young life when I felt closest to her.

I now believe it was this sensitive, artistic person who was at the core of her being and who she learned to bury after that terrible time in her life when she closed her heart.

Toward the close of the 1930s, sometime around 1938, everything in Lowell changed. My father, who was so active in the local Greek community, knew that the state of Massachusetts was planning to build a huge housing project somewhere in the center of town, though the local government wouldn't say exactly where. Word had it that the plan was to build it smack in the middle of "Greek Town"—to tear down most of the tenements in and around the Acre. My father devoted much of his time to battling this development, even going so far as to mount a lawsuit to stop any demolition. But before the lawsuit could be brought to trial, the state pushed the project through and demolition of the Acre began. In 1938, "Athens in America" was all but destroyed. Greeks (and Armenians, Jews, Irish, and other immigrant families) were forced to relocate. I don't know if it is coincidental or not, but around that time, we Dukakises relocated as well.

In 1939, we moved to Somerville so that my

father would be closer to his work at Lever Brothers. I was nine then, and I don't recall being particularly sad about leaving Lowell. I remember that we moved into a second-floor apartment in a big old house where downstairs lived the priest of the local Greek Orthodox Church. He and his wife had six daughters. Having so many girls around was thrilling for me.

But things got tougher on the street. The level of aggression among the ethnic kids was much more hostile here, much less in the spirit of tribal gamesmanship. We were also older, and the boys were stronger. At some point, I realized that, as a girl, I was in danger now in a way that I had not been before. My response to this was to become even more aggressive and confrontational. One time, I was tied to a tree with a dirty sock stuffed in my mouth. Someone came along and untied me and I spent the next three weeks tracking down the kids who did it.

Fortunately, I started to find other outlets for my energy and aggression. I really began to like school and I brought home as many gold stars as possible. I became an overachiever in the classroom, and I remember loving my teachers. There was Miss O'Neal, who taught English and read the poem "Evangeline" to our class. I remember

being completely transported, as she read so dramatically, so romantically. She was right out there with it! There was also Miss O'Connor, my Latin teacher, and my favorite of all, Miss French, who taught math. She was the essence of teacher to me: she was fair and had a true clarity of purpose about her. She treated each of her students with genuine respect.

I discovered the thrill of reading and the sanctuary of the Somerville Public Library. I would walk there on Saturday mornings and fill my arms with books, which I would devour over the course of the week. The next Saturday, I would trudge back with my load of finished reading and load up on another pile of books for the coming week.

My father, for reasons I never understood, decided that the church in Somerville was not the place for us. He decided that we should all go into Boston on Sundays to attend mass at the Greek Orthodox cathedral there. How I hated those Sunday trips! We had to take a bus and then the trolley; it seemed to take forever. I would start to feel sick as soon as the trip began. I would get terrible stomachaches, and on occasion I would even throw up. Just thinking about having to sit through Mass there and listen to that priest, who I found creepy, made me feel sick. One day I an-

nounced to my parents that I would no longer go
to that church with them, I planned to go to the
Salvation Army church instead with my friend
and her family. My mother was horrified but my
father listened to my argument and said that I
could go to church with my friend—as long as I
gave him a full report on what each Sunday's ser-
mon was about. He was serious. He didn't just
want proof that I actually went to the Salvation
Army church (which I did—for over a year: I even
rang the bell by the collection well on the street at
Christmastime): he wanted to know what kind of
information I was getting there. He wanted to
know what I was doing with my mind. This is
something my father did then, and for the rest of
his life: engage me in discussions about politics,
philosophy, and history. He always suggested
books for me to read. One of his favorite expres-
sions was Socrates' dictum that "the unexamined
life is not worth living." He also liked to quote
from the temple of Delphi: "Know thyself, never
in excess." He instilled in me, quite early on, a
consuming curiosity about life.

It was about this time, when I was twelve years
old, that I started to menstruate. I told my

mother that I was bleeding to death or was in some way injured. She simply hugged me proudly and promptly called my father into the room. She blurted out to him that I was now a woman, and though I was baffled as to why this news should delight them both (my mother had never talked to me about menstruation, let alone sex or any of the other changes my body was going through), I remember feeling very glad that here, at last, was something they were both proud of me for— though I certainly did not share their excitement at the prospect of wearing a Kotex pad; this would put a real constraint on my ability to play sports.

In my early teens a number of very important changes took place in my life. First, my beloved **yia yia** died. She had moved in with my uncle Panos and his family. Though I knew she had been unwell, I was not allowed to see her when she was dying. Apollo and I were never allowed to go into the room to visit with her. I would peer over my mother's shoulder into the dining room (where my grandmother's bed was set up) and I could see her white head on the pillow. How I wanted to be with her, to get close to her and tell her how much I loved her. My parents didn't think it appropriate that Apollo and I witness her

passing, but I regret to this day not being able to say good-bye to her.

At roughly this same time, I also saw a movie that made a lasting impression on me. **Madame Curie** starred Greer Garson as the great Nobel Prize–winning physicist, and Walter Pidgeon played her scientist husband. Here was a woman who truly had it all: an adoring husband who nurtured and supported her work, children, and an important career (she and her husband did the very dangerous work of isolating and identifying first polonium and then radium and contributed enormously to the development of radiation). I had found a role model. Here was a woman who was portrayed as smart, tenacious, outspoken, hardworking, passionate about her work, **and** a wife and mother. I decided I should work a little harder to get good grades, particularly in my science classes.

It was around this time that I started to put on little plays and carnivals in and around the neighborhood, and I always recruited my brother, Apollo, to star in my productions. One Christmas, we mounted a recreation of the Nativity—Apollo played the baby Jesus. Another time we put on a circus and Apollo was the strongman. I always preferred to act as the writer,

producer, and director—all rolled into one—
rather than do any of the acting. Even so, I
portrayed "the Spirit of Young Greece" in a pro-
duction my father put on to raise funds for the
Red Cross. I was supposed to open a box and free
two white doves into the air, as symbols of liberty
and freedom. I remember taking a dove in each
hand, lifting them to the sky—and having one of
them relieve itself all over my arm. Now I recog-
nize this was an omen about what much of my life
in "show biz" would be like.

I was becoming acutely aware of the dynamic be-
tween my parents and I found my loyalties be-
coming more and more aligned with my
father—against my mother. As I moved into my
early teens, my father began to treat me like an
adult. It's as though he had been waiting for me
to outgrow my babyhood, to become old enough,
in his words, "to reason things out," and we
started to grow closer. This burgeoning relation-
ship with my father came at a price—it meant I'd
become even more alienated from my mother,
whose behavior was turning ever more violent
and confusing to me.

Just at the time when my father began engaging

me in discussions about the world at large, my
mother began to suffer from dramatic and baf-
fling episodes. At odd times and without warning,
she would begin to choke. She would grab herself
around the throat and continue to choke as she
slid from her chair and onto the floor. The next
thing we knew, she would be writhing on the
floor, her eyes fluttering, and she would nearly
lose consciousness. My father appeared detached
during these episodes, as though nothing unusual
was happening. Years later I tried to describe
these scenes to a therapist who suggested that
they were like the "swooning" or fainting spells
that Victorian ladies would have. While my
mother would lie on the floor, my father would
start smiling and whistling. On these occasions,
my brother would be pleading with my father to
call the doctor. I would just stand there, seething
with anger while I watched the whole scene. I felt
enormous contempt for her at those times. I
couldn't stand watching her humiliate herself that
way. This family tableau was insane. I vowed that
I would never let myself reach such a level of self-
abnegation. Never.

It wasn't until much later, after I had visited the
part of Greece where she was from and learned
more about the emotional heritage of her people,

that I understood that this kind of display of withheld pain, rage, and grief was the only way that many women of my mother's generation could express themselves. But at the time, all I wanted was to put as much distance between me and my mother as possible. I found a willing accomplice in my father.

My father took to engaging me in discussions about worldly topics while excluding my mother—even if she was in the same room with us. I would come home from school, drop myself into a kitchen chair, and begin my homework while my mother was fixing supper. If he was not working or staying out late, my father would come home, take off his coat, and join me at the table. He would quiz me about my school day, ask what I was reading, doing, and so on. All the while my mother would be working with her back to us, like a servant, washing the dishes. If my mother ventured an opinion in a conversation she clearly had not been asked to join, my father would tell her to "shut up." He believed that my mother's opinions were uninformed and not well thought out—and she accepted his treatment. She knew her place and she'd simply slip back

into a state of silence. If they were going out and he didn't think she looked appropriate or attractive enough, he would tell her to go back upstairs and change her dress. I could see her humiliation and shame at these times, but she never contradicted my father. Worst of all, I never came to her defense.

I found myself behaving in a similar fashion toward her. My contempt for her grew. When my father treated her in ways that I found demeaning or disrespectful, I kept waiting for her to stand up for herself. But she never did. At those times, I honestly hated her.

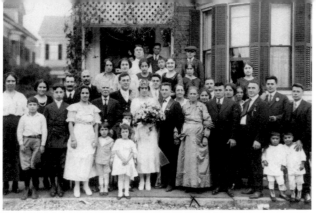

1

2

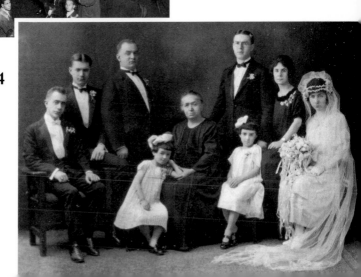

3

4

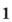

5

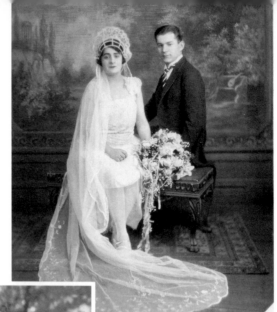

6

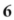

7

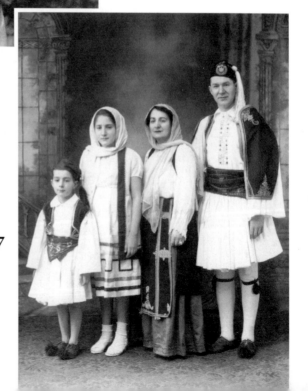

8

9

10

11

12

13

14

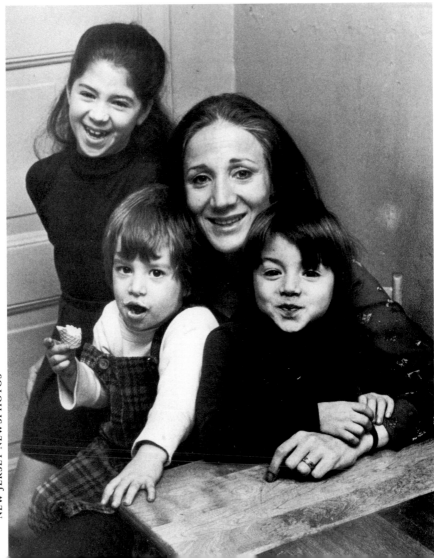

WHOLE THEATRE

©1989 BILL CLARE

15

16

17

JIM CHAMBERS

JULIE SNOW

18

19

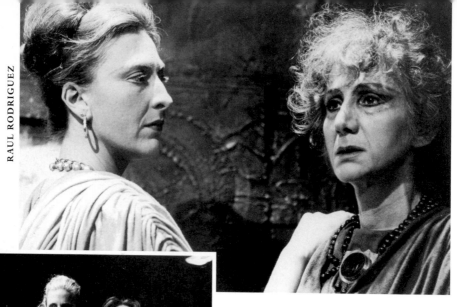

RAUL RODRIGUEZ

20

C.G. WOLFSON

COURTESY OF THE WILLIAMSTOWN
SUMMER THEATRE

21

22

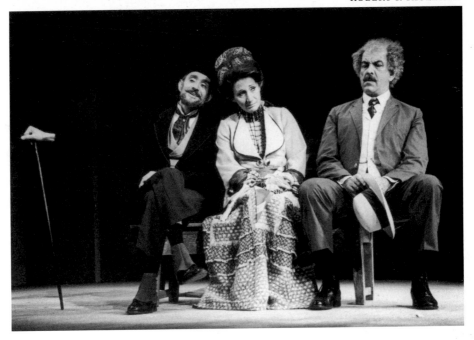

23

24

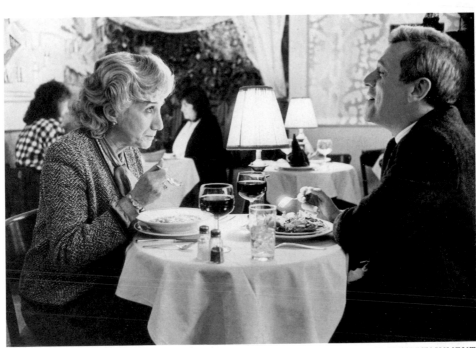

25

26

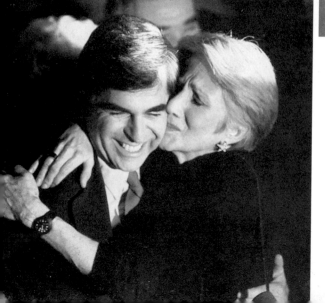

27

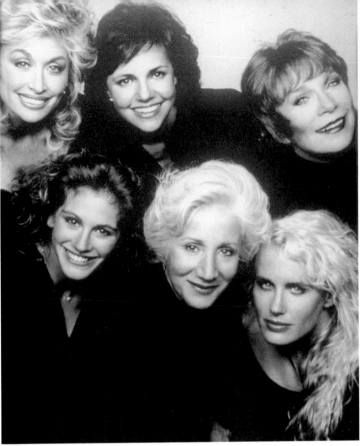

28

COLUMBIA PICTURES

29

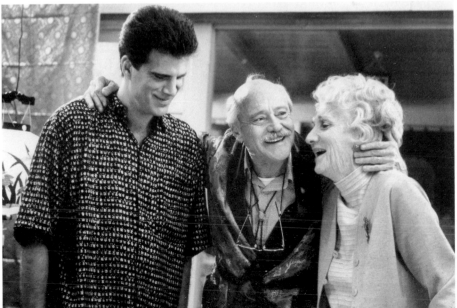

30

31

32

KRISTIN HOEBERMANN

CLAUDIA MANN

33

VANESSA PRASAD

34

35

JOAN MARLER

JOAN MARCUS

36

37

38

39

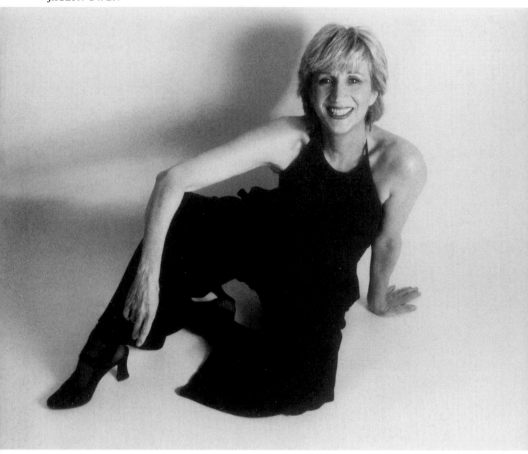

40

Chapter Five

Just after I began the ninth grade, my family moved again, this time to Arlington, Massachusetts, which was just a few towns away from Somerville—but which, in so many ways, felt worlds apart. It was 1946, World War II was over, and my father had saved enough to buy us a house of our own. When we left Lowell, I had to learn to survive in a world of ethnic hostilities that was much more vicious than the one I left behind. In Arlington I found myself living in a very homogenized, very "white" community where my Greekness really stood out—where the discrimination was based on an absence of diversity rather than on a clash of cultures. I found this lack of racial plurality to be so unsettling, I asked my father if I could at least finish my first year of high school back at my old school in Somerville.

Much to my surprise, he said yes. After the first year, I had no choice but to transfer into Arlington High School and this transition was tough.

First, I was one of only a handful of ethnic girls in my class. On my first day of school at Arlington High, when the teacher asked me to come to the front of the room so that she could introduce me to my new classmates, she said my name and everyone laughed. Surrounded by so many American last names, my sense of being an outsider—of being Olympia Dukakis—became excruciating. I channeled all of my separateness, all of my natural aggression, into playing every organized sport I could find.

Aside from my first true love, which was basketball, and which I'd played since junior high, I was more comfortable competing one-on-one than working with a team. I found it difficult to embrace the idea of "teamwork" with people who I felt looked down on me for my ethnicity. I found myself drawn to sports where I would have to rely solely on my own wits, skill, and competitive appetite to prevail. Ironically, these sports also involved wielding some kind of weapon—a tennis racket, a fencing foil, a rifle, and even a Ping-Pong paddle.

In retrospect, I'm very lucky to have found sports when I did. Sports gave me an outlet. They provided a safe forum in which I could be myself without shame or fear that I was being "too much, too over-the-top." I found my way into fencing when I was recruited to spend Saturday afternoons with a friend, sharing a class. Our teacher, Cliff Powers, trained us using a French foil, with an emphasis on form. My friend quickly lost interest in fencing but I didn't; I loved having a sword in my hand. I loved the quickness of the sport. The blade was an extension of my arm—of **me.** I continued my training at the Boston Fencing Club, where I met Master Vitale (students called their teachers "Master"), who was the fencing coach at MIT. He specialized in the Italian foil, which lent itself to a more open and aggressive style of fencing. It was at the Boston Fencing Club that I first saw a team of Hungarian women train. These women were incredible! They were athletic, loud, fast, aggressive, and very focused. I yearned to be as free and uninhibited as they were. It was inspiring to see women so unapologetically playful and competitive.

I joined a rifle club in high school and went to the Arlington police station several times a week to practice in their firing range. We had state

matches and I would compete with a black patch over one eye. I couldn't—and still can't—close just my left eye. On the night of my junior prom, I shot a perfect score in the "prone" position, firing from flat on the ground. In my senior year, also on prom night, I shot a perfect score in the "sitting" competition. I could shoot a man through the heart at twenty paces, but I couldn't get a date for a dance.

I played basketball, but we had to play by "girl's rules," which was frustrating. The ball could only be dribbled twice and then you had to pass it. No body contact was allowed. To play all out like the boys was not possible. Many years later I went to see the professional women's team—the New York Liberty—play at Madison Square Garden. I wept to see them playing at full throttle, unashamed of their competitiveness, without apology. Their grace, strength, and agility were so moving to me.

I also played tennis, with a racket my father had bought at a used sporting goods shop for twenty-five cents. It didn't matter, I loved playing the game. I was named captain of the team. I played a lot of Ping-Pong with my cousins, and in the winter I skied and went ice-skating on the ponds

around Arlington with my very own hockey stick and puck.

I graduated from Arlington High in 1949 and got some financial aid for college in the form of a work-study grant from Sargent College in Cambridge, Massachusetts, which was then affiliated with Boston University. I commuted to school each day and worked after class, organizing the costumes and props in the school theater loft. I had declared a major in physical education and planned to earn a bachelor's degree and become a gym teacher.

Once I got to Sargent, I continued to fence at the Boston Fencing Club and my life began to open up in other ways. I started to make some friends and even began to date a little. I remember one time when I had been out late with a group of new friends and I got home about four o'clock in the morning. I was barely through the front door when my mother lunged from the shadows toward me, her face crazed. Before she could raise a hand to me, I spoke first. I stared right into her eyes and said, "If you hit me, I'll hit you right back! I am bigger than you now." This stopped her dead in her tracks. That moment, it turns out, marked a turning point for me. From

that time on, my mother never raised a hand against me—she never again tried to rein me in by using physical force. What transpired between us in the middle of the night was profound and significant, yet we never spoke of it again.

This was the first of many steps I took toward autonomy, but I was at an impasse. The gap between what I aspired to be and what I was taught was appropriate, created tremendous turmoil. I came dangerously close to breaking down before I was able to rebuild myself. I had feelings of anxiety, depression, and despair. Yet these years in my twenties helped liberate what is most vital and essential in me as an artist and a person.

I continued to fence. Once I had switched from the French to the Italian foil, I also switched teachers. I started going to MIT to work with Master Vitale, who I had met at the Boston Fencing Club; I would help him maintain the equipment and spar with the younger members of the MIT fencing squad, and in exchange, he gave me three classes a week.

After about a year of working together, he finally registered me for the Junior Division of the New England Fencing Championship. The only requirement was that I would need a regulation fencing uniform.

We had no money for extras, much less money to spend on a fencing outfit. My mother asked me to take her into Boston to a sporting goods store, where she examined the women's fencing outfit, making detailed drawings. At home, she got out large sheets of newspaper and began to draw a pattern, something she'd learned in her work at the WPA. Two days before registration closed, I found a package on my bed: the jacket and pants of a white fencing outfit. She'd even made a bag for my foils. Though it was not a "regulation" outfit, my mother had done a terrific job of approximating a commercially produced fencing uniform. Without one word or iota of fanfare, she had given me exactly what I needed. This was the beginning of my understanding that the support I thought was missing was there; it was silent support.

Thanks to my mother, I made my way into my first New England Fencing Championship—but I was nearly thrown out of the competition after my very first match. It was held at Harvard University and I would be competing against girls from all over the area, many of whom attended one of the many exclusive private schools in the region. My first match was against a blonde girl who embodied, in my mind, everything that I was

not. She carried herself with an air of Waspy assurance that I both coveted and hated. The referee signaled for us to prepare, and then, with the utterance of the words **"En garde!"** we began our match. I could see immediately that she was not a strong fencer just by the stiff way she held her foil. I began to go after her as though I had just stepped onto a battlefield and I was facing my mortal enemy. I began to lunge and move as though I meant to draw blood, and the sounds that came out of me! The art of fencing was a century old, and here I was, grunting and thrusting and screaming as though I were in a street fight. At the close of the match, which I won handily, Vitale could barely make eye contact with me.

"Olympia," he said. "You've got to stop this and fence." I knew he was right, but I did it again. This time, he threatened to pull me from the competition.

Fencing is an art, and it is an art with discipline; it marries athletic prowess with form. Every encounter begins and ends with a bow to your opponent, regardless of how aggressive you feel. Fencing requires you to channel competitiveness appropriately. I desperately needed this form, these boundaries. I desperately needed the safe structure the sport offered my contradictory and

overwhelming emotions. I promised Vitale I would not lose control again. I kept my word: I went on to win the Junior Division title of the New England Fencing Championship that year and for the next two years as well.

I found myself increasingly self-conscious about my looks. I had always been aware of how "ethnic" I looked and it had become more and more difficult for me in high school. Now I was in college, trying to make a social life for myself, and I felt that my looks were standing in my way. I had always thought that my prominent Greek nose (which was the spitting image of my mother's) was the first thing everyone—especially boys— noticed about me. I was always talking behind my hand as a way of shielding whomever I was speaking with from having to gaze at the large bump that sat on the bridge of my nose. During the summer between my first and second year at Sargent, I met a girl who boasted to me about her recent surgery, and how she had had her nose "bobbed." I was amazed by this frank admission. I approached my parents about having the surgery. My mother remained silent as always, but my father, much to my amazement, agreed. So in

the summer of 1949, at the age of eighteen, I had a "nose job." It was one of the first major decisions I ever made that was about helping myself, about freeing myself. I didn't want a pug nose, or some version of the perfect, all-American nose, but I didn't want to spend my life thinking about my nose, either, and now I would no longer have to. Even though I still have a strong Greek nose, I have one that I have lived with comfortably for more than fifty years.

During my sophomore year, a classmate, Joyce Kadis, and I were selected to put together an original stage revue that would be performed in front of the whole college. I was excited about this, but nervous as well. Whenever I walked by the auditorium in high school and watched the theater club rehearse, I had always wanted to join in—I just never dared to. Though I had appeared in some of my father's benefit productions, and had put on neighborhood plays with Apollo, I had never been involved in anything this ambitious before. Our idea was to do a series of skits based on popular movies. We made a soundtrack based on the hit songs of the day that we wrote new lyrics for. I even enlisted Apollo, who was in high

school then. We shared all of the duties of acting, directing, and making our costumes and scenery. I was in a skit as Rudolph Valentino, playing opposite the shortest girl in the school (who was also an all-American lacrosse player), who played the "desert beauty." I loved all of it: the writing, the rehearsals, and figuring out the staging and the props. I felt alive, present, and **happy.** We did a good job and when the show was over, I knew this was something I had to pursue.

I announced to my parents that I was going to leave Sargent and pursue a degree in theater arts at another school. I remember my father being struck dumb, as though he couldn't understand the language I was speaking. Theater was what you did **after** you finished your workday: it was a hobby, a leisure activity, albeit an honorable one. My mother's reaction was more to the point.

"Olympia," she said. "We just don't have the money to send you to college for another four years, for you to start again. It's Apollo's turn now. If you want to study theater, you will have to pay your own way." Even though I had my work-study income at that point, my parents were still covering much of my tuition. I appreciated her being so straightforward with me and then I set about figuring out how I could move forward

with my new plan. Given the reality of our finances, I realized it would be foolhardy to quit school when I was halfway to a diploma. I decided to figure out how to make this happen, even if it meant I had to delay my goal for a little while.

One of the highest-paying jobs for women at that time was that of physical therapist. Sargent, coincidentally, had only one other major program besides physical education and it happened to be physical therapy. I had always been a strong science student, so instead of dropping out, I decided to switch my major and, within two years, complete the bachelor's degree in physical therapy. Then I'd be able to work, earning enough money to put myself through theater school. This was a pragmatic, even mercenary decision on my part. I was no Marie Curie. It was 1952 and terrible polio epidemics were sweeping the country. I received a full tuition scholarship from the National Foundation of Infantile Paralysis in exchange for working for two years as a "field" therapist after I graduated. But I had no idea what I was signing up for, what I'd experience before I was able to again set foot inside a theater.

The course work for physical therapy majors was demanding. We were expected to excel in calculus, physics, chemistry, physiology, and, espe-

cially, anatomy. In the physiology lab, I was one of the only students who could pith a frog or dissect another animal without even flinching. The other students turned to me when they couldn't do their own dissecting and I would do it for them. It was only much later, once I had moved beyond my life as a physical therapist, that I realized how detached I was during this time. I kept up my determined march toward graduation, with no distractions.

I continued to work with Vitale throughout college, and I continued to compete—until I became interested in something far more compelling my junior year: I fell in love. Then something equally exciting happened—Vitale got a call from the United States Olympic Fencing Team. They had heard about me and wanted to come see me work out. One afternoon these officials showed up at the Boston Fencing Club and watched as Vitale took me through a rigorous and grueling workout. We sparred for well over an hour, and when we were finished, every muscle in my body was shaking. I stumbled over to the water fountain. "Don't drink," Vitale demanded, "and don't sit down." I stood panting, leaning against the wall.

"If you drink something, you'll throw up. And if they're interested in you, we'll be working like this every day so you better get used to it."

I knew, at that instant, that despite how competitive I had been and still was in many ways, I just didn't have that kind of desire anymore. At least not for fencing, and besides, I was in love and wanted to take walks by the Charles River, have hot chocolates at Schrafft's, and make out in doorways.

Though I had dated some (always tentatively and uncomfortably), meeting N changed my life. He was the son of friends of our family, but they had moved out West when we were both young, so we really didn't know each other until we were reintroduced while we were finishing our undergraduate degrees in the Boston area. One Thanksgiving we found ourselves sitting next to each other at dinner. N was very charming—and very handsome. He was also a wonderful listener and looked at me as though I were the most enthralling person on the planet. And he had the bluest, clearest eyes I had ever seen. We began to date and from very early on I was sure N was someone special. Something was opening up inside of me and it was thrilling.

N and I became inseparable. He admired my

athleticism and my determination to pay for my own education and thought it was wonderful that I was working so hard to find a way to pursue my real dream of becoming a theater director. He, too, had a similar "secret" passion: though he was expected to complete his studies and go into business with his father, in his heart he wanted to become an architect. Just before I graduated, we became secretly engaged.

I graduated with a degree in physical therapy in 1953, the year Jonas Salk began the preliminary testing of his polio vaccine. It also happened to be the time when the worst polio epidemic in decades was at its peak. I was terribly naive at that point, almost completely unaware of what I was getting into. Polio is a virus that attacks the motor nerves in the brain and spinal cord, often leaving the victim's legs, arms—or their entire body from the neck down—paralyzed. In the most severe cases, the muscles of the respiratory system and throat are also paralyzed, which makes speaking, swallowing, and breathing difficult or impossible. From the time of the ancient Egyptians five thousand years ago until 1955, when Salk's vaccine was delivered to the masses, polio epidemics would flare up the world over. Most of the victims were children. If a patient was lucky enough to

survive the virus, he or she would need physical rehabilitation in order to retrain the muscles that had been paralyzed by the virus. Helping people regain their mobility through intensive rehabilitation would be my job for the next two years.

Leaving Boston and my family home was something I had been looking forward to. In fact, I was itching to get out on my own and become independent. The prospect of leaving N, though, was another matter entirely. We agreed that we would write each other constantly, so with this promise in hand, I left Boston for rural West Virginia. I was on my own for the first time in my life.

Just getting to Marmet, the tiny hamlet in the Kanawa Valley where I was to work, was an adventure. I first took the train from Boston to New York City in order to register with the National Foundation for Infantile Paralysis. I spent my first night ever in a hotel, and the next morning, I boarded an airplane from New York to West Virginia. I was twenty-three years old and I was taking my first airplane flight. The stewardesses got such a kick out of how excited I was, they got the pilots to invite me to sit in the cockpit for a few minutes. After landing, I was brought to a

tiny frame house that would serve as my lodgings for the next several months. Up a path from the house was the clinic, a renovated schoolhouse.

Despite how remote Marmet was, the population had been hard hit by the epidemic. There was no full-time doctor tending to the children who were being treated. Twice a week, a doctor from nearby Charleston, West Virginia, would come through on his rounds and check the status of each patient. Other than that brief encounter, we were all on our own. The therapy department was desperately shorthanded, and the staff—all two of us—worked ten-hour shifts, treating twenty-five to thirty patients a day. We had both been trained to handle a caseload of only twelve patients a day. It was grueling and humbling. Each time we'd begin to make progress with one child and he or she would be taken out of the iron lung and moved to a bed, it seemed as though two more very critically ill children would arrive.

One of my first patients in Marmet was an eight-year-old boy named Daniel Cade. He was blond, blue-eyed—and encased in a respirator because he was unable to breathe on his own. Every day, I would work with Daniel by reaching into the side openings of the iron lung and stretching his tightened limbs. He would tell me, in no un-

certain terms, to ease up. ("Don't take it up so fer!" he'd say in this mountain dialect everyone there spoke.) But every day his condition worsened. Miraculously, one day he seemed to turn a corner and begin to improve. When he was finally removed from the respirator, Daniel was still very weak and I had to work hard with him to begin the painful and long process of reawakening the muscles in his body.

One rare day off, a Sunday, I had gone to see the feature at the local movie house. While I was sitting there I had a premonition, and I stopped at the hospital on my way home, just to check in on Daniel. He wasn't in his room. He had had a relapse and was once again placed on a respirator. Next to him, kneeling on the floor and sobbing, was a giant of a man who I recognized must have been his father. Standing next to him was a woman who was obviously Daniel's mother—she had his clear blue eyes and blonde hair. She was staring out the window, praying. I stood there, taking in these people, so overcome by grief and a sense of helplessness. Soon after I left the room, Daniel Cade died. I had never been so close to death, had never witnessed people who were forced to sustain such heartbreaking loss.

Within a week of losing my first patient, I, too,

contracted polio—luckily, not the paralytic kind. I had all the classic symptoms: a stiff neck and tightness in my hamstring muscles. I spent a week in my tiny house, alone most of the time except for the occasional visit from one of the nurses from the clinic. Though I recovered quickly from the virus, I've never forgotten that experience. Three months later, I was sent to the next viral "hot spot" in Duluth, Minnesota.

"It's freezing here" is how I started every letter I posted to N from Duluth. I found myself living in the middle of the northern prairie just as winter hit—in a dramatic change from the stultifying heat of the Appalachians. This was about as far as I could have gotten from my experience in Marmet. The hospital in Duluth had every piece of equipment money could buy, much of it state-of-the-art, and a full staff of doctors and nurses. My job was focused on recovery rehab, which meant that I spent most of my time with patients who had already survived the virus. They were now retraining their muscles in order to regain mobility. During my three-month stint there, not one victim of the epidemic died—not one. But I had another experience with a patient that I will

never forget. A young woman came into the hospital extremely sick with the virus—and eight months pregnant. Her condition was bad enough that she had to be placed in an iron lung. Miraculously, though she was paralyzed from the neck down, she managed to deliver a healthy baby—even while on a respirator. But it soon became heartbreakingly clear to us that this woman would never be able to actually hold her baby. I have thought about that woman over and over again throughout my life.

The Minnesota winter was long, hard, and dark and I missed N. His letters to me were becoming more passionate and urgent, and they made our being separated all the more difficult. I started to rethink my plans: until I was called up for my next "tour," why not move to New York City and enroll in a theater program there? I had saved enough money—maybe I could even start a term at Columbia. With that thought in mind, I finished my work in Duluth and made my way back to New York.

On my very first day in New York, N and I met at the Empire State Building and then found a hotel to check into. He was able to leave Boston and come to New York City every other weekend. He was very close to graduating, which meant

we'd be together all the time. I had found a furnished room (with kitchen privileges) and had begun taking classes as planned. One night, around two A.M., I heard a pounding on the door of my room. It was N. I unbolted the door and took a step back to look at him and saw that he was in awful shape; he had a black eye and his face was all scratched and bleeding.

"What happened? What are you doing here?" I asked as I pulled him into my room. "I had to come. I couldn't wait. So I hitchhiked down from Boston. I stopped in to a bar and got into a fight . . ." Before he could finish, we were falling into the tiny bed that dominated my furnished room.

Since I had been in New York, we had been able to spend lots of time with each other, but things had become complicated. N's parents were pressuring him to marry. And they had picked him out a bride. In traditional Greek fashion, they had set their sights on a girl back in N's hometown, someone he had known his whole life. In their eyes, this girl was far more appropriate than I as a future daughter-in-law. Here I was, a woman who had been traipsing around the country, but even worse, now I was living on my own in New York City and studying theater! N's parents

thought I was too independent. They insisted that he marry the girl they had chosen. N assured me that he would not give in to his parents' pressure. With his graduation approaching, we spent hours planning how we would break this news to his parents and more hours planning on how, once we were settled back in his hometown, I would open a community theater and he would begin to study architecture, his true passion. I called home and told my mother and father to plan on a dinner in a few weeks; N and his parents would be coming and he and I were going to share some important news. We spent that weekend in New York blissfully fine-tuning our plans.

The day came when N would formally announce to my parents our plan to marry. My mother prepared a proper Greek feast and my father set the table with the best china and silver. N and his parents arrived and I immediately sensed that something was wrong. There seemed to be a forced friendliness. Even though our parents weren't close friends, they knew each other well enough to enjoy a drink and a meal together. As dinner was winding down, I kept waiting for N to propose a toast. I kept trying to make eye contact with him, but he wouldn't meet my gaze. The dishes were barely removed from the table when

N and his parents announced they had to leave. This was supposed to be the moment when our engagement became public (we had secretly been engaged for almost a year at that point), and then our parents would raise a toast and set a wedding date for us. Instead, we found ourselves hustling to the door behind N's family, promising to see each other the next day at his graduation. At that point my mother remarked, "There's something we have to talk about here." My father stood by silent and humiliated. With vague excuses as to why they had to leave, N's mother reassured mine, saying, "Don't worry, we'll talk tomorrow, after the graduation." With that, they were gone.

The next day, I stood by, barely acknowledged as an acquaintance—let alone their son's fiancée—while N graduated. After the ceremony, I felt sick to my stomach as I watched N hand his diploma over to his father. They then turned and walked away without ever acknowledging me or my parents. I felt so disgraced and embarrassed, both for myself and my parents, who were clearly feeling the same way.

I remained hopeful—and in love. I thought that N needed more time, needed the opportunity to convince his parents that I was his one true love. Though I was still hurt by his inability to take ac-

tion at that moment, I again left Boston, this time for Dallas, Texas, and my next tour of duty as a therapist. My goal was the same: to save as much money as I could so that N and I would be able to begin our life together . . .

Dallas was hot, humid, and hostile. I was assigned to work in the children's ward of the county hospital. The outbreak was so bad and so widespread, we were even seeing patients from the nearby prison. Even jail cells didn't protect people from contracting polio. I remember a black convict in his thirties who came in feverish and delirious and shackled in chains—even though he was clearly paralyzed and couldn't rise from the stretcher he was strapped to, let alone walk.

"Take the chains off his legs," I ordered the policeman who accompanied him. He just looked at me as though I were crazy. "I mean it. How do you expect me to treat this man if I can't move his legs?" I turned to the prisoner, knowing full well he couldn't walk. "Will you promise me that you won't run off if they unlock these chains?" He nodded yes, his eyes burning with fever. The guard unlocked the leg irons—then stood over us both with a loaded gun pointed at my patient until I finished the treatment. I thought I knew

about prejudice from my own experiences back in Massachusetts, but being in Dallas, in 1954, was an eye-opener.

Two weeks after I got to Dallas, I got "the letter" from N. I suppose I should have seen it coming, but I was hoping so much for a life with him that until I read his words, I believed that our plans would come true. His letter began in the way that all such letters begin: **Dearest Olympia . . .** It was over. . . . **simply can't fight my parents any longer . . . need to get on with my life and want you to get on with yours . . .** I held the letter in my shaking hands and walked over to the mirror, took a hard look at myself, and said, out loud, "Okay, Olympia: now what are you going to do with your life?"

I no longer had a future. I had no idea what I would do next. I couldn't go back to Boston and face my family and the shame I had visited on them. I couldn't bear the idea of going home and seeing pity in their eyes.

I decided to stay in Dallas and enroll in classes at Southern Methodist University. I wanted to take more humanities courses, since I had concentrated so much on the sciences. That was the ex-

tent of my plan. I enrolled in a handful of classes,
including a fiction writing class. I began writing
poetry, and encouraged by the teacher, I submit-
ted a few poems to literary magazines. They were
published. I had been alone working the epi-
demics, but I had never felt lonely until now. I
was again the outsider, but now I was separated
not only by my ethnicity and because I was a
northerner. I was also isolated because of my cir-
cumstances. Here I was, a young woman who
could hardly pull herself out of bed in the morn-
ing, drinking Cokes and smoking cigarettes for
breakfast, who wore her pajamas to class. The so-
cial world at SMU was built around the "Greek"
system of sororities and fraternities, and I was
considered a freak by the standards of this sys-
tem. Or at least an exotic East Coast bohemian.
On the "fuckability" scale that everyone talked
about, I scored the highest rating—the highest for
being the **least** likely to succumb to the charms
of all the good ol' boys around me. One of my
fiction-writing classmates approached me after
class one day and asked if I was a lesbian, as
though this would explain why I came to class
with uncombed hair and no makeup. The only
thing that kept me grounded was the encourage-
ment I got from my fiction-writing teacher.

At the end of my second semester, I got a phone call from Uncle Panos, my father's brother and our family physician, calling from Boston. My father was gravely ill—could I come home at once? My father, then in his mid-fifties, had worked many nights standing at the printing press, and he had terrible circulation problems from his varicose veins. He had gone into the hospital to have them removed, but the routine surgery hadn't gone well and he had developed a postsurgical pulmonary embolism. I looked at the meager amount of money I had left in my drawer and decided that I had just enough to take a train from Dallas to Boston.

Two days later I went directly from the train station to the hospital and to my father. He was going to be okay, but it was immediately apparent that something else was going on.

"I just want you to know that your father has done nothing bad." These were the first words out of my father's mouth when I walked into his hospital room. Then he said, "And if anything happens to me, you have to help Apollo get an education." I had no idea what he was trying to say. That night at home, I learned what had been going on.

"Do you know Dad was gone for awhile before

this?" Apollo said. My father had simply driven off one day and didn't come back for almost two months! Before he left, my mother had found cups with pink lipstick stains, smelling of liquor, in my father's car. And then he was gone. He would call her every three or four days, telling her that he had **had** to flee—that he was being pursued by Senator Joseph McCarthy. His prolonged absence sent my mother into a complete tailspin: she would rage and curse, and run weeping out of the house to pound on the doors of churches. She took on the keening and lamenting that reminded me of the women in her village back in Greece who I saw many years later. My mother **lamented** my father as though he were dead. I remembered when I was still in high school, my mother would stand weeping in the kitchen, in the dark, waiting for my father, who was "working late," to get home. He was absent this way much of the time when I was growing up. And here she was again, waiting for him.

Apollo, who was only seventeen and still living at home when my father disappeared, was furious with me for leaving him to handle this alone. Now my father had come home, in order to have the operation. My parents were back to their old

game of pretending nothing had happened. It was as though they had a pact that relied on silence as a way to convince the world—even their own children—that everything was fine. My brother and I felt worn down and confounded.

My father had been somewhere in Delaware or Maryland, presumably traveling from one cheap motel to another with some woman, though we never knew for sure. Whatever he had done, the transgression was so great that he would never again have the moral ground over my mother, but some things remained the same. My mother dressed herself in the role of dutiful wife and my father once again wore the mask of his "Anatolian smile." In this way, they went forward in their lives.

I was now almost twenty-three and Apollo was almost eighteen years old. Once again, I had to leave. I had worked one summer during college as a waitress on Martha's Vineyard, so I decided I would spend another summer there, working and writing. I found myself just hanging around and partying, not getting much writing done. I also began to hear over the radio repeated calls for

physical therapists. This time the epidemic was closer to home: it was in Boston and it was bad. I knew that I was wasting my time, so I left the Vineyard and went back to work.

At Boston's Hospital for Contagious Diseases, many people had already died and more were dying daily. I was working around the clock, alongside an army of doctors, therapists, and nurses. One afternoon the power went out and we were forced to manually pump the respirators in order to keep our patients alive. I will never forget that sound—the rhythmic mechanical rasping of those machines—as I sat hunched over, pumping the handle of a respirator. It was exhausting, physical work. I developed blinding headaches that came every day. I realized I could no longer do this work. I went to the head therapist and told her I was leaving, that I was going to pursue the theater. "The world doesn't need another actress," she said. "It needs physical therapists." She was right, but I needed to move forward. I applied to the theater program at Boston University. Without ever being interviewed or asked to audition, I was accepted into the master's program. It was 1955. I was twenty-four years old.

Chapter Six

When I began my master's in fine arts at Boston University, I felt like a war veteran rejoining a civilian population that had no knowledge of what was happening on the front lines. For two years I had been treating people sickened, paralyzed, or dying from polio. I had lived far from home and moved so often that I had no close relationships. I was part of a national health crisis that involved life-and-death struggles every day. I was only a couple of years older than my classmates, but I felt ancient in comparison. I judged them to be frivolous and superficial. Once again, I felt like an outsider.

I took a room near the school, even though my parents had very much wanted me to live with them. After all I had been through, I couldn't bring myself to return home. My life had moved

forward and I needed to stay out there in the world. I needed to be on my own, to navigate this part of my education and life on my own terms.

I was elated to be back at school. I could pursue my dream at my own expense, and I was determined not to squander any of it. I dove into my studies with a single-minded determination, almost obsession. I signed up for as many liberal arts courses as possible, including classes in literature, literary theory and criticism, history, and classicism. I was curious, so hungry for this that I made the conscious decision to forgo a social life and put all of my energies into my studies. I would write myself a weekly study schedule and stick to it. I recall walking by bars on my way home and seeing my classmates socializing and flirting. I thought they were wasting their time, that they should be home studying. I would then get home and study until I was exhausted.

In my first year in the MFA program, I met one of the great acting teachers and mentors of my life. His name was Peter Kass and he taught the acting class at BU.

Peter was himself the son of immigrants. He was fearless; he let us bear witness to his own

pain, rage, and vulnerabilities. He valued emotional integrity and expected his students to follow his example. He was always forthright and honest, even if it meant he cast himself in a dark light. He ran his classes with a sense of purpose and directness and never flattered any of us with faint praise. He was also unnervingly insightful.

Acting class was by far the hardest course I took that first year. Peter assigned us parts in scenes that we would perform in front of one another. When he was satisfied with our work in one scene, he would assign another. I had been assigned Lola in William Inge's **Come Back Little Sheba.** While I watched many of the other students move on to their next scene assignment, I struggled with Lola again and again. Peter said nothing.

In hindsight, I believe he recognized a great resistance in me. Rather than offer suggestions or advice, he just let me go on until I couldn't stand it anymore. One day in class, I raised my hand, ready to do the scene once again. I heard the class groan at the thought of hearing me do Lola one more time. Peter ignored me and called on someone else. Why was this scene so impossible for me?

Lola is the wife of an alcoholic, and although he

treats her with contempt, she continues to try to ingratiate herself to him, to win his approval and love. I had learned over the years to hide feelings that were too personal or revealing. Rather than tap into my own feelings, I was acting out Lola's emotional state by illustrating how I thought she would behave. I had decided what I thought were Lola's feelings and character traits (she was loving, dutiful, compliant), then tried to "indicate" these characteristics. Unlike most of my classmates, I had no prior training as an actress and no experience on stage. I didn't know how to solve my problems, but I insisted on being given the chance. When Peter passed over me, I felt like my years as a therapist, saving my money for acting class, boiled down to this one moment. I didn't know what he wanted from me. I felt thwarted, but time was up. We broke for lunch.

I took off to find Peter and caught up with him in the restaurant where he was having lunch. He invited me to sit down. I was shaking. I **demanded** that he give me the opportunity to work. He took a long pause, smiled, and said, "Okay, let's go back. You're up next."

Peter had an ability to meet each student as an individual, to tune into each of us with great insight, and, most important of all, to demystify the

craft of acting. To find your way into the text of the play, first and foremost, you had to understand and **inhabit** the world of the story openly and fully. Peter used the metaphor of being a plumber, and he was constantly exhorting us to make sure we had a "full set of tools" in our plumber's bag. To extend his metaphor, we had to lay down the pipes, to piece them together—before we turned on the water. It was that unglamorous, but it was vital. The acting meant nothing if the pipes were leaky.

He asked that we be honest in expressing feelings and our **own** emotional reactions to the situations in our scenes. I had spent the semester so far withholding my feelings and hiding my own emotional life. That's why I was still with Lola, having trouble with my scene.

I was still shaking when I walked into the classroom. I took off my coat and started my scene. The next thing I knew, I found myself in a rage. Where Lola was compliant, I was defiant. Where Lola was conciliatory, I was confrontational. The poor actor playing the husband could barely speak. I had been raised on the performances of Alexandra Dukakis! When it was over, the room was silent.

That moment marked a true turning point for

me. I had found a container to hold what was most precious and dear—my own humanity. That container was the stage. I could now concentrate on the craft of acting.

I moved into a tiny apartment in a seedy part of Boston with another student, Annie Johnson, and we became each other's emotional support and sounding board. As I became more and more emotionally honest in class, I found that outside class, I was becoming more and more troubled. I was frightened about where all this was going and what it meant. I was terrified that the feelings that I was now so honest about would take over my life. I couldn't sleep and was experiencing severe anxiety.

A psychiatrist prescribed sleeping pills, which helped at night, but in the morning I would have no desire to get up. So he prescribed uppers to help me function better during the day. Then he prescribed Compasine to help even me out in the later afternoon. This was the fifties. Drugs were not acceptable.

I felt deeply ashamed of needing pills in order to function. One day, while I was walking home from class, I turned and saw a truck coming

down the street; I stepped out in front of it. As the truck was bearing down on me, a stranger ran up behind me and pushed me out of the way. When I got home, I went straight to the bathroom, got out a razor blade, took off my shoes and socks, and began cutting my feet. Annie came in at that moment. I tried to hide my bloody feet from her, but she wouldn't let me. Instead she took the razor blade. "Olympia," she said calmly, "you can't do this." Then she sat with me for a long time.

The rest of my year was marked by periods of progress in class, and progress in therapy—accompanied by terrible, intense spells of depression and darkness. I had stopped taking the drugs and now I was **feeling** everything again. One particularly grim period came when a brief relationship ended very badly. I had begun seeing an Albanian poet, the first man I had dated since N had left me. I wasn't sexually involved with this man yet, nor was I in love with him, but when he announced to me that he was seeing other people, I fell apart. I suffered a full-fledged anxiety attack and took to my bed for three full days and nights. When I was finally able to rouse myself and get dressed, I went straight to the health clinic at BU. While I was waiting to see a doctor, I lit a cigarette and dropped it—burning—into my lap. The

next thing I knew there were two doctors standing over me asking me to sign some papers. They thought it best that I check myself into a hospital, where I could be treated for depression. In my gut, I knew that going into the hospital wasn't the answer. I had worked too hard and waited too long for this opportunity to be here, studying acting. I couldn't walk away now, not even to save my life.

My cousin Stelian was the only member of my family who could see what was happening to me. In the middle of my first year at BU, he came to visit and found me in my living room—which I had painted dark, dark red with black trim—surrounded by piles of books, studying with intensity. He took one look at me and knew I was in trouble. Stelian was Michael's older brother and had always been a kindred spirit. We had played tennis and Ping-Pong together when I was a kid, and he had a sensitivity about him that I had always trusted. He had gone through a tough time in his early twenties, had been hospitalized and treated with, among other things, electroshock therapy. Though he was considered "cured" and was now doing well, something in him was very changed. He was checking on me, to make sure

that things never got so bad for me that I'd have to go through what he had.

He offered to pay for me to see his therapist, and after some prodding, I took him up on this offer. I will never forget his kindness. And that's how I made my way into formal psychotherapy for the first time. Almost immediately things began to shift and change in my life in ways that terrified me. This particular psychiatrist was a traditional Freudian who met every one of my questions with one of his own. During my initial visit, he asked me why I had come. I answered him: "I want to be able to love and work." The simple act of stating what I wanted and needed was encouraging, even liberating, and gave me a platform to proceed with my quest for self. I got worse before I got better, but I was no longer as frightened as I had been of walking around leaking feelings from every pore.

I did draw some comfort from the fact that there was so much "acting out" going on around me. Boston University, and the neighborhood around it, was a volatile place in the late fifties, and looking back, it seems to me it was a prelude to the sixties. There was a lot of drama, promiscuous sex, and even drugs going on, though no

one spoke about it. All this was going on under-cover, but I knew enough to no longer feel like a total outsider.

There was one woman in acting class who seemed every bit as "out there" as I was: her name was Jane Cronin. She had short-cropped flaming-red hair that stood up on end. Her look, her persona were very punk—long before punk was born. I wanted to know her, so one day I decided to speak to her, and over time we became very good friends.

In the meantime, I clung to Peter Kass's words as I had to Vitale's coaching. I knew that if I could just stick with it and begin to build my skills as a craftsperson, I would find a path to becoming a decent actor. My work was the one place I was learning a craft. I was learning how to fulfill the demands of the script. By the time the year ended, I was no longer on the fringe of the class. Along with Jane and eight others, I headed off to northern Maine to do summer stock. Finally, I was moving toward something—and not simply running away.

• • •

We went up to Maine on a wing and a prayer: a "producer" one of my classmates knew said he'd sponsor us for the summer, but within two weeks of getting there, we found out he had spent our housing money and we were basically stranded up there with nothing but a lot of energy. We decided to stay. We ate a lot of peanut butter sandwiches and tuna casseroles that summer, and we improvised everything: we borrowed our props and costumes from local thrift shops—then returned them. One time we even used tomato paste to paint a backdrop—it was much cheaper than paint—and the theater smelled like a pizza parlor for the run of Shaw's **Don Juan in Hell.**

On our opening night—my first performance ever in front of a paying audience—I refused to even speak my lines. The other actors on the stage had no idea what was happening to me and continued to play around me. I sat, frozen to my chair. The play was **Outward Bound,** a 1930s melodrama about seven passengers on a cruise ship. I didn't utter a word for the entire first act. During the second act, I spoke and was able to get up and move around the stage—but with all the subtlety of a robot. After the curtain went down, I found myself drinking everything I could

get my hands on. Once I was completely plastered, I walked out the back door and down the hill toward the lake. I just kept walking. I walked until I was up to my neck in icy cold water. I heard someone yelling; Jane had followed me. She yelled until I came back to shore and told me what a fool I was, then helped me get to bed.

The next day, no one in the company mentioned my behavior of the night before. On stage that night, I mumbled and stumbled my way through my lines—it was a dreadful performance, but a performance nonetheless. I had at least stayed the course, and I knew that if I could say my lines once, I could say them again. Only next time, hopefully, I would do better.

I worked this way all summer, putting one tentative foot in front of the other, and started to feel more comfortable being on stage, more comfortable letting myself inhabit the skin of whichever character I was playing. Our last production of the season was **A Streetcar Named Desire,** by Tennessee Williams. I played Stella to Jane's Blanche and we had a marvelous time, a wonderful experience. It was the first time that I felt connected to the other players on stage in a way that felt organic and true. We finished out our season,

then made our way back to Boston for our second and last year of our master's program.

Once back, I auditioned for—and got—the lead in the first major production of the year. It was Federico García Lorca's **The Shoemaker's Prodigious Wife.** Getting the lead was a total shock. I didn't even consider myself one of the good actresses in the school—but I was secretly joyous.

One of the important things Peter taught us was that the craft of acting is all about fulfilling the demands of the play. Actors, he believed, need to study the script the way a plumber does a leak, in order to find out what it is in the script that makes the character, and the play, come alive.

Our understanding of character, or how to play a scene, emanates from the text. An actor must find what his or her place in the play is, and, beyond that, what aspect of life the play is dealing with. Understanding the demands of the play entails dissecting every line, breaking it down into its smallest unit, which is the "beat," or single action. Every scene is composed of beats and transitions. We had to be able to identify each action,

the point of transition, and then the new beat. It's an act of deconstruction: we hold the finished product—the script—in our hands; our job is to unravel it, to get to the bottom of it, to understand what motivated its coming into existence. About every act, every scene, every piece of dialogue, we have to ask ourselves: Why is my character saying this? What does she hope to achieve? When does the energy in the scene shift?

Actors have to understand the plot as thoroughly as we do the character. A play's action can be overt or buried. If I want to win you over, that's the overt action. But maybe I want to win you over because I need you, because I'm afraid of asserting my own independence. That's a buried plot. Now, suppose I encounter an obstacle: you find someone else you want instead of me. Now I have to find yet another way to win you over.

The specific emotions of a character in a scene are triggered in part by outside elements. If I'm playing a love scene in lingerie, I do it differently than if I'm wearing an evening gown. If I'm sitting down while a man makes a pass at me, I react differently than if I'm standing up. All these changes make a huge difference in how the character comes across.

As Peter taught about the craft of acting, I heard Vitale talking to me about the discipline of fencing. Without craft, or discipline, I'd be at the mercy of my history and my emotions. **With** the benefit of craft and discipline, I'd learn to focus, to channel what I was feeling so that I could express and communicate it. The contradiction coiled at the heart of acting is this: the only way to portray uncontrolled feelings is to control them. You learn how to do that through craft.

Now I had the lead in a play and I thought of something Peter had said in order to keep myself from being overwhelmed by having to play a complex lead character. Peter used the example of Hamlet. "To many he is the most complicated person to walk on stage. Hundreds of books have been written about what motivates him to act as he does. But to me, every actor who plays Hamlet is much more complicated than the character he plays. Every human being is much more compli-cated than any single fictional character, who is created with certain dramatic needs in mind."

Another way to look at this, and the way I de-scribe this process to my own students, is to think of a prism. Each of us is like a prism of glass in that we have many facets. The point is to identify what the character is and then turn that aspect of

yourself toward the light. The first time I grasped this concept was during the production of **The Shoemaker's Prodigious Wife,** which gave me the self-confidence to believe I could play a lead in a big show.

While we were rehearsing the show, I had the chance to hear the great Harold Clurman lecture. I knew of Clurman—just about everyone did. The legendary Group Theater, which he'd founded in 1931 along with Lee Strasberg and about thirty others, may have existed for only a decade, but that was long enough for it to completely reinvent American theater.

Clurman took the podium at nine that night and was still going strong at one A.M. He talked about the transforming experience he'd had when he was only six and his parents took him to see Jacob Adler, the renowned Yiddish actor, in the then-thriving Yiddish theater on Manhattan's Lower East Side. "I didn't understand a word!" Clurman explained, but he was riveted by what he could read between the lines, by the passion, the humor, the camaraderie, the enormous energy on stage. This childhood experience determined his career: he not only devoted himself to

the theater but ended up marrying Adler's daughter, Stella, herself an actress and acting coach.

Clurman, a nonstop talker, was by turns funny and serious but always animated and passionate; he had devoted himself not only to altering the course and very nature of the American theater but also to persuading everyone that this was a worthy enterprise.

It's thanks to Clurman that we **have** an American theater. Before the 1930s, most American dramas were all variations on the upstairs-downstairs theme, exploring the exploits of the upper classes and their servants. **My Man Godfrey,** the classic 1936 "screwball comedy," is the perfect example: an eccentric heiress socialite finds a hobo and hires him as her butler, only to have him teach her about "real life." Mannered and formulaic, most dramas were also either transplanted from England or written by Americans about England and the English (only musicals, derived from the minstrel and vaudevillian traditions, were homegrown).

Top-notch American actors such as John Barrymore studied in England, cutting their teeth and earning their credibility by performing Shakespeare. English acting schools stress voice and verse—that is, learning to use the voice as an

instrument, and to speak verse so that it sounds not like poetry but like live speech. American acting schools were nearly nonexistent. In fact, the drama program I was enrolled in at Boston University was in its very first year.

As an undergraduate studying drama at the University of Paris, Clurman found himself questioning his identity, seeking to define, as an American, what set him apart from the Europeans he met in the classroom and on the streets. "Where are the American actors and playwrights?" he asked himself. "Where are plays that tackle the unique American experience?" There was no shortage of great American artists: Whitman, Melville, and Emerson were transforming poetry, novels, and essays. Even American painting was coming into its own. But American theater, which had been hopelessly mired in things English, was now wiped out by the stock market crash of 1929. There were no plays written by Americans about Americans— about pioneers, businesspeople, shop owners, immigrants; there were no plays that embodied the adventurous, freewheeling, optimistic, entrepreneurial American spirit.

Meeting Constantin Stanislavsky, the founder of the renowned, influential Moscow Arts

Theater, further changed Clurman's life, and the future of American theater. Stanislavsky used a method of teaching acting that would eventually come to be known as "method acting." His theories represented a huge break with the past. Before Stanislavsky, actors were urged to leave their own feelings offstage and inhabit the roles of the characters they were playing. Stanislavsky urged actors to delve into their own pasts, to dredge up their own emotional reactions to situations, and portray these on stage. If the character needs to appear envious, for instance, Stanislavsky instructed the actor to remember a moment when he felt envious in his life and bring that to the part. He devised a series of exercises to help actors access these hidden parts of themselves.

Method acting has a huge following in this country—Marlon Brando, Eli Wallach, James Dean, Marilyn Monroe, and Robert DeNiro, among many others, were trained in it—thanks to Stella Adler, Lee Strasberg, and Harold Clurman, who adopted and adapted it. But Stanislavsky's feelings about the role of the theater had an equally profound effect on Clurman. Stanislavsky, who worked with both Leo Tolstoy and Anton Chekhov, believed that actors should

work together in an ensemble company. Only by working together day in and day out, rehearsing a broad range of material, could they learn to really trust each other—and this degree of trust was essential to acting of the highest caliber. Stanislavsky was after realism and emotional honesty. Actors had to be **believed,** even more than they had to be understood.

As a director at the Group Theater, Clurman began to articulate his own ideas about American drama, completely distinct from the European tradition. Under his direction, Clifford Odets's groundbreaking plays—**Awake and Sing! Golden Boy, Waiting for Lefty**—gave American audiences real Americans to care about, root for, and cry over: taxicab drivers working twelve-hour days for five dollars a week trying to decide whether to unionize and risk the little they had for the promise of so much more; two-bit boxers who yearned to give up the corrupt ring for the purity of music; lower-class families living in too-small apartments in the Bronx who struggled to hold on to their Marxist ideals while taking in boarders and handling out-of-wedlock pregnancy. These were the issues and ideas roiling America during the Depression. Long debated by politicians, covered in newspapers, and talked

about by everyday people on street corners and on bread lines, they finally found their first theatrical expression in Clurman's theater. The Group Theater staged more than a series of innovative plays—it staged a coup. American theater was never the same.

When that company fell apart, Clurman turned to Broadway, where he produced groundbreaking plays by Eugene O'Neill, Carson McCullers, and Arthur Miller. But he never lost his vision and never tired of tackling big ideas. "The purpose of theater," he said that night, "is to intensify our understanding and desire for life."

By the time Clurman finished talking, I was also in tears. Here was a man talking with such fervor and passion about the work that I planned to commit my life to. I was invigorated by hearing him speak.

For our very last production as students, Peter decided to mount Chekhov's **The Seagull.** He cast me as Arkadina, an aging actress whose lover, Trigorin, a writer, falls in love with her son's friend Nina, who is yearning to begin her own career on the stage. Arkadina is a woman who has lived a full life and who has weathered many

storms in her life and has learned how to take control of events that threaten her. Nina, on the other hand (who is the "seagull" of the title), is young and rushes naively toward life, unaware of what awaits her. Like a seagull, she drifts along the currents of life, at the mercy of external forces. This was Peter engaging in a bit of therapeutic casting. I could have played Nina easily, but playing Arkadina was another matter. I worked as hard as I could and brought all the craft I had to work with me every day. But every time we got to the scene in the play where Trigorin confesses to Arkadina that he wants to leave her for the young Nina, I would start weeping and could not proceed. By the night of our final dress rehearsal, Peter was so frustrated with me that he lost control. "You are a coward!" he shouted within earshot of every person connected to the production. I walked out of the theater and just kept walking. I knew I was in trouble because I didn't even know where I was. I looked around, saw a pay phone, and dialed the psychiatrist I had been seeing. He wanted to know where I was, and I was so lost that I just whispered, "I don't know, I don't know." "Olympia. Look up. What does the street sign say?" he asked calmly. Within minutes, the doctor drove up and took me home. He gave

me a tranquilizer and I fell asleep until late the next morning.

I had no idea at the time how much playing Arkadina tapped into my own feelings of rejection and sorrow—feelings I had refused to acknowledge when N left me. I had not shed a tear about N—then or since. I had succeeded too well at burying my feelings and denying how wounded I was. It all seemed to be coming up now, though.

That night at the theater, everyone was buzzing with opening-night adrenaline, except Peter, who was keeping a very low profile. I heard that he had suffered some kind of collapse after I walked out. A couple of actors in the cast glared at me, but Peter's wife came by the dressing area with some yellow roses for me. "Good luck tonight," she said.

That night, during the scene with my lover, I began to weep but I managed to say all my lines. I took Peter's suggestion and did a bit of stage business. I took a handkerchief from my skirt and smoothed it on the floor before I—Arkadina— kneeled down. One of Arkadina's characteristics is that she's incredibly fastidious. Because I portrayed her so, even in this heartbreaking scene, it made the audience laugh. In the end, Arkadina prevailed, and so did I.

Toward the end of my second and final year, I chose three performance pieces I needed in order to qualify for my master's degree. A classic: Clytemnestra in **Agamemnon;** a contemporary American, Mary Tyrone from Eugene O'Neill's **Long Day's Journey into Night;** and a Japanese classic in which I played a bird goddess. I wrote my master's thesis on Bertolt Brecht.

After graduation, a number of us from the BU program were invited to pull together a company and so made our way to Buzzards Bay on Cape Cod. We had a primitive theater—the stage and chairs for the audience were under a tent. When it rained or the wind blew, we had to run around and anchor the flaps. We put on six plays that season, but the most sensational one was our production of **La Ronde,** written at the turn of the century by Arthur Schnitzler. **La Ronde** is about the transmission of venereal disease and it caused quite a sensation when it was first staged in the early twenties. In fact, it was banned and Schnitzler was charged with obscenity. Apparently, things hadn't changed much during the intervening fifty years, because when we mounted our version in 1957, the town fathers of Buzzards

Bay decided that we, too, were engaging in public obscenity and revoked our performance license. We retaliated by making the performances free (which meant we didn't need a business license at all) and worked strictly on donations. This was the first professional performance that my parents ever came to. I was playing the whore—the one who triggers the venereal disease outbreak. Every performance was attended by a picketing crowd, including the one my parents came to see. I remember looking out from the stage after the show and seeing my father, sitting there stone-faced. After the show, he was unable to speak to me. My mother said he was too upset at seeing me play "that part." The charges against us for staging **La Ronde** were eventually dropped in court in Boston.

We finished our summer on the Cape and a core group of about eight of us decided to go to Boston and open a theater company. We found a space, an empty loft, on the third floor of an old building on Charles Street in Beacon Hill. We had to build everything ourselves—the stage, the seats, and the prop and dressing areas. Then we had to build the sets, make the costumes, and even print the tickets—everything! We planned a season and assigned jobs, and mine was acting as

the group spokesperson when dealing with our landlords or other vendors. I enjoyed doing this job and, as it turned out, I was good at it.

We called ourselves the Actors Company, and our first year was rocky, exhilarating—and a success. We revived **La Ronde** and it did very well, though this run was much less scandalous than our run on the Cape. We did a production of Sartre's **No Exit,** Federico García Lorca's **Blood Wedding,** Oscar Wilde's **The Importance of Being Earnest,** Arthur Miller's **A View from the Bridge,** Tennessee Williams's **Orpheus Descending,** and Truman Capote's **The Grass Harp.** We were hailed as "one of Boston's most exciting up-and-coming theaters."

That summer, we took on a producer, the lawyer who defended us on the obscenity charges the summer before, and did another summer of stock on Martha's Vineyard. I was even approached by a New York talent agent who told me to call her if I ever got to the city. I took her number and forgot all about it.

When we got back to Boston that fall, we added a director to our staff and moved into a bigger theater in downtown Boston on Warrington

Street. Though we still called ourselves the Actors Company, we named our theater the Charles Street Playhouse so that theatergoers would know that we were the young company from Beacon Hill. The space on Warrington Street was on the second floor, above a lesbian bar. Depending on the backstage configuration, we often had to walk through the bar to get from one side of the stage to the other. I remember walking through the bar during **The Crucible,** by Arthur Miller, and everyone in the bar would fall silent and stare at this eighteenth-century woman in full costume.

But it wasn't that easy to get the theater open. Every time we thought we had everything up to code, some inspector would cite us for another violation. This was beginning to cause real problems, as we were seriously short on cash and in jeopardy of closing before we had even opened. That's when "Big Joe," our landlord, came to our rescue.

Everyone said that Big Joe was "connected," but I liked him because he was so direct, and I particularly liked his wife, who was an ex-stripper. He understood our dilemma. "Meet me here tomorrow morning at seven A.M. and I'll show you how we open a theater in Boston, little lady." The next morning, I was standing in front of the the-

ater when Joe pulled up in an enormous black car. The driver kept the car idling at the curb while Joe went into the theater. I watched as each inspector came in, looked at the theater, and talked to Joe. Joe would reach into his pocket, take out a huge wad of cash, and peel off a few bills. Then the men would shake hands. When the last of the inspectors left, Joe turned to me and said, "And that, little lady, is how you open a theater in Boston."

We had a second well-attended season, but our group began to change and things began to fall apart. The lawyer who produced the summer season left. A Boston businessman and our director decided the two of them would form a producing team. They told us we would all be creating an ensemble, but as the year went on it became clear they wanted control of the company. They wanted to bring in outside actors. We saw the writing on the wall. We were being marginalized and people began to leave, but I stayed until the bitter end. The producers insisted that they owned all of the props and costumes and other materials the company had either made or purchased during our first year. I was outraged by how we had been lied to and deceived. One night, I got a friend to drive me to the theater. When we got there, I asked him

to wait with the engine running and I headed directly to the costume closet, grabbing as much stuff as I could carry. With my arms full, I started to run across the balcony of the theater. From down on stage, I heard the producer yell, "You can't take those—they're not yours." Then I heard Big Joe say, "It's okay. Let the little lady go." I threw all the costumes into the back of the car. "Step on it!" I yelled—I was scared. I called my cousin Michael, who was then practicing law. I asked him what to do. Without missing a beat, he said, "Time to go to New York."

Chapter Seven

I got to New York in late 1959, when I was twenty-eight years old. I had exactly fifty-seven dollars in my pocket. My friend and former roommate Roberta had taken an apartment in the East Forties, and she suggested I stay with her until I got work and could find a place of my own. I was grateful for her couch and her generosity.

I loved the energy and diversity of Manhattan and I loved the anonymity of the crowded streets. Everyone was from someplace else. Everyone had a different story to tell. I felt free of my preoccupation with ethnicity, since I was surrounded by it. I wasn't "other"; in this city, **everyone** was "other." Now the challenge was making a place for myself as an actress. I spent every evening reading the trades and every day running around town to find auditions. In order to audition, you

needed an appointment, but I had no contacts, so I tried to crash auditions! I had no agent, no manager—I didn't even have a résumé or a headshot. I must have seemed right off the farm. All I had was one good pair of shoes and a lot of drive. My money was dwindling. Roberta never asked me to contribute to the rent, but it bothered me. It was finally getting through to me that making a living as an actress was not going to be easy. The first thing I had to do was pay my bills, which meant getting what actors call a "job-job." Physical therapy was an option, but that was a **real** job, eight hours a day with no time or energy for anything else. Waitressing was perfect for me. The first job I got was in a deli-restaurant, but I didn't last long, only long enough to get my own apartment.

I found a roommate, a darling young actress named Linda Lavin, who had worked at the Actors Company on the Cape. That first year I took whatever job I could: I waited tables, proofread, worked at Bloomingdale's, and I even worked as a secretary for a short time until my boss found out that I had lied when I said I knew stenography and was a good typist. I could do neither! All I cared about was getting acting work. I just knew I had to be an actress.

Maybe I should have been frightened by how

little I understood the business, but I was blessedly ignorant and determined to succeed. But success was more than getting a job and paying my rent. I'd been in New York for months and all I'd really done was work a series of nonacting jobs and wear down the heels on my one pair of shoes. One day I was sitting on the steps of the New York Public Library, where I'd stopped on my way home and decided to sit outside. People-watching was great, free entertainment. I was watching all the little dramas of people's lives playing themselves out when I realized that on either side of me were the two massive stone lions that guard the steps of the library. They were named by Mayor Fiorello LaGuardia during the Great Depression and for the mayor symbolized the persevering spirit of all New Yorkers. Their names are Patience and Fortitude. Sitting there, I decided in that moment that I would not only survive here but—to use the phrase William Faulkner used when he accepted the Nobel Prize—I would **prevail.**

If ever there was a time to be in New York, the late fifties and early sixties was it. The theater was exploding with thrilling, risky, avant-garde work like Ionesco's **Rhinoceros,** which won the Tony in 1960. Or Genet's **The Balcony** and Edward

Albee's **Zoo Story** and Samuel Beckett's **Krapp's Last Tape.** The theater scene was experimental and exciting and I wanted to be part of it.

I wanted to reconnect with acting. I didn't want to lose my energy for it while I was waiting tables and going on auditions. I went back to class to study with Peter Kass, who was now teaching privately in New York. And I found myself a therapist. I still felt I needed clarity in my life in order to work and love the way I knew I could.

On New Year's Day, 1960, I had just stumbled home from a wonderful New Year's Eve party. I had barely gotten myself to bed and the phone rang. It was Alan Ansara from Peter Kass's class. He was starring in **The Breaking Wall** down at the St. Mark's Playhouse.

"Olympia. Something's opened up and I think it's right for you," he began. "It's a small part, an Italian peasant." I sobered up. "But you have to be here now. They need someone to start immediately."

I got the part, my first paying job as an actor in New York! I would be paid twenty-five dollars a week and an additional five dollars for maintaining the costumes and props. I even got a nice mention in the **Village Voice** review.

Within a very short time of **The Breaking Wall** closing, I was cast as the landlady in **The New Tenant,** by Eugene Ionesco. The actor playing opposite me was a scene-stealer, a true glutton on the stage. One day I told Peter it was so bad, I was going to quit. He said, "No. Don't leave until you learn how to be better at it than he is." He wanted me to **learn** something from the experience, so I did.

Then, thanks to my old friend Ed Heffernan from the Actors Company in Boston, I got a job in the subscription office of the Phoenix Theatre, where Ed was now a member of the company. He also got me an audition for their educational touring company. We traveled around regional schools performing classics such as **Romeo and Juliet, Antony and Cleopatra,** Chekhov's **The Boor,** and others. The students were a great audience. They especially loved the "girls against the boys" battle in **The Taming of the Shrew.** I loved hearing the girls cheer for Kate and the boys for Petruchio. The most important thing of all, though, was that this was an Equity job. I got my union card and became a **working** actor. Now I could afford my own place with no roommate. I moved to a fifth-floor walk-up in Alphabet

City on New York's Lower East Side that I furnished with castoffs from the street. My bathtub was in the kitchen and I shared a hallway john with two drunken Ukrainians. My apartment was the site of an ongoing gin game with other actors from the building and the neighborhood. My rent was $27.50 a month. The only area of my life that was unsatisfactory was my love life. But that's not to say that I didn't have one.

The summer of 1960 I went to Saranac Lake to do summer stock and tumbled into a passionate affair with a handsome actor named H who was in the company. I was doing **The Rose Tattoo** and my old friend Jane Cronin, who was also in the company, noticed that night after night, H was in the audience or in the bar where we went after a performance. H wasn't in this show and wasn't supposed to be there until rehearsals for the next show began. "There he is again," Jane would say to me. "Why don't you go say hello."

I knew he was married and had two children. I had seen other women friends get involved with married men and it was always a heartache. But my own curiosity got the better of me.

It was wonderful to be together. We had great fun and I was **happy**—happier than I'd been

since N. I let myself exist only in the moment, with no thought of the reality that awaited us back in New York.

Back in the city, H went home to his family on Long Island. We continued to see each other, but the role of the "other woman" was making me physically and emotionally distraught. One day H showed up, almost wild with grief; he'd returned home after our last meeting to find his wife and their children in the car with the motor running and the garage door closed. I was horrified. There was no way to continue, so without any hesitation I told him he had to go back to his wife. We both knew we had to stop seeing each other. I spent the next couple of weeks feeling as though I was in limbo. I was withdrawn and distracted. Slowly, I came out of my cocoon. I forced myself to start "dating," but I couldn't bear the idea of another passionate affair that could end badly. For the first time, I was seeing more than one man at a time, playing the field.

I dated nearly two dozen men over the next six months, all of them for about a week, none of them for more than a month. The man, the duration of the involvement, what we engaged in; it was all on **my** terms. The only drawback to socializing so aggressively was that I was also drink-

ing, part of the whole mating game then, as it is now. I found that even while I was claiming my body, my sexuality, and my independence, I was also becoming a little too fond of boilermakers, a lethal cocktail made by dropping a shot glass full of Scotch into a pint of beer. To complicate things, lately I had been enjoying a bit of marijuana with my drink.

Our watering hole was Blue and Gold on Seventh Street, between Second and First avenues (it's still there!). It was a Ukrainian bar with a little dance floor and an accordion player. There was also a great jukebox. The owner's wife served pierogis and potato pancakes at the bar, and the occasional hard-boiled egg as a nod to the Irish. On my thirtieth birthday, in June of 1961, we'd had a great party, dancing with a group of Ukrainian sailors who'd come into port. I went home alone.

When I woke up the next day my body felt beaten up. I gave myself a birthday present: "No more hard liquor," I said. "From now on, wine only."

About six months into my thirtieth year I took a job as a reader for **The Opening of a Window,**

which was being produced by Jerry Giardino, an actor with whom I'd played in **The Breaking Wall.** Even though this wasn't a formal audition, I knew Jerry would hear me read the part of the female lead with the actors auditioning for the male lead. After about a week, he saw how right I was for the part and hired me. One day, the most stunning man I'd ever seen came to audition. He was tall, about six feet three, with black curly hair and a trim black beard. His energy and spirit took over the room. The casting director introduced him: Louis Zorich. When Louie told me he was playing Hercules in a production across town, I thought, "Now there's a piece of inspired casting." When we read together I realized he was not only good-looking, he was also a fine actor. The only problem was that the character he read for was frail and sick and would die of consumption. There was no way this well-built and healthy Adonis could be convincing. But I had a very good time in the play and I got my first substantial review. In the **New York Herald Tribune,** Judith Crist wrote: "Olympia Dukakis manages to make the cliché come to life . . . in the flash of a smile, a naive gesture, a sudden slump of her shoulders. She has tenderness and warmth and fleeting revelations of inner fire; she rises above

the role." I permitted myself to feel I was on my way. And though Louis Zorich didn't get the part, he would get the girl.

I started to immerse myself in the theater scene. I went to see other actresses I admired—Julie Harris, Maureen Stapleton, Kim Stanley, and Colleen Dewhurst. Geraldine Page, who I had seen in **Sweet Bird of Youth,** was my hero because she was so much her own woman. All of these actresses inspired me.

Over the next year, I'd see Louis Zorich around town, usually dressed to the nines and always with a different woman on his arm. When we finally connected, everything in my life changed. Everything truly began to open and flower. It was wonderful—and scary.

I was in a workshop production of **Medea,** directed by Tom Brennan, who I'd met in the summer of '61 when I did a season at the Williamstown Summer Theatre (now known as the Williamstown Theatre Festival). The actor playing Medea's husband, Jason, quit to move to Los Angeles. I suggested that Tom cast Louie Zorich and Tom took my word for it. Now I got to see Louie every day. I was involved with another man at the time, but I was so attracted to Louie that I'd purposely make love with my

boyfriend just before I'd leave for rehearsal so that I wouldn't be completely distracted by Louie. I remember him even kidding me one day because I showed up wearing my sweater inside out. There was no overt flirtation between us on the set, but one night, Tom offered us two tickets to a musical version of **Twelfth Night** starring Dom DeLuise. I wasn't sure if he was offering us two pairs of tickets or if he was suggesting that we go together, so I simply held my breath and waited for Louie's response. "Would you like to go?" he asked. I couldn't think of anything I'd rather do. After the play, we went for drinks, and it became clear there was an attraction between us. We ended up back at his place. Louie lived in a brownstone on Horatio Street in the West Village that looked like it was plucked from the pages of a Henry James novel. It was a beautiful brownstone on one of those shaded, quiet streets you occasionally come across in the Village when you stop and wonder if you haven't somehow traveled back in time to some European city. Louie's building, in addition to being beautiful, had a charming courtyard planted with trees and rows of colorful flowers. Every other actor I knew lived in a tenement.

Inside was another story. His apartment had all

the warmth and ambiance of a monk's cell. The only furnishings were a cot, big enough for one, a dresser, a table, two wooden chairs, and a recliner. His kitchen contained an assortment of protein powders and vitamins in the cupboards and fruit, nuts, and grains in the refrigerator. Everything about the apartment said "No visitors allowed!"

The next morning, Louis got up, made some coffee for himself, and went out to buy the paper. I had been involved in enough one-night stands to know the drill: I'm sure he expected me to leave. Instead, like something out of a bad French movie, I stayed, lounging around in my black slip, smoking cigarettes. When he got back, he barely acknowledged me. He sat on one of the wooden chairs, drinking his coffee and reading the paper. Continuing to ignore me, he did his voice exercises and made himself a protein drink, and all the while he never said a word. This went on until the phone rang. "Sure, come on over," I heard him say. The next thing I knew, a lovely young woman came to the door. "Come on in," Louis told her. I was still there, still in my black slip. My behavior, I knew, was risky (and completely unplanned), but he never suggested I leave. He could have found a way to get rid of me, but he

didn't. I wasn't exactly sure what that meant, but I knew I had more to lose here than just the "next man" in my life, so I took it as a sign. Louis and his friend chatted uncomfortably for awhile, and finally—probably realizing that I was going to outlast her—she left. When the door closed behind her, Louis looked at me and said, "You know, don't you?" I couldn't talk, but I knew. I just nodded.

We were inseparable from then on. Louie, it turns out, was as fiercely committed to his own quest as I was. He approached his work with absolute dedication and professionalism, and he took good care of himself, body and soul. He was intensely curious and an avid reader. He also understood that honing your craft was essential. He treated himself with a kind of respect and seriousness that I aspired to. And he treated me with the same respect. We discovered we had a lot in common.

Louie, who is six years older than I am, is also a first-generation American. His family immigrated to Chicago from Yugoslavia. He had been responsible for caring for his four younger siblings. When the United States entered World War II, Louie struck off on his own, joining the army at age eighteen. He served in Normandy, working as

a fireman during the Battle of the Bulge, and when he got home, he took advantage of the GI Bill to study opera. This led him to study theater. He joined the Studebaker Theater in Chicago, where he worked with people such as Mike Nichols, Ed Asner, and Luther Adler, with whom he traveled to Canada with a tour of **A View from the Bridge.** He stayed there for a few years, working in television and on the stage. But he felt New York was where it was at, so he came back to study with the acting coach Lee Strasberg. He got work right away—always as the heavy, a "tough guy." When we met, he was well entrenched in what we came to jokingly refer to as "the long march," his path to self-fulfillment. It was our shorthand for his own quest for the American Dream. One of the things we had in common was growing up with the same frame of reference as first-generation Americans. We both knew what it was like to live with parents who spoke a foreign language; we knew what ethnic bias felt like; and we both knew what trying to survive on the streets was all about. We knew it took discipline and work to carve out an identity for yourself. This shared experience made moving forward together all the more possible and exciting.

After dating for a month, Louie and I decided to move in together, an enormous step for both of us. The day I was due to move in, I arrived at Louie's door with two huge suitcases. I had a key to the place but couldn't make myself go in. I dragged my suitcases to the bar across the street and had a drink. I was on the verge of making a commitment to another person. This person's feelings and opinions would now have to be a part of my life. I had my drink, gathered up my bags, and made my way across the street. My heart told me to do it.

Louie was also very good at giving people a lot of space, since it was something he wanted and needed himself. I had no idea that two people could live in such close proximity without ever feeling crowded or controlled. Once I got used to it, I decided there was nothing better.

Louie, on the other hand, was frequently confused and confounded by feelings he had never had before. He'd say to me, "I don't know what's happening to me." I would laugh—he was so sweet and honest and vulnerable in those moments, and **his** confusion made me more confident of my own feelings. I trusted what was happening.

One evening, Louie turned to me and started

to . . . mumble. "Olympia, wou . . . yu . . . mar. . . ." Just what was he trying to say? He kept repeating this blur of words: "Would . . . you . . . ma . . . ?" Oh, I got it. I said, "Louie, that won't do. You have to **say** it." Then, very slowly, he said, "Will you marry me?" Without hesitation, I said yes. We made an important and private vow to each other; we promised to do whatever we could to help each other realize our dreams, even if we didn't approve of them. This simple idea has sustained us, has bonded us together in love and respect, for more than forty years.

Now that we were living together, some things had to change. We needed a bigger bed—one that two people would fit in. Some mornings we woke up and the apartment was so cold that we could see our breath—Louie agreed to ask the landlord for more heat. I even convinced him to eat meat once in a while; he had been a vegetarian eating nuts and beans and green leafy things even though his apartment was in the middle of the meat district.

My mother came to visit a couple of months after we moved in together. She looked around, her face like stone. She didn't like this "living together business." Later she told my brother, "Your father and I will have to leave the country."

• • •

It was a season of breakthroughs. I was hired as Dame Wendy Hiller's understudy in **The Aspern Papers.** The play, based on a novella by Henry James, follows an American editor in Venice as he attempts to track down letters written by a famous Italian poet to his mistress. For my audition, I read for three parts—the French mistress, her English niece, and their Italian maid—three different accents and three different ages!

I'd been studying voice ever since I'd arrived in New York, and now my efforts were to pay off. In the middle of my audition the play's producer, Michael Redgrave, came tearing down the aisle of the theater: "Who **are** you?" he asked me. "Where did you come from?" He conferred with the play's director, Margaret Webster, and I got the job. As an understudy, my chances of ever getting on stage were nothing if not slim, but the play was slated to open on Broadway, and opening on Broadway was, for any aspiring actress, an enormous, almost incomprehensible milestone.

We rehearsed in Philadelphia. I rearranged the furniture in my hotel room to resemble the set so that I could run my lines, knowing I'd never set foot on stage during a performance. Dame Wendy

owned the stage. A classically trained English actress, she'd debuted in the movies in 1937, winning acclaim for her role in **Pygmalion.** Twenty-one years later she won an Academy Award for best supporting actress in **Separate Tables.**

One afternoon, we learned that Dame Wendy had a painful eye infection and wouldn't be able to appear. Suddenly my services were needed. It was all so sudden that I didn't have time to be nervous.

Margaret Webster took me aside. "I know you can imitate Dame Wendy," she told me. "I've heard you. But don't do it that way. Do it **your** way."

I started to work. I'd rehearsed in my hotel room so many times that I felt comfortable. But in the middle of my first scene, I sensed someone walking behind me. Then a hand on my back pushed me off the stage, as Dame Wendy finished the line I had started. Unable to rest at home, she'd come to the theater to take her place on stage.

After the play, as I bounded up the stairs to my dressing room, I heard Dame Wendy call to me as I passed her dressing room. "Miss Olympia," she

said, beckoning me to come in. I knew she enjoyed me; she thought I was a character. I thought about that small hand, pushing me off the stage with all the might of a hammer.

"I bet if you broke your leg you'd drag the bloody stump to the stage before you'd let anyone else go on for you," I said.

"That's right. You'll never play this part." She smiled.

That summer, we got a call from Nikos Psacharopoulos, the artistic director of the Williamstown Summer Theatre in Williamstown, Massachusetts. He wanted us to come up for the summer to appear in Eugene O'Neill's masterpiece, **Long Day's Journey into Night,** directed by Tom Brennan, who had directed us in **Medea** in New York. Tom wanted Louie to play James Tyrone, and for me to play his wife, Mary. I didn't think I was right for the part. Mary Tyrone is Irish, I was not. I couldn't possibly be convincing! Olympia Dukakis playing Mary Tyrone, who would believe it? I told Louie to go without me. I even suggested to Tom other actresses who might be suited for the role. When I told the psychiatrist

I was seeing, he called me on it. "Why would you want to give away the part?"

"I'm **not,**" I said, "I'm just not right for it." He asked me to describe the character. "Well, she's an addict," and that statement stopped me. I could play **Irish,** it was the addiction I didn't want to go near. I feared that inhabiting this character would evoke in **me** a need for drugs again. The therapist pointed out that I **knew** what this character was about and wasn't that, after all, what an actor brings to a part? I decided to accept.

We had only two weeks to rehearse. Opening night was well received. The second night, on the way to the theater, I started to hyperventilate and fell to my knees on the grass, gasping for air.

"You have to get up, Olympia." Louie was leaning over me, speaking gently, trying to reassure me. "You have to get up. There is no understudy." I managed to get through the first two acts, but in the third act, where Mary is totally high, I suddenly "went up"—which means all of my lines flew out of my head. This is not an uncommon occurrence for actors, but it was the first time it ever happened to me. I turned to the prompter, but he wasn't in his place. I started wandering

around the stage, improvising half-formed sentences and touching the furniture. Finally I caught a full line and Mary's dialogue seemed to float back into my consciousness. I had survived. I had withdrawn from the situation but had found my way back. I felt strengthened by this. I had come a long way from the coward who couldn't stop crying in **The Seagull.**

Once we got back to New York, I was cast as the lead in Brecht's **A Man Is a Man** that opened at the Masque Theater. This part brought me national attention for the first time (the play was reviewed in **Time** magazine); I was also nominated for an Obie, an off-Broadway award. I would not be able to attend the ceremony because I had landed a small part in a movie filming on location; Louie would attend on my behalf. On the off chance that I might win, I gave him a list of people to thank. When indeed my name was called, Louie strode to the stage, ignored my note, and said, "She deserves this!"

Shortly thereafter, I took a part in a production of Ibsen's **A Doll's House** only to be fired after my first rehearsal. Clearly being an Obie winner didn't mean I was safe from rejection.

Louie and I tried to work together whenever possible. Our song was "Moon River"—we were

definitely "two drifters, off to see the world." One of the things we loved doing during our courtship was going to see foreign films—we especially loved movies by Bergman, Fellini, Truffaut, Godard, and Visconti. Dinner consisted of hot dogs and beer from Grant's soda fountain between double features.

Tom Brennan cast us together once again, this time in Strindberg's romantic comedy, **Crimes and Crimes.** After opening night, the **New York Times** gave it a terrible review. The reviewer **hated** everything about the production—except Louie and me. The second night we showed up at the theater and it was deserted! The play had closed, only no one bothered to let us know. Louie turned to me and said, "Well? What next? Let's go to the movies," as though we had not a care in the world.

Chapter Eight

Sometimes it seemed like my life was one big effort to insist on my own definition of myself. Whenever I felt someone trying to define me, I tried to get there first. I didn't want to be defined by my ethnicity or my gender or anything that I didn't choose. When Louie and I decided to get married, we **chose** to do it in a civil ceremony at city hall. My parents wanted a traditional wedding, in a church, followed by a big reception. Once again, I failed to be the dutiful Greek daughter they'd wanted.

In the end, though disappointed by my decision, my parents came to New York for the wedding. Louie was more nervous than I was (he panicked when he thought he'd forgotten the ring), and our friends Roberta and George stood up as our witnesses. Afterward, we all went across

the street to Schrafft's and had a sherry. We didn't take a honeymoon; Louie was appearing in **Moby Dick** on Broadway and had to make the seven-thirty call.

I would be lying if I said being married wasn't hard for me at first. Something in me resisted it. Three months after we were married, I broke out in a terrible rash. I appeared to be allergic to Louie. I would go to bed, and when I'd wake up, whatever side of my body had been touching him during the night would be covered with red bumps. My system was reacting to this new state of matrimony. It was as though having someone so close, who was not going to leave, was more than my body could handle. If it wasn't Louie himself, perhaps it was the **comfort** of marriage that was making me itch: I certainly wasn't used to living with someone who was so supportive—and, well, so **tender.**

Along with that hideous rash, I also began to neglect my share of the chores—and Louie. Finally, after weeks of doing all the chores him-self—and of very little intimacy—he'd had enough. He pointed out the unmade bed, the unswept floor, and the stack of dirty dishes he now refused to wash. "You're not even a good roommate anymore!"

As he shouted, something in me snapped and I ran into the kitchen, shouting back at him, "You want me to get rid of these?" I grabbed a plate and smashed it on the kitchen floor. Then I grabbed another. And another. I didn't stop until every dish we owned was in pieces. Louie responded by walking calmly into the living room and mangling four Greek metal trays we'd been given as a wedding present. Before we were finished, we'd broken or torn every single wedding present. Finally, exhausted, we sat down and started talking. Well, **I** started talking—Louie listened. I told him I didn't want to turn into a "wife," at least not someone else's definition of what a wife was. He said, "And I don't want to be someone else's idea of what a husband is." We were going to figure out for ourselves what it meant to be married.

By 1962, many of the social mores and institutions that had begun to loosen during the 1950s were starting to give way to experimentation. Both Louie and I had spent our lives trying to understand who we were within the context of our immigrant families and our ethnic communities while also trying to define ourselves as individu-

als. Now we were trying to define ourselves as a couple. As part of our journey of self-discovery, we, like many couples in that era, had what was known as an "open" marriage. We had a few encounters—all brief, mostly fun—and, mercifully, none of them interfered with our feelings for each other.

In 1965, while Louie was up in Williamstown doing summer stock, I found out that, despite using birth control, I was pregnant, but were we ready? Would we be good parents? My doctor told me that no one was ever really ready and that if I waited until I was "ready," it was possible my life could slip through my fingers. From that moment on, I knew with every fiber of my being that I wanted this child and it was time for us to "close" our marriage.

I loved being pregnant. I gave up smoking and drinking. Louie and I took natural childbirth classes with Elizabeth Bing, who advocated partner-supported labor and delivery. Louie was in the delivery room with me when I gave birth to our daughter, Christina, thanks to our obstetrician, Dr. Walters. I was a week overdue and the doctor said, "What are you waiting for?" Louie

was in Washington, D.C., doing a play, and I told the doctor his only night off was Monday. Dr. Walters said if I didn't give birth by the following Monday, he was going to induce labor. That Monday I woke up and started having contractions. Louie flew in from Washington and made it back in time to be my labor coach. When Christina was born, she sailed into the world like a brilliant silver fish. Whoosh, and she was on her own.

My mother didn't offer to visit once during my pregnancy. Then again, I never asked for her help or invited her to come. The fact that we were both now mothers to daughters didn't help assuage the tension between us.

I never knew that I could love another person so unconditionally and protectively until I had my daughter. Even before we got home from the hospital, a sixth sense began operating in me. One night I awoke in the maternity ward, certain that something was wrong. I immediately went to the nursery, where I found Christina surrounded by nurses; one of them was taking blood. She had become jaundiced and they needed to test her liver function. Fortunately, the problem (which is

not uncommon) resolved itself in a few days and we were able to go home on schedule.

Once we were home, my insecurities took over. I again didn't trust my instincts. I would ask Louie if he thought Christina was warm enough. Was the room too cold? Was she sleeping in the right position? Louie had his own issues; he gave everyone else space to live their lives and now we had no space at all.

When I finally felt stabilized enough with Christina, I invited my parents to come meet her. Becoming a confident mother helped prepare me for the criticism I knew my mother would have. As soon as she started to point out everything I was doing wrong, I asked her to leave my kitchen. She stopped. It was that easy.

Even so, they were delighted by their first grandchild. In the Greek tradition, they showered her with silver coins to ensure good fortune; they also showered her with love and affection.

I went back to work when Christina was about six months old. I took her with me to Maryland, where I did **The Rose Tattoo.** When I returned, I was cast as Tamora in Shakespeare's **Titus Andronicus,** directed by Gerry Freedman and produced by Joseph Papp in Central Park. It's a bloody, violent story of murder and revenge.

Tamora is a force of nature, a complex, powerful, and awesome figure who is at once a woman, a queen, a murderer, and a mother. I got excellent reviews for my work, and though many people assume this is what actors are after, it was very hard for me to take.

I couldn't miss what was happening. When I got bad reviews, I felt bad about myself. When I got good reviews, I was **supposed** to feel good about myself, but this wasn't happening. In fact, a kind of desperation started to build within my body.

Having reached an impasse, I had left "talk therapy." I had begun to understand that there was a very real link between our bodies and our emotions, a mind-body connection. Because of the building desperation and terrible anxiety I had begun to feel, I made an appointment to see Dr. S, a bioenergetic therapist.

The philosophy behind bioenergetics is about the physicality of feeling—the idea that our bodies take on our repressed feelings, disrupting the flow of energy in our bodies and in our lives. Dr. S didn't want to talk, he wanted to observe my reactions to various physical exercises he led me through. In this way, we worked toward getting to the surface the feelings that were affecting me physically.

During my sessions with him, a series of events began to unfold. I began to experience my body as a dark, empty tunnel. **Who was I?** I couldn't find **me.** I had let reviewers tell me how I should feel about myself—good or bad, depending on **their** point of view. What was the difference between this and letting people define me because I was Greek, or a woman? **None.**

Then one day my face began to contort and I couldn't control it. "What's happening to me?" I cried, clutching my paralyzed cheek. Dr. S suggested I look in the mirror, and what I saw shocked me: it was as though my face had been cleaved in two, with one half at rest and the other in agony. Dr. S reassured me that this was simply the physical manifestation of my inner conflict— my contradictory feelings were coming to the surface and were now written on my face. I couldn't then think about what that meant, I was worried about how I would go on stage in just a few hours. Dr. S assured me my face would return to normal before too long. At five o'clock I was still sitting there when Dr. S said good-bye to his last patient. My face had returned to normal, but inside I was in a panic. I begged him to give me some drugs. He gave me two aspirin. I said, "This won't do anything!" I demanded drugs. He told

me no, I needed to **feel** what was going on. "But how can I manage? How will I do it?" He said, "The way you've always done it—will power."

That night I took some smelling salts on stage with me and even managed to give a decent performance. What happened that day was a breakthrough, and I continued to work with Dr. S.

In 1968, pregnant with my son Peter, I was performing in Vaclav Havel's **The Memorandum,** also a Public Theater production, and something quite wonderful happened. I lost my reason for going on stage. Suddenly, I no longer needed to prove that the little Greek girl from Lowell, Massachusetts, was as good—better—than everyone else in New York. That realization liberated me and now I was free to go on stage and **play.**

Things were going well for us. I dubbed Louie "Carl Commercial" because he had finally cracked the market and was making money. Christina was there and already had quite a personality. And now we had Peter, our first son—a beautiful child.

I was still working with Dr. S, who encouraged me to take a further step in my therapy—join an

encounter group—and he gave me the name of a couple who were putting one together.

The first night of group, I walked into a room of about a dozen people, all between the ages of twenty and forty, all strangers to one another. The group leaders, Mike and Sonia Gilligan, had developed therapeutic techniques in their work with addicts. They had found that addressing repressed feelings in front of others as witnesses helped release those feelings. Sonia began that evening by asking who wanted to go first. I raised my hand and said I wanted to get to my anger, that I had been trying with a bioenergetics therapist but had been unsuccessful, and he had suggested I come to this group.

"Who are you angry at?"

"My mother," I blurted out.

Then she asked me to imagine my mother's face on the wall and address her directly. "What do you want to say to her?"

"No!" I felt out of breath.

Sonia gave me a breathing technique and I continued to say, "No. No. No." Then I began shouting it.

Then Sonia said, "Say I won't," and from that I just let all my anger out and was shouting things.

What was remarkable was that I connected with all my deep-seated rage and no one was hurt. I was no longer afraid of my anger—what it could do to me—and knew that it was necessary. My anger could be a part of my life, and my work. This technique worked so well with my mother, a few weeks later I put my father "on the wall." For so long I had felt that most of my inner turmoil had to do with my mother. I had never once confronted my father about his own erratic behavior, about how secretive he was with all of us. It began to dawn on me that perhaps my mother was not just being deferential to him; perhaps she had been protecting him. Or perhaps she had been protecting us. The work I did in group reminded me that there are two sides to every coin, two sides to every story—and two people in every marriage.

Louie was so intrigued by my experience that he decided to join the group, too.

Louie and I learned a great deal about each other through this group work. We learned how to have a good fight, which meant we learned how to say the hard things to each other. To trust that we meant no harm. Louie and I were so good at this encounter stuff, the group leader suggested we start our own group. We wanted one made up of

theater couples. I had been talking to Louie about wanting a theater company, similar to the Actors Company in Boston. Maybe the encounter group would lead to that.

The group filled up very quickly. We met twice a week, and by the end of the year, the group had jelled and consisted of theater couples who shared our dream of forming a company. As we began to sketch out our plans, Louie was offered a role in the film version of **Fiddler on the Roof** to be shot in Yugoslavia and England. It was a great opportunity—far too good to pass up—so we decided to pack up our two kids and go to Europe. At the time, I was three months pregnant. Much to our delight and amazement, six couples who were involved in our burgeoning theater decided to come along, too. In Zagreb, we'd all gather in a beautiful, ornate guild hall and share our various approaches to theater. Thanks to our group therapy work, we all knew how to resolve conflicts and support one another in a community setting, crucial skills for putting together a theater group.

We spent three months in Zagreb and one month in London, returning to New York just after Christmas in 1971. The stewardess on the New York flight from London panicked to see I

was then nine months pregnant. I gave birth to our third child, our son Stefan, a few weeks later.

Back in New York, we continued to flesh out our plans for our theater company. This was really going to happen: we were going to launch a company, surrounded by a sizable group of people—nine other couples—who shared the same dream.

I was getting a lot of work in New York, mostly in not-for-profit theater, like the Public Theater and Off-Broadway, neither of which paid a living wage. To supplement that work, I had started teaching acting classes in the graduate program at New York University. I was offered the occasional spaghetti commercial, which helped financially, but I was starting to get typecast. Most of the parts I was offered were either "ethnic" women or prostitutes. Once in a while I got to play an ethnic prostitute.

If I wanted to play more of the roles that were important to me, I would have to travel around the country to regional theaters, three children and all our baggage in tow. That's why our idea of having our own theater was so important to me: I didn't want to do that to the kids. I wasn't even

convinced bringing them up in Manhattan was the best thing for them. I wanted them to be able to go outside in a place where they could feel independent and where I would feel they were safe.

We heard about the town of Montclair, New Jersey, from friends who lived there with their children. It was in easy commuting distance to the city, and it was ethnically diverse and culturally aware. It was friendly and safe. It didn't take us long to find the perfect home, a beautiful Georgian-style house, built in the 1890s, on a big lot with a giant green lawn framed by six mature weeping willow trees. I could see beyond the shag rugs and early seventies decor and knew the bones of the house were superb. The only problem was the asking price: the monthly mortgage was three times the rent we were currently paying! Forget renovating, forget eating out—just to keep this roof over our heads would be way beyond our reach. We kept crunching the numbers, and in the end we went for it. Once we had signed the deed and the last page of the mortgage papers and shook hands with the banker, I promptly excused myself, went into the bathroom, and threw up. Then we went back into the city, packed up our belongings and our kids, and moved to New Jersey. Actors with a mortgage: inconceivable.

• • •

We had always pictured our theater company in New York City, the center of the theater world, but after we moved to New Jersey, the other couples in the acting company saw the "lifestyle" and wanted to move, too. They were all starting families and Montclair looked as good to them as it did to us. My brother, Apollo, and his wife, Maggie, came, as did my friend Tom Brennan and his wife Tiffany. Tiffany found a space to rent in downtown Montclair in a Baptist church; there was already a theater built adjacent to the sanctuary. We put together a benefit and raised five hundred dollars that we used to renovate the space. Everything was done on a shoestring. One of our members even built the lights out of empty, giant-sized tomato juice cans. We put together our season. I had to go do a play in Williamstown, and while I was there, the company decided the first play would be **Our Town,** by Thornton Wilder. I knew we had to concentrate—at least at first—on known plays, but I didn't think we'd select such a chestnut. Yet it turned out to be the perfect choice; we could market not only the play but the theater and our presence. Montclair was now "our town."

It took us weeks to decide on a name for the

theater. My favorite was "the Long-Haul Theater Company" because that summed up my expectations. But some members thought it sounded like a trucking company, so that didn't make it. Other suggestions included "the Actors Forum," "the Theater Lab," and someone even suggested we name it after Louie and me. The Dukakis/Zorich Theater: talk about hitting people over the head with ethnicity!

In the end, the company named itself. We had broken up the entire company into committees to handle various aspects of the theater. People were always asking, "Is this something for a committee, or for the whole theater?" By 1973, the Whole Theatre was up and running.

For the next several years, we built our lives in Montclair. The kids had friends, liked their schools, and were happy. The theater was building an audience and a reputation. Thanks to my teaching at NYU and Carl Commercial's continuing work, we were even paying the mortgage. There was still no money to decorate or renovate the house, but I made a wonderful discovery. The front door looked like a plain, ordinary front door, but I discovered that behind two sheets of wood, front and back, was a beautiful turn-of-the-century door with wide panels and an inset

window that let in the morning sun. I refinished that and then went on a frenzy with my putty knife, scraping everything to see what lay underneath. Chip, chip, chip. Here was a double fireplace that had been blocked up. Chip, chip, chip, there was beautiful golden oak under the white paint that covered the beams in the living room ceiling . . . and the window frames, the doors, the banisters . . . all beautiful, painted over oak. Louie would say, "There she goes, chip, chip, chip." I spent the next year uncovering the treasures hidden in the house.

In Montclair I had work, home, and family. It felt good to be living in the same town as Apollo and Maggie. Then my parents decided to sell their home in Arlington and move to New Jersey. Initially, they were to live with us, and when Apollo's tenants left, they were to move into their duplex. We made an apartment for them on the third floor and they settled in. Within a short time, my father had two accidents: first he slipped on the icy snow in my driveway and injured himself. Then he had a serious fall at my brother's house. He was hurt so badly that he couldn't get

out of bed. At that time, I had been seeing a masseuse who specialized in shiatsu and believed she could help my father. He agreed to one session with her as long as I came along.

I sat in the outer office and could hear him moaning while she worked on him, but when it was over, the pain was gone. This lasted three days, and on the fourth, the pain returned, but he wouldn't go back to the masseuse. "I'd rather die than go through that again," he told me. He did what he always did when he was sick: he called his brother Panos, the doctor. Panos recommended an operation; he said it was the only way to alleviate my father's chronic pain. I tried to convince him to continue with the massages—the last time he'd been operated on, he'd developed a dangerous blood clot—but he wouldn't listen to me. In early May 1975, my father had back surgery.

He sailed through the operation without complications. To avoid another blood clot in the future, his doctors put him on blood thinners. For the first few days, his recovery was routine; he was already out of bed, getting around the hospital with a walker. Then they discovered he had a pulmonary blood clot. I remember going to the hospital and feeling helpless at the look of fear in his

eyes. I reminded him that he had been through this once before and would get better. He nodded and smiled tentatively.

Late that night the phone rang, waking me up. It was his doctor. "It looks like we're losing your dad," he said to me. Since that time, I have discussed with family what I did then; I've discussed it with therapists; I've discussed it with friends. I've come to understand why I did what I did and I've even had dreams in which my father forgave me. But I've never lost my deep sense of regret, nor have I forgiven myself for hanging up the phone and going back to sleep. I didn't wake Louie, or call my mother or brother. I refused to react to what the doctor told me. Early the next morning the hospital called to tell me my father had died. Alone.

"God has hit me!" my mother shrieked when we told her about my father. She repeated this over and over again while making a chopping motion with her hand. "If only I had been there," she went on. "Costa died alone . . ." Apollo, who was weeping, held my mother while she lamented. I stood by, dry-eyed. I felt I had done something terribly wrong and I couldn't bring myself to confess. I spent the rest of the afternoon making fu-

neral arrangements, then went to work at the theater.

The funeral took place in Lowell, where my father was laid to rest alongside his parents and his brothers. So many people came to say farewell to my dad that we held two viewings. I was overwhelmed by stories of my father's many kindnesses—I had no idea he had been so important to so many people. Apollo and I were able to spend a few minutes alone with our father, and I slipped a photograph of my children into the breast pocket of my father's suit. Apollo did the same, with a picture of his son, Damon. At the cemetery, my mother, overwhelmed by her grief, fainted three times. Apollo held her up while she drifted in and out of consciousness. How would my mother recover from this and what would be expected from Apollo and me?

My mother retreated from us and surrendered herself to an intense, very private period of mourning. I could not forget that because of me, my father had died alone. I know I'll never have an easy answer for this. I know I was angry at him for not taking my advice about the surgery, but

more than that, I wanted to punish him. For all the nights he didn't come home and left us alone. For not protecting me from my mother. For being so secretive about what was really going on in his life. The list goes on but does not justify what I did. I also loved my father very much and I certainly did not want him to suffer, especially at the end of his life. I finally told Apollo, and without a word he put his arms around me, hugged me, and forgave me. I was never able to find the courage to tell my mother.

If I were my mother, I would say that 1977 was the year "God hit me." I was diagnosed with cancer three times. One night I woke up with a terrible pain in my pelvis. Early the next morning, the doctor diagnosed an unidentified "mass" in my belly and wanted to perform emergency surgery. I got a second opinion and was told it was an inflammation in my small intestine and could be treated without surgical intervention. A few weeks later, I was diagnosed with cancer of the thyroid and had to have a partial thyroidectomy. I awoke from the surgery with Louie's sweet face close to mine saying, "No cancer! There's no cancer!" There were just two cysts and a benign tu-

mor. I went to the hospital a third time because I was bleeding vaginally. I had been through this and the doctor suspected cancer again, but after a D & C, I was told that it was the final stage of my menopause.

That year was also the year that we moved the Whole Theatre Company into a bigger, more centrally located space in Montclair. We were opening with a production of Bertolt Brecht's **Mother Courage,** a scathing indictment of capitalism and war. Mother Courage is a great role, because she is a woman who is not courageous at all, at least not in the classic sense, but she is determined to both survive and prevail. She drags her children and her business—a wagon of goods for sale—all over the battlefield. I was cast as Mother Courage herself but I had no idea how bitterly ironic playing this part would prove to be.

Chapter Nine

One autumn night in 1977 I received another phone call. It was about midnight and the kids were asleep. An emergency medical team was calling from the site of an accident on Route 3. Louie was very badly injured and on his way to the hospital.

A drunken teenager, who was driving an uninsured rental car with his father at his side, had smashed his car through the divider that separated east- and westbound traffic on Route 3 in New Jersey and caused a five-vehicle pile-up; and then he fled the scene. Of all those involved, Louie was by far the most seriously hurt. His long legs were crushed beneath the dashboard of the compact he was in when it crumpled on impact. I saw the wreckage on the way to the hospital and

was terrified. I found Louie in the hallway in the emergency room writhing in agony, waiting for a doctor. The place was chaos. The nurses were on strike and patients were being tended to by nurse's aides. No one seemed to know where anything was, or who to ask. I lifted the sheet that covered Louie's legs. His left knee was a large pool of smashed purple flesh: it looked like an overcooked eggplant. I sprang into action, searching for a doctor. "My husband is in shock; we need some blankets!"

The doctor said, "You'll have to wait."

I grabbed his coat. "Where are they, I'll get them myself."

"I don't know where they are," he yelled. Then, more softly, he said, "If you want to help your husband, get him out of here. He won't get the care he needs here." It was two A.M. In a blind panic I ran to the nearest pay phone and started calling our doctors in Montclair. I couldn't even get an answering service to pick up. In desperation, I called the doctor at NYU Medical who had seen me through my partial thyroidectomy. Unbelievably, he answered the phone. He referred me to an NYU orthopedic specialist who I then woke up, and he agreed to meet us at NYU

Medical Center. The dark stretch of road that led through the Lincoln Tunnel and into the city felt endless and bleak.

We were met at NYU by the medical team led by the orthopedic surgeon. He immediately prepped Louie and took him into surgery. Five hours later, the doctor emerged from the operating room and told me that Louie was doing okay. That he was stabilized. And that we could see him.

Louie was sleeping soundly, surrounded by monitors. I kissed him and headed for home.

I had just walked into my kitchen and had barely put my bag down when the phone rang again. A blood clot, a pulmonary embolism, had lodged itself in Louie's lungs. I called my brother and together we made the trip back into the city. I couldn't believe this was happening again! My father had died of a blood clot and now this.

We stayed with Louie for several hours, until it was clear he was safe. As we were leaving, the doctor took me aside and told me about the operation. He had set Louie's fractured and dislocated hip, reconstructed his shattered left knee, and spent hours repairing as much nerve and muscle damage as possible. He then very gently told me that though Louie would get better, it

would be a long and painful process. He was paralyzed from the knee down and would have to wear a brace for the rest of his life. He doubted Louie would ever walk again without the aid of crutches or a cane.

Louie remained hospitalized for three months, first in traction, and then going through painful, intensive physical therapy. I brought the children in to see him as often as I could, and this helped keep all our spirits up. At the time of the accident, the children were still very young; Christina had just turned twelve, Peter was eight, and Stefan was six. The first time they saw Louie in the hospital, it stopped them in their tracks. Louie's shattered knee was exposed—it had to stay uncovered—and there was a large metal rod going right through it. The rod was hooked up to the traction mechanism to keep the leg stable. It was a frightening sight. Without saying anything, the kids went to him, kissed him, and held on to his hands.

Six years earlier, when Louie and I had made the decision to leave New York City, our children

were still very young. We'd agreed that Louie would travel for work and I would work in and around New York until the kids were eighteen. We wanted a life that was stable and structured—not just for the children but for ourselves. Now here I was with a husband who couldn't walk, let alone work, and three children under the age of thirteen. In addition to all our expenses, we had a mortgage—a mortgage!—that I would have to figure out how to pay. There's only one thing more improbable than two actors with a mortgage, and that's **one** actor with a mortgage.

Louie came home and settled into the hospital bed we had set up on the first floor in our dining room. That night, I sat at the kitchen table and wept. When he was in the hospital, everything felt like a temporary crisis. Our goal was just to get him home. Now he was here and I could see the years of struggle ahead. Louie, incapacitated and unable to work, faced with a long rehabilitation. My life, completely changed. Starting tonight, I would even be sleeping alone. I cried until I was exhausted. I couldn't keep on at the theater—it didn't pay anything. I'd have to take more commercial jobs—if I could find them. If I could only get out from under the weight of the mortgage, I'd be okay. We'd have to sell the house! But **wait,**

this is our family home. The kids couldn't take on any other major changes now—and neither could I. I **wouldn't** sell the house. I **wouldn't** quit the theater. Somehow, we'd manage. I'd figure out some way to hang on to all of it.

That New Year's Eve, we all gathered around Louie's bed in the dining room and had champagne. Louie and I stayed up late, holding hands and crying. We all looked forward to putting 1977 far behind us.

The next several years, I found myself in "high alert mode," constantly prioritizing problems, solving them in turn, moving on to the next. If there was an obstacle in front of me, I'd climb over it. If I couldn't scale it, I'd figure out how to go around it. And if I couldn't do that, then I'd blow the damn thing to smithereens. Not the most elegant way to cope with things, but it got the job done.

I was working at the Whole Theatre and teaching two graduate-level acting classes at NYU. I'd get an occasional day or two on a soap or a movie. I was working as a private acting coach, but the monthly bills proved to me that I still needed another job.

Out of the blue, I got a running part in the soap

opera **Search for Tomorrow.** I'd never been able to get a "commercial" job before and now, just when I needed it, I got this. It was a huge financial break for us. Weeks into the job, the casting director told me she was going to have to fire me. The TV audience didn't find me likable enough. I'd been fired before, but now I was in desperate need of a paycheck. I did something then I've never done before or since: I talked my way back into the job. I told the producer I knew how to make the character appealing and lovable. I changed my wardrobe, my hair, my makeup, my entire demeanor—and it worked. At least until she herself was fired—along with everyone she had hired—just three days before Christmas.

People have asked me if I resented becoming the sole breadwinner for our family. I panicked, despaired, felt inadequate and overwhelmed, but I was never resentful. Louie (Carl Commercial) had shouldered the burden of being the main provider for many years while I had been free to pursue my own interests: the parts I wanted, producing and directing at the Whole Theatre, which paid next to nothing. Louie had taken his turn and now it was mine.

What I did feel was a huge sense of disappoint-

ment with how I acquitted my duties and responsibilities during that time.

I was always late. I was late for work at the theater, late for auditions, late for parent-teacher conferences, late getting dinner on the table, getting the bills paid, getting the kids to their doctor's appointments. I was late getting up and late getting to bed. I was constantly checking my watch—how late was I?—checking my schedule to see what I'd missed, and always, **always** looking for excuses and new ways to apologize.

One freezing winter day it was my turn to drive Stefan and a bunch of his ice hockey teammates to a game somewhere out on Long Island. I **had** to do this for Stefan so that he wouldn't be the only one whose parents were not participating. So there I am, driving out to Long Island with four boys and their enormous bags of hockey equipment. About halfway to wherever, my car died on the Long Island Expressway. By the time help arrived and my battery had been recharged, the kids were frantic: we were already fifteen minutes into game time. When we got there, the coach was so furious, he wouldn't even look at me when I apologized.

As disastrous as this was, the game I got to on

time was even worse. I was there for the face-off, sitting in the center of the bleachers, eager to show my support for Stefan and his team. The game began—I cheered and cheered, shouting such inspiring phrases as "Go team, go." At half-time, Stefan skated over to me, pointing to his jersey. "Mom! Mom!" he whispered. "We're in blue! Montclair is in **blue**!" And then slowly skated off. I had been rooting for the wrong team.

On top of having so much trouble holding it together outside of the house, I started coming home to piles of the laundry I had yet to do, bills that were unpaid, and children who wanted to watch TV instead of do their homework. When I would remind them to do their chores, they would engage me in a debate until I just gave in.

"Okay," I finally announced one night at supper, when everyone, as usual, was complaining about the food I had just slapped together in record time. "I need you all to help me." The first job was to help Louie in the morning. He would rise and immediately start his physical therapy of rigorous exercise. He had to do his exercises every two hours. Peter helped Louie put on his support hose and tie his sneakers. Christina became the chief launderer, but that only lasted a

few months because Louie protested that this was too sexist of an assignment (Louie was a born feminist). It was decided that everyone should be responsible for his or her own laundry.

I'd make a shopping list, then tear it into three pieces at the grocery store. Christina would head off in one direction, Peter in another, and I headed off with Stefan in a third. We would then meet at the cash register, where I would find myself buying a good number of items that weren't on the list.

We tried to work as a team, to juggle the daily domestic duties, but the phone would always ring when we were knee-deep in homework or tending to a sports injury. The problems at the theater always seemed to interrupt us. And of course, it was impossible to find any time for solitude or reflection, except for the Number 66 bus from Montclair into New York City. Three times a week, I'd commute into the city to NYU, where I was teaching. These hours on the bus were the only time I could sit still long enough to contemplate the big picture. The endless details and constant chores receded and I could review what was happening, to see if anything—or anyone—was slipping below the surface.

• • •

Christina had just started high school and with one parent laid up and the other on the run, she was left to navigate this important transition on her own, without the parental supervision she needed. Peter and Stefan were still too young to be left on their own, so I kept a closer eye on them and trusted that Christina could take care of herself. But I didn't see that my preoccupation, and Louie's emotional withdrawal and the loss of his consistent and always gentle assurance and presence, seemed to leave a real gap in her life. After the accident, Louie was missing as an active member of our family. He had to stay focused on his recovery, there was no doubt. But he also suffered a terrible depression that took him away from us. Christina was the one who eventually pointed this out and helped bring him back to us, but the situation went on, unnoticed, for some time.

Around this time, I went into rehearsal at the Whole Theatre for **The Trojan Women,** by the great Greek playwright Euripides, directed by my brother. I was to play Hecuba, the queen of Troy. As her beloved city burns around her, Hecuba

survives the loss of her husband and son, and now must watch as her daughters become slaves. She herself will become the slave of her conqueror, Odysseus. There is a moment late in the play when Hecuba falls to her knees and beats the ground with her fists, crying, "Do you see? Do you hear? Do you know?" I was puzzled. "Who is she talking to? What is she trying to make happen?" Apollo suggested that perhaps she's appealing to her ancestors. Now I was completely intrigued.

A week later, I went to my favorite used bookstore in Montclair to buy token opening-night gifts for the cast and crew. I could always find treasures within my budget at the aptly named Yesterday's Books. From a box in the back of the store, I pulled out a small book called **Perseus and the Gorgon,** by Cornelia Steketee Hulst, an archaeologist who wrote about a 1911 dig on the island of Corfu. The book was dedicated to Gorgo, a goddess figure from Greek mythology— she with the hair of writhing snakes—so terrifying that anyone who gazed at her would turn to stone. According to Hulst, the Gorgon of Corfu had once been the goddess Ashirat (which means happiness, energy, and joy). When the island was overrun by Perseus (whose name means "to lay

waste"), he cut off her head and sacked her temple. He also decided that her name should be stricken from all written records and that henceforth she should only be known as Gorgon, the snake goddess. In describing what Perseus had done, Hulst wrote that he had "buried in oblivion and covered with silence the teachings of the Great Mother." This line struck me with so much resonance. What teachings was Hulst talking about? Who was the Great Mother? I bought the book for two dollars, but instead of giving it as a gift, I kept it for myself and continued reading.

Finding Hulst's book marked the beginning of an extraordinary time of reading and discovery for me. I wanted to know who the Great Mother was and why her teachings had been buried in oblivion. I began to look for information about this history—or, rather, this prehistory—wherever I could find it. Information and material on this subject began to find its way to me in extraordinarily serendipitous ways. For example, just a few weeks after coming across Hulst's book, I wandered into a Buddhist bookshop in the East Village and a book fell off the shelf, landing at my feet. The book was called **When God Was a Woman,** by Merlin Stone. She had used archaeological evidence and historical documents to

piece together a compelling portrait of the Goddess religion that predated the Judeo-Christian legend of Adam and Eve. Merlin Stone was the beginning of my passionate interest in prehistory. The phrase "buried in oblivion, covered in silence" stirred my heart. Merlin Stone's book opened my eyes.

Then I went to school. I read everything I could find. I'd read one book, check the bibliography, and find other authors to read. Esther Harding's **Women's Mysteries,** Barbara G. Walker's **Woman's Encyclopedia of Myths and Secrets** and her **Woman's Dictionary of Symbols and Sacred Objects.** And on and on. I began to understand that there was a time when the feminine was celebrated. When men and women worshiped a Goddess who was revered as the wise creator and the source for universal order and harmony. It wasn't until the ascension of Greek male-oriented culture, when the Goddess began to be perceived as threatening, that these matri-focal cultures were dismantled and even erased from the historical record. I became a sponge for any information I could find about the Goddess and prehistorical culture. I felt I had found something of incalculable value that I had somehow lost or misplaced. I kept reading.

Then something inexplicable happened to me. I was lying on a massage table, and while the masseuse was working on me, I slowly became aware that there was someone—something?—else in the room. I opened my eyes and there was nothing there. When I closed them the sensation came back. I sensed a large, androgynous presence in the room. From the back of my head I heard a voice say, "Celebrate Her. Celebrate Her."

I got frightened and started to cry. The masseuse asked what was the matter with me. I was very reluctant to admit what I just experienced. I was afraid she'd think I had lost it—**I** was wondering if I had lost it—but I finally told her about the presence and the voice. She said, "Well, say something back." I started to cry even harder. "I don't know how. I don't know how to celebrate Her. I know how to suffer, but not how to celebrate." Then the voice spoke again. "You are of Her. You will know how to celebrate Her."

I asked the masseuse never to tell anyone what had happened. On the way home, I decided it was some aural hallucination brought on by stress. I kept it completely to myself.

The next time it happened, I'd just gotten off the N train at Forty-second Street and was an-

grily pushing my way through the rush-hour crowd on the ramp, trying to make the five-thirty bus. I was late as usual. Everyone was moving so slowly, my patience was at an end. I couldn't bear the thought of having to wait another thirty minutes if I missed this bus. I had to get home and make dinner for the kids.

Then I heard a voice, as if it were coming through a loudspeaker, saying, "Turn around, turn around." This time I wasn't scared, I just turned around. Below me on the ramp and the platform was a sea of people. I heard the voice say, "She loves everyone."

Call it aural hallucination. Call it inner perception. Or even a spiritual experience. Whether it comes from a female essence or a male essence, the message is, we are loved.

It would be nice to think that that experience altered my perceptions completely, but the truth is, I was still so overwhelmed by work and responsibilities that I was blind to things I should have seen.

On one front, good things were happening. Louie relearned to walk and slowly began to pick up the threads of his work life. This was hard and

often demoralizing. It must have been incredibly difficult, but I watched Louie continue his "long march" without complaint. Christina, on the other hand, was not doing so well.

One day I got a call from Christina's school telling me that we should come in for a parent-teacher conference, where we were told that Christina, who had always been an excellent student, had lately been no student at all: she had cut almost seventy-five days that year. If she wanted to graduate the next year, she would have to make up the credits.

She had wanted to go to Martha's Vineyard that summer to waitress, but I insisted she stay home and not only make up the lost credits but see a therapist. After she'd been seeing the therapist for a few weeks, he asked if Louie and I would join her for a few sessions, which we did. One day, he asked to see me alone. After talking with me a bit, he said, "Louie's okay. Christina's okay. You're the one in trouble. Unless you do something for yourself, I'm going to ask you not to come to the sessions anymore."

I had to let go of the high alert mode I'd been operating on for the years since Louie's accident. I had no idea how to do this, but I knew that it was time—and that I didn't have a choice.

Chapter Ten

It had been a long five years since Louie's accident and the therapist was right. I was now the one in trouble. Everyone thought it was a great idea for me to finally do something for myself. I thought about going to a spa or visiting the Jersey Shore, where we'd taken some family vacations, but then a friend told me about a place she'd just come back from, the Omega Institute in upstate New York. The mission statement in their literature puts it succinctly: "To create inspiring learning environments that awaken the best in the human spirit." How bad could that be?

The one week I could free up on my calendar coincided with what Omega called "Spirituality Week." I told Louie it sounded like a camp for precocious adults. But the brochures listed the vegetarian food, the beautiful nature walks, and a

pond for swimming and, best of all, it was cheaper than any spa I could find.

The program for the week centered on a core faculty of leaders from different religious and spiritual traditions. We were instructed to focus on one leader for the week and attend all their workshops. I had read some books about shamanism, so I decided to sign on for the sessions led by an American shaman, a woman, who had swum with the whales. I figured anyone who had the chutzpah to swim with the biggest mammal on earth must have something to offer me.

The first evening began with a reception where all of the spiritual leaders were introduced. As I sat in the audience, I was struck by the presentation of a small Indian woman dressed in saffron robes who was introduced as the Reverend Mother Gayatri Devi. "Ma," as she was called, had an almost visible aura of well-being about her.

The next morning, I got up and dutifully went off to the shaman's first workshop. There were about twenty of us, and the shaman began by "clearing" the space with sage smoke. Then she passed around instruments and people started

beating drums, and, as I recall, we did a lot of chanting. I began to wonder what was supposed to happen here and what would be expected of me. This was all very foreign to me but everyone else looked comfortable. I started to imitate what people were doing. I didn't do it well, or with any confidence, but I was participating.

The next day, the group had tripled in size and now there were about sixty of us. When I got there, the sage had already been burned and the drums were going and people were shouting, crying, raging, singing, and emoting—I felt like I'd wandered into a first-year acting class. Then the shaman asked, "Why are you here?" While she went around the room and people answered, I found myself panicking and thinking, "I can't say I'm here because our therapist told me he'd stop seeing me if I didn't do something for myself." I had no idea how I would answer the question. I found myself getting choked up, and when it was my turn I blurted out, "I came here to open my heart," and then we all went back to drumming and chanting. During a break, I escaped.

All of this demonstrativeness was uninteresting to me. I decided to just walk around—the gardens, especially the vegetable gardens, were lovely and restful. I continued to wander around; I

walked by a little house, peeked through the window, and saw about a half dozen people, men and women, sitting on cushions—in front of the elderly Indian woman I'd seen the first evening. I slipped into the house and took a seat in the back of the room. I soon realized this woman was talking about the Great Mother. I knew I'd found my place.

Gayatri Devi had been born and raised in India, in the Vedanta religious tradition. She told us that Vedanta "teaches the oneness of our existence, and the harmony of all religions." "There is one God," she said, "and many paths to that God. That is why Vedanta reveres the prophets and teachers of all religions and worships the divinity of the soul."

She went on to tell us there are four paths to divinity: knowledge, work, meditation, and devotion. She had dedicated herself to the path of devotion; devotion to the Great Mother.

As she talked, I cried. I felt totally receptive to her and everything she was saying and the tears streamed down my face. When the session was over, I approached her assistant and asked if I could speak to Ma. "No, no," Sudha told me. "Ma spends four days a week in solitude and dur-

ing the three days that she's available to the community, she has many obligations." Ten minutes later, I was still hanging around and Sudha approached me. When she said Ma wanted to see me, I panicked. "No, no, that's all right, I know she's busy." Sudha pointed to where Ma was sitting, under a tree, facing an empty chair. As I walked up to see her, I felt I was floating. I sat down at her feet and Ma said she had seen my tears. Did I want to talk? And then I told her what I had yet to speak of to anyone. I told her about the two times I thought I heard voices. She put her hand on the back of her head and asked me if the voices came from there. I nodded. "Yes, yes," she said, and then asked, "What are you afraid of?" all the while looking at me as though she had X-ray vision and could see right into my heart. I thought about what the voice said: "She loves everyone." I told Ma, "I'm afraid of all this love, I'm afraid I will be lost." She nodded and said, "You're afraid of drowning in the sea of her love." She sounded positively joyful as she said this. She then told me, "You'll be all right." As we parted, I asked Ma if I would ever see her again. "Yes," she said, "we will see each other again."

Meeting Ma validated so much of my own read-

ing and inquiry, but it also validated what was going on inside of my own heart. And I was no longer alone with my secret.

Not long after my week at Omega, my eighty-four-year-old mother was a passenger in a senior citizens' van that was hit by a car. I couldn't believe this was happening again. Though she suffered no broken bones, the muscles in her leg were seriously damaged and the pain was severe. Painkillers were prescribed. By the time she came home to Apollo's house, she was a changed woman. At first we thought it was the painkillers that caused her to withdraw into herself. Soon, she no longer listened to the music, which for so long had sustained her. She took to keeping the curtains in her apartment drawn and almost stopped eating. She became pale and thin—and terribly tired. She wasn't doing any of the things she used to do. We no longer sang Greek songs together and she refused to play our usual card games. She played endless games of solitaire.

One day I finally convinced her to play a card game I knew she loved, casino. She'd grown up playing it with her sisters and was the family champion. We played game after game and she

lost each one. I could see that she couldn't stand it any longer and started to really pay attention. When she lost **that** game, she came back like a demon and started to win. Alec was back.

Now all that was left was to get her out of the house.

I had a flash of inspiration. I knew what to do. I said to her, "Alec, I'm ashamed of you." She reared back, she was astonished—I'd never spoken like this to her before. I could see it was going to work.

I went on. "I've never seen you back away from anything. I've never seen you frightened." She said, "Get your coat," and we walked out the door.

She only made it to the corner the first day, but pretty soon we were walking around the block. She never thanked me, of course, but I knew she finally thought I'd been a good daughter.

Slowly we started to change with each other. The tenor of our relationship moved more toward being sisters than the antagonists we had been. Sometimes she would run through all of her sisters' names before getting to mine. And she seemed to need my emotional support.

One day we were at her kitchen table, talking about our lives back in Arlington, when I was fin-

ishing high school. Those were the days when my father "worked late" and she would wait up, gazing out the kitchen window, weeping, while she waited for him. The days when he would say, "Shut up, Alec. You don't know what you're talking about," or criticize her for what she was wearing. My feelings came flooding back to me and I started to cry. I said things to her I never thought I'd say. "Why didn't you speak up for yourself? Why did you insist that we respect him when he didn't deserve it? Why did you let him treat you with such disrespect?" By then I was shouting. "Why didn't you leave him?" Now I was sobbing. She didn't defend or explain herself. Instead, she looked at me and said, "All right now, darling, stop crying. You've cried enough." She spoke with such tenderness, trying to soothe and comfort me. I saw her heart, her love for me. Her mother's living heart. In the end, she only cared that I no longer carry these painful memories.

It seemed the more frail and less active she became, the more her heart opened. If I admired a piece of jewelry, she'd flick her hand and say, "Take it. I have no use for it." She started to neglect her plants and spent less and less time with her friends and neighbors. Apollo and his wife, Maggie, had always wanted to move to Los

Angeles and it seemed the time had come. I talked to Louie and we agreed my mother would come live with us—the Zorichs. She would never be able to manage stairs, so we moved her favorite things into our dining room and converted it into a beautiful room for her. From now on, she would live only steps away from her favorite room in the house—the kitchen.

Coming to live with us seemed to restore my mother some: she began to cook and showed some interest in the garden. She even taught me how to make some of my favorite Greek dishes. She also appeared in a couple of productions at the Whole Theatre; she was such a scene-stealer. She was in one play where she was supposed to sit at a table, eating spaghetti, while the other actors were engaged in dialogue. She made such a bit of business out of eating the spaghetti that the audiences began to ignore the play just to watch her and laugh. I told her she couldn't do it anymore. She said, "Why not, they love me. They think I'm funny." I said the other actors didn't like it. "Oh," she said. "Okay."

I had been working all that year, between projects at the theater, compiling material, hoping to cre-

ate something related to the Goddess culture for the stage. I met with Scott McVay from the Dodge Foundation. Scott had long supported us at the Whole Theatre, and during this annual meeting he happened to ask me what I was reading these days. I thought, **Do I tell him? Run the risk of alienating him?** Then, trusting that he was indeed a man of vision, I told him about my research into prehistory cultures. I told him I was uncertain how to synthesize this material and present it in a way that would have meaning for people today. On the spot, he offered financial support if I came up with a way of putting it on the stage. I found a writer and continued working, now with her on board. I traveled to her summerhouse on the Cape, where I realized I would be only a few miles from Ma's East Coast ashram in Cohasset. Also nearby was a place where you could swim with the dolphins, an idea that had great appeal to me.

On my way to Ma's, I went to the dolphin swim. There was a group of people preparing to go in the water with the dolphin. We watched a video to learn some basics about dolphins and were told we should not assume there would be any interaction. There was one old, enormous white dolphin that lived there, but they told us he might

not respond to our presence. We put on snorkels, masks, and wet suits. When I got in the water, I suddenly lost my enthusiasm. I was **hoping** the dolphin would ignore me. I felt vulnerable and unprotected. I floated there, on the surface, unable to move, and then slowly, a long white form passed by me, turned and hung in the water in front of me. I felt that the dolphin sensed my fear and was trying to communicate that I was safe. He then swam away and I spent the rest of the time looking for him. When we were called back to shore, everyone left the water except one man and me. At that moment, the dolphin broke the water and started swimming back and forth in front of us. We both started shouting, with delight, "You're great! Oh my god, you're great!" The dolphin, in a smooth white streak, disappeared beneath the surface.

When I got to the ashram, I realized Ma was not going to be as forthcoming and involved with me as she had been at Omega. I was expected to be on my own. I ate delicious food, read, talked with other visitors, walked the grounds, attended services, and listened to Ma's Sunday talk. Hearing her speak continued to move and inspire me.

Back home, **The Goddess Project** moved forward. I elected a director, and together with the

writer we structured an evening in two parts. Part One was "Women's Passages," about the three stages of a woman's life central to Goddess worship and culture: Virgin, Mother, and Crone. In Part Two, we dramatized a version of the Sumerian myth of Inanna. In this story, the goddess Inanna, who reigns supreme in the world above, descends into the underworld to visit her exiled sister, Ereshkigal, who reigns over the world below.

One interpretation of the Sumerian myth is that Inanna and Ereshkigal represent two aspects of the female essence, one that is "acceptable" and therefore can live aboveground, and one that is "unacceptable" and must reside belowground. For me, Ereshkigal exemplifies that aspect of woman that is "buried in oblivion and covered in silence." As we enact it, the two sisters are given an opportunity to see and know each other, becoming a tale of rebirth and regeneration. Our first performance was at the Whole Theatre; it was a physical, exhausting, exhilarating evening. At the end, the audience jumped to their feet and I went to find my mother. She looked at me in wonder and said, "I never thought I'd live to see anything like this." My satisfaction in making this happen for her was profound.

• • •

In 1989, I went to Los Angeles to make the movie **Dad** with Jack Lemmon and Ted Danson. We had a week off, so I went to Ma's West Coast ashram in La Crescenta, California. Again I was told to do what I would.

I remember one woman in her eighties who had spent a long career as a nurse, specializing in schizophrenia. She had elected to clear the leaves from the walkway by the shrine. I wanted to contribute but had no idea how. Then, during a long walk, I came upon a grove of trees and discovered some overgrown stone steps, leading to a small glade. I found a dirty marble bench covered with leaves and decided to clean it. I then noticed something covered by overgrowth directly in front of the bench. I cleared away vines and branches and uncovered a statue of the Virgin and Child. I realized I had found my job. It was to tend to this little grotto, to weed it and keep it clean so that others could come and sit with the Virgin mother.

As I sat there, I remembered a prayer that my mother and I would say together at bedtime:

Give me Holy Mother
Give me your help

And never never leave me
Far from thee, Holy Mother
Make me a good child
To love knowledge
And to my good parents
Always give them prosperity

During this stay at the ashram, I had a unique experience. While I was chatting with a fellow visitor, Ma's assistant, Sudha, handed me a small vial; it was from Ma, water from the font of the Black Madonna, and Ma wanted me to drink it. Just as I swallowed, I heard a deep rustling sound. I looked up and saw a huge owl flying over me. I couldn't help connecting the water with this bird of wisdom, hoping it was a sign. Someday, wisdom would come.

After I returned to L.A. and went back to work on **Dad,** I received a script from a Greek-American screenwriter who I agreed to meet with. During the course of our meeting, it turned out she had worked as a translator for the controversial archaeologist Marija Gimbutas. I asked that she introduce me.

Marija Gimbutas was a feisty, clear-headed, and brilliant woman. She was an impeccable scholar with a sense of humor and a reverential respect for the mystical. When we first met she was skeptical about me: after all, I was a movie actress. But she soon realized that my interest was genuine, that I wanted to learn more about her and her work.

Marija's book **Goddesses and Gods of Old Europe** is considered a classic text, spearheading the study of Goddess cultures and prehistory as a legitimate discipline. Through her scholarship, Marija created a portrait of life during prehistory. She showed that in Goddess cultures, there was no separation between the secular and the sacred, and that societies were built around the realities of the cyclical nature of life: the processes of birth, death, and regeneration. These civilizations enjoyed a long period (several thousand years) of uninterrupted peaceful living, and they predate the ages of weaponry and male-established hierarchical systems. What first struck Marija was how no weapons were ever found from earlier cultures, which were highly sophisticated and productive. They were built on patterns of sexual equality and nonviolence. Central to these cultures was a queen or priestess who encouraged

and promoted unity and an understanding of the divinity within all living things. Her work had a major influence on my thinking, and meeting her turned out to be one of the most important encounters of my life.

During the time I was in L.A., I got a call from a speakers' bureau asking if I would appear as the keynote speaker at a women's expo, a daylong series of seminars and talks on women's issues. I was intrigued, and not at all sure what they wanted me to talk about, but I had a sixth sense about it and decided to do it.

Two hours before I was to speak, I was frantically trying to write an outline for a speech about how hard work had brought me success, or something—anything. What on earth did I have to say to a roomful of women I didn't know? After two hours I had written only a single paragraph.

The courage and determination to claim our lives, however we wish to live them, is at the heart of the matter—to honor the spirit within that seeks to know and realize itself is at the heart of the matter—to

value consciousness that reaches out to nurture and love is at the heart of the matter—to raise the voice that can and will speak up, changing and shaping the lives of young people, is at the heart of the matter.

With this one short paragraph in hand, I walked onto a stage to face an audience packed with women of varying ages, ethnicities, and economic backgrounds, all of whom were looking at me with great expectation. Clutching that slip of paper, I made my way to the podium and began. I read my paragraph, and then just started talking.

I began talking about the Oscar and the role of Rose Castorini. I spoke about how strange it was to be an overnight sensation—after working for thirty years. I shared some highly unglamorous details about show business, including how frustrating it had been to confront the ethnic thing on a day-to-day basis. How my agent would get calls from people who said, "Can she speak English?" or "Will she change her name?" And these were just for auditions. I talked about living from paycheck to paycheck, month to month, and how I nearly went broke during my first weeks in New

York. But I also talked about how, after I signed my first Broadway contract, I treated myself to a steak and baked potato at Tad's Steakhouse.

I talked about all the time I thought about quitting but stuck with it anyway. About being scared to try new things and doing it anyway. About the years of therapy and different approaches and how it was all part of the mix.

Some of these women had never worked outside the home, others had worked since their early teens, and most had devoted their lives to raising their children and supporting their spouses (if those spouses had stuck around). All of them wanted to know how I had managed—in their eyes—to have it all. They wanted to know how I had managed to have a career as an actress while also having a family and holding a marriage together. My first response was (and always is) two words: Louie Zorich. I told them the only way I could do any of this was because my dreams were supported by a man who loved me and wanted me to be happy. I also told them that having it all is an illusion, or at least "all" means the good and the bad. I told them about Louie's accident and how it decimated our family. And how we came back from it.

They asked me what the high points of my life

were and I said there were three: Christina, Peter, and Stefan.

As I spoke, I saw heads nodding in recognition and heard murmurs of affirmation. Meeting and talking with women has helped me to know and understand that in a very real way, I am no longer an outsider.

As I was expanding my circle of women friends, the most important woman in my life began to drift away from me. My mother was doing odd things: she would put the paper towels in the oven to dry. She was starting to forget and misplace things. She would eat only toast. She began to forget our names. I tried to ignore this, to chalk it up to old age, but we couldn't ignore it for long: it was especially painful for my mother. One day, while Louie and I were sitting in the kitchen, my mother burst through the door, clutching her hair and shouting, "My mind! My mind! What are we going to do about my mind?" Just as suddenly, she stopped, looked at us, and very sensibly announced, "What am I telling you for? What can you do about it?" Little by little, she was losing the independence she had held on to so proudly.

• • •

I traveled to Greece during a break in shooting the film **Ruby Cairo** in Egypt. I wanted to see where my mother and father came from. Karavella, the village where my mother was born, is in the southern part of Greece, known as Mani. Life there is anything but easy: it's all about hard, physical work and scratching out a basic subsistence living. Even knowing this before I got there, I was stunned by how barren it all was—rough-hewn streets of small houses built around a tiny square, one little store, and a small church. As I made my way around town asking, no one remembered the Christos family name. The main square was knee-deep in mud and water, and a local shopkeeper, a very old and frail man, told me that recently the town's only water main had broken. I met three women and we started to talk. I asked them what had happened to the village. One of them chopped the air with her hand and cried in Greek, "God has hit us!" I felt at home. I realized they all had hazel eyes—just like mine, which is unusual for Greeks. As this recognition set in, I began to weep. One of the women moved closer and began to stroke my arm.

From Karavella I went to Mytilene, the island where my paternal grandfather and grandmother were born. The first thing I saw was a sign that

said **The ancestral home of Michael Dukakis.** I asked a group of people in the street where this home of Michael Dukakis was and they pointed to the top of the hill. I paid a young boy a dollar to show me the way.

The house consisted of two rooms, one on top of the other, with a teeny stairway connecting them. The cooking was done outside. The man who had originally bought the house from my grandfather still lived there—he was ninety years old, and blind. I walked back to the town square thinking of my grandparents as newlyweds, living in that house, then moving to Turkey and then fleeing . . . to the United States.

I wanted to see more of the island they had come from. Erosso, in the southwestern part of the island, is famous for being the summer home of the poet Sappho. I had read about her and wanted to see this place. While I was there, a woman recognized me and said there had been an announcement on Greek television that Olympia Dukakis had to call her home in the United States. I found the nearest pay phone and dialed Montclair.

Chapter Eleven

There was a crisis with my mother. She had been running out of the house in her nightgown and stopping cars in the street. She was calling 911 to report men breaking into the house to rob and kill her. She was out of control.

Apollo had flown back from L.A. and once he saw the situation, he realized our mother needed twenty-four-hour care and had to be put in a nursing home. He wouldn't do it without talking to me.

I argued with him, as he knew I would, but then Peter got on the phone and told me that he'd been unable to leave the house, leave her alone, the whole time I'd been gone. "Mom," he said, "it's gotten really bad. I can't live like this." I'd been in denial about the extent of my mother's condition, but when I heard Peter's voice, I real

ized it wasn't fair to him or anyone else. So over the phone, from Greece, I agreed we should find a home for my mother.

Because of her diminished mental capacity, my mother qualified for the special Alzheimer's unit of the best local nursing home. The care she received was superb. The nurses were especially compassionate. Almost immediately after being admitted, she seemed to improve. She even regained her sense of humor. When I would come to visit, she'd be surrounded by other patients. When she saw me, she'd go through a very elaborate and theatrical good-bye, raising her arms and saying, "Friends, I must leave you now: my daughter is here." Then she would wave like the queen of England, grab my arm, and in a low, sinister voice she'd say to me in Greek, "Olympia, let's get out of here!" and off we'd go.

We'd walk around the neighborhood, singing Greek songs together. Though often she couldn't remember my name, I always felt like we connected when we were singing. Soon, though, she couldn't remember how to sing and I had to sing alone.

In 1992 I went back to Omega for a week, along with three actress friends, Leslie, Remi, and Joan,

with whom I'd been developing the Goddess material. We were going to do a workshop for women over forty based on the characters and conflicts from the myth of Inanna. This would be the first time we presented this workshop, and while we were all acting teachers, this kind of work would be a new experience for us.

One of the participants was Madie Gerrish, a psychologist specializing in family therapy and bereavement. We became good friends. And I continued to do non-Goddess-related work.

My agent called one day and said he was sending over a biopic about Frank Sinatra. About an hour later, an enormous package arrived at my door. Tina, Frank's daughter, was producing the movie and wanted to get the project into production as quickly as possible. They offered me the part of Frank's mother, Dolly Sinatra. The offer was very, very generous. I was intrigued.

The script was close to a thousand pages long, and I spent the rest of the day and well into the evening reading about Frank's life. When I was done I reviewed just Dolly's scenes; that didn't take too long. I looked up at my assistant Bonnie, who simply raised an eyebrow to ask, "Well?"

"I can't do this," I said. "There isn't a part here." Then I lifted the phone book–sized script

and heaved it over the side of my desk, where it landed with a clang in the metal wastebasket.

I told my agent I thought it best that I pass on the project, but asked him to thank Tina for thinking about me. He called me back to say that the producers would double their original offer if I would reconsider. At that point, I thought it would be downright ungrateful of me not to take the offer, part or no part.

I called my friend Mary Lou Romano, who had spent her entire life trying to get rid of her North Jersey Italian accent. I taped her reading all my lines and listened to the tape over and over again. I began to enjoy the energy and aggression inherent in this dialect.

Dolly Sinatra, as it turns out, was quite a woman: she was feisty, in your face, authentic. She was also an immigrant struggling for a foothold in this country. She was even a bit of an outlaw. In the twenties she performed abortions for local girls "in trouble" and she'd dressed like a man to get into the fight clubs when her husband boxed. Later on, she worked for the local Democratic Party machine, delivering key blocks of votes as a ward captain. From her hairdresser I learned that she always looked like a million bucks. In the end playing Dolly Sinatra was great

fun for me, and I was even nominated for an Emmy Award for my performance.

A few years after completing **Sinatra: The Miniseries,** I got another call from Tina's production company. She was producing a television movie called **Young at Heart** about a widow who had shared a passion for Sinatra's music with her husband, Joey. In the final scene, Frank is supposed to appear at her birthday party. He was supposed to take me into his arms and say, "Joey sent me." After our first take, he whispered in my ear, "I've got a little money left—wanna run away?"

Then Armistad Maupin's **Tales of the City** came into my life. I was offered the role of Anna Madrigal, the transsexual landlady. This was not only hugely flattering but a stroke of great luck, as actresses on both coasts wanted to play this part. Maupin originally wrote the stories in serial form for the **San Francisco Chronicle** (à la Charles Dickens), and in these remarkable vignettes he created a universe set around an apartment house in the seventies and eighties. It was a time of discos and drugs, and Maupin wrote about it all via a vivid kaleidoscope of characters that included

gays and straights, men and women. At the heart of Maupin's city is Anna Madrigal, a middle-aged woman who used to be a man; a free spirit who owns a rambling, charming apartment building, 28 Barbary Lane, somewhere in the heart of San Francisco, where many of the other characters end up living. With the same tenderness she lavishes on her marijuana plants growing in her garden, she tends to her tenants, all of whom are searching for happiness and identity.

Alastair Reed, a British director, directed the series. He told me not to read the books before filming, so I didn't. I did read books about transsexuals, though, which were tremendously moving. After a few days of rehearsals, Alastair and I talked about how we viewed Mrs. Madrigal. We both agreed that she was a happy person; she wasn't suffering from her decision.

Yet she'd been deeply unhappy as a man, unhappy enough to have what some people even in 1993 considered an unthinkable procedure to change her sex. She'd found a way to survive herself. She reminded me of Rose Castorini, who could look in the mirror and say, "I know who I am." But she also reminded me of **me.** I always knew I had male and female energies within me, but I had silenced everything that was vulnerable

and female until so recently. I hadn't felt entitled to it. Learning to embrace it, to value it, was a struggle I was very much in the midst of.

No matter how much I thought I understood the character, I knew I needed to talk to someone who had gone through the experience. Through a member of the cast, I was put in touch with a therapist living in Los Angeles who had been through the same operation as Anna. I called and invited her to breakfast.

When she walked into my hotel room, the first thing I noticed was that she didn't seem ill at ease or apologetic or as if she had anything to prove. After a few minutes of small talk over coffee and croissants, I started to ask her questions. "I've read how difficult the process is, both physically and psychologically, to change from a man to a woman," I said. "To change your body so dramatically, to get rid of organs, create new ones, take hormones, to turn your life inside out, to suffer through all the emotional issues afterward—what made you go through with it?"

Without one second's pause, she said, "I always wanted the friendship of women."

She explained that it was women's friendships that she'd always felt deprived of as a man.

"When women talk to each other, they talk in a special way."

This insight was on my mind in one of the first scenes, when Mary Ann Singleton, played by Laura Linney, moves to 28 Barbary Lane and Mrs. Madrigal invites her over for a visit. The script called for us to talk in the living room as we examined various knickknacks that Mrs. Madrigal had collected, but I had a different suggestion.

"Let's move the scene to the bedroom," I said. I wanted to flop on the bed with Laura. Put women in a room with a bed and they'll naturally gravitate to it. It's a sign of their easy intimacy and comfort with each other. If the scene in question was supposed to highlight our burgeoning friendship, then the bed would be the place to do it. In the end, Alastair agreed with me and asked the stage crew to make us a bed specifically for the scene.

Another scene took place on the porch with Chloe Webb, who played Mona Ramsey, another tenant in the building who eventually turns out to be my daughter. I found myself sitting as a man would sit. My makeup artist, who has worked with me for many years, called my attention to it.

"You sure you want to sit that way?" he asked. "It's so masculine."

But I did want to sit like that. In every episode, I tried to find at least one moment in which the mannish side of Mrs. Madrigal could emerge.

This program was wildly popular—several other seasons followed the original—and also generated more controversy than we ever imagined. A Christian fundamentalist group assembled all the "unseemly" moments on a videotape and sent it to Jesse Helms and his colleagues in Congress in an effort to block funding for PBS. As a result of the pressure from the religious right, some television stations pixilated certain scenes; others refused to show the program at all. Yet at heart, the series is simply about a group of young people trying to figure out who they are, and to connect with each other. Mrs. Madrigal is central to all their lives because she's figured out how to live in the present. She doesn't dwell on the past, and she's no longer postponing her life, waiting for something to happen in the future. She's alive in the moment, alert to all the possibilities of life. Mrs. Madrigal, who has transformed herself, knows that **life** is transformative, and that sometimes the old has to die so that new life can emerge.

• • •

In the meantime, my mother was becoming so frail, so tiny. She was beginning to withdraw from us in ways that we knew were irreversible. She rarely spoke, and when she did, she was talking to people who were gone—her parents, her brothers and sisters, my father. She no longer knew us. During one of Apollo's visits from L.A., we went to see my mother, and as she sat in a chair, Apollo began to rub her feet. I stood behind her and massaged her shoulders. Apollo began to weep, and all of a sudden my mother slowly raised her fist and said, in her fiercest voice, in Greek, "Tighten up on yourself!" And again she was silent.

A few weeks later, Peter and I went over to take her out for a walk. As we wheeled her out into the sunshine, she lifted her head and, turning her face toward the sun, said, "The sun loves me!" I marveled that within her small world, she could still find love. I thought of the hot summer days she would take us to the ocean and realized that she still took comfort in a loving universe.

Over the course of the next year, I was to lose the three women who had been my most important

guides and teachers. First, I lost Marija, whose long battle with cancer finally came to a close. I flew out to see her when she was in the hospital. She was being fed intravenously, but this didn't stop her from eating the spinach pie I had brought. She wanted to know what I was up to, what I was working on. I told her that I was still trying to figure out how to bring the Goddess work to the stage. She pointed her finger at me and said, "Do it, Olympia! Just go do it!" She introduced me to other women who were visiting her during those last days, women like myself who had been inspired by her work. She wanted us to connect with each other, to become friends.

My friend Madie, whom I'd met at the Goddess workshop at Omega, came to visit with her partner. We talked about my mother and I told them how her body was deteriorating, as well as her mind, and the feelings I still had: my fear of her anger, how I'd resisted her and finally pulled away, and how I'd never been honest with her— never told her how much I'd resented her trying to shame or beat me into submission.

Madie said, "You've got to tell her." I fought this idea. "My mother's ninety-three, she doesn't

even know me. It's my problem now." Madie pressed it and I said, "Visiting hours are over."

"Visiting hours are never over," she said, and we drove to the nursing home.

My mother was lying in bed on her side, so small and thin, like a pencil under the sheets. I gently shook her awake and said, "Mother, it's Olympia." Without opening her eyes she said, "Olympia, I've been looking everywhere for you." This was the first time she had said my name in months. Immediately I started to cry. Then Madie spoke: "Alexandra. Olympia has something to tell you." My mother said, "What is it, darling?" I told her how I'd been afraid of her when I was young, that her anger really scared me. She never moved or opened her eyes, but said, "It was a difficult birth." The connection between the difficulties of my birth and her subsequent anger had never occurred to me. It was her way of telling me that she had done the best she could. Still crying, I told her how important she was to me, how much she had given me, that I knew how deeply she loved me and I loved her just as deeply. Then Madie whispered, "Tell your mother that it's all right to go." I told her. I told her I was fine, she could go now. Louie and the children were fine. She immediately asked about

Apollo and I told her he and Maggie and Damon were fine. "It's all right, Mother. You can go whenever you want." With her eyes still closed, she tucked her hand under her cheek, lifted her free hand and opened and closed her fingers, like a child waving, and said, "Bye-bye. Bye-bye."

Over the next several weeks, my mother's condition worsened and she was moved into the hospital. Her heart was failing. The doctors told me that if I didn't allow them to place a shunt in her chest, my mother would die. Even though I had promised her we would uphold her living will, this really shook me and I called Apollo. "You know what she wants, Olympia." I had to let her go. But I was determined that my mother wouldn't suffer. The same doctors who wanted to perform an invasive procedure were now reluctant to give her pain medication. I was livid. The nurses overheard this conversation and one of them came to me and said, "Don't worry: we'll take care of her."

We began to get calls that the end was near, and we would get to the hospital only to find my mother had rallied enough to be out of danger. I did not want a repeat of what happened when my

father died. On my last trip to the hospital, I was walking out of the elevator toward her room as a nurse was coming out. She said, "Olympia, your mother has passed." Seeing the expression on my face, she added, "She wasn't alone. I was with her."

I went to see my mother. She was so still. I lifted her and held her in my arms and said to her, **"Koranaki, koranaki,** it's over, your suffering is over." I was happy for her that it was over, that these last difficult years were over. I was happy for both of us. I felt she was **free.**

My mother, Alexandra Christos Dukakis, died on July 9, 1994, in the same room in the same hospital where my father died. She was ninety-three years old.

I thought I had been ready to let my mother go. She'd been dying for a long time. But I wasn't prepared for how it hit me. I would be walking along, caught up in my day, when I would be seized by the sensation of being utterly alone and adrift, so overcome by a feeling of emptiness that I would stop and lean into buildings for support. It still happens from time to time.

• • •

Shortly after my mother died, I learned that Ma was failing. When I visited her at her ashram in Cohasset, Massachusetts, she was eating and watching religious services on TV. I was saddened to see how diminished she had become. We talked, and after watching me, she told Sudha to put in a specific video, about a Catholic priest who, after suffering two heart attacks, had experienced a revelation. In the video, he talked about his first heart attack. As it was happening, he felt as though he were "falling into darkness" and was scared. But during the second attack, he understood the "darkness" as "Her love." Ma didn't say anything, but I knew she was remembering when I told her of the voices I'd heard and my fear of losing myself in the love of the Great Mother. She wanted me to realize that what we think of as "the darkness" is actually the deep, rich sea of the Great Mother's love, and that realization would "uncurse" that place of "darkness." Even now, though she was clearly turning away from this world as my mother had at the end of her life, Ma was still guiding me, still teaching me. Before I left, Ma told me that she would hold me and my family in her prayers. I knew I would never see her again. I began to weep. "Even after death I

will continue to guide you," she said. Those were the words my teacher left me with.

Because of my love for my mother, Ma, and Marija—and their love for me—I've come to understand that birth and death are part of the mysterious cycle of regeneration. My recognition of this cycle allows me to live in the moment, with all my contradictions. I find that it calms my soul, this insistence on accepting the true nature of things; it keeps things real.

Divine Mother Heart. Proof of Thy
 Unceasing Care
I find in every turn of life
With many arms dost Thou shield me,
With many hearts dost Thou love me
With many minds dost Thou guide me to
 the road of safety
 —The Handbook of Daily Worship

Epilogue

In 1999, Louie and I decided to sell our house in Montclair. It had been a good house for us with plenty of room for three children and later, my mother. It was perfect for throwing the large and crowded parties we occasionally held for the Theatre. The serene lawn and gardens always provided me with a place to "get away from it all," even if only for minutes at a time. But by then the kids were all off making their own lives—taking with them the piles of sports equipment I'd had to live with for all those years—and the house was too big for us without them. I would wake up at night, thinking I could hear their footsteps, and slowly realize it was just my imagination. That chapter of our lives was over. With no theater, and no children, it seemed right that we move back to

New York City, where we'd started so many years before.

We found a loft in downtown Manhattan and worked with an architect to get the place exactly as we wanted. I began to think of it as my "real" home, where I chose what it looked like from the layout of the rooms on down to the kind of furniture in it. It has become the perfect nest for the two of us.

Living in the city is oddly relaxing. I am no longer rushing around to get from one place to another—from the theater, to school for a meeting or sports event, to the house to cook dinner, and then back to the theater again. I am no longer riding the Number 66 bus into the city, feeling like that hour each way is my "downtime." Louie and I are doing exactly what we want to do, on our own timetable. This new chapter seems to have brought us full circle, as we are again living the kind of life we once had in our early courtship and marriage.

Now there is time to sit in a neighborhood coffeehouse on Sunday mornings and talk over cups and cups of cappuccino. There is the opportunity to steal off in the middle of the afternoon to see a film, the way we did when we were first married. We can spontaneously decide to meet friends for

dinner if we have a free evening. And there is always the work. As I write this, Louie is appearing in a Broadway revival of **Ma Rainey's Black Bottom** with Charles Dutton and Whoopi Goldberg.

The Goddess Project is an ongoing process. I travel around the country doing "concert readings" of **Rose.** I continue to take on new roles that intrigue me. I'm inspired by the women who come to the speaking engagements I do and I'll continue to do them as long as I'm asked. But more than enjoying the continuation of the things I know, I look forward to things I've yet to experience. It was good to look back, but I also need to focus on where I'm going. I want to be able to look forward to changing, to taking the next step—and there's **always** a next step. "Who am I?" "Who am I going to become?" These questions don't go away as we get older, unless we allow them to. I don't want them to go away. They've been the driving force in my life and that isn't about to change anytime soon. Yet, as it was in the beginning, I'm still finding out who I am within the context of being Olympia Dukakis, Greek-American, woman, wife, and mother.

I realize I'm more Greek than I ever thought I was. I inherited from my father the intellectual

curiosity that has driven me so much of my life. From him too, I inherited a commitment to excellence, no matter how short I fall. From my mother I inherited her humor and life force—a spirit—that has kept me from knuckling under in the face of obstacles. I also inherited her flair for the dramatic. From them both, I inherited the strong passions and indelible work ethic that defined their lives. I take enormous pride in the accomplishments of all the other Dukakises I grew up with: my cousin Arthur spent thirty-three years as the Boston Regional Director for the US Bureau of the Census. My cousin Stratos, after twenty-five years as the Superintendent of the Montachusett Regional Vocational Technical School in Fitchburg, Massachusetts, recently was honored when they named their new arts center the Stratos Dukakis Center for the Arts. Michael continues to impress me with his devotion to teaching and public service and my brother, Apollo, is an ongoing inspiration to me, both through his brilliant acting and his character. I'm a part of a generation that absorbed their parents' lessons, and I made my contribution through the important craft of acting—giving voice to the stories that make up our lives.

• • •

Acting saved my life. It taught me to be in the moment, not get caught up in what happened yesterday, or what will happen tomorrow. It taught me to acknowledge my feelings and embrace them, rather than be ashamed of them and try to cover them up. Acting validated my desire to define myself. It challenged me to be honest about who I am and what I feel. It forced me to be my authentic self. Acting was the conduit for the unfolding of my spirit. Acting has allowed me to go on.

I want to continue to find work in plays and movies, roles that challenge me, or better yet, scare the hell out of me. I aspire to do dangerous work that feels risky. I want to travel places I've never been. I want to be here for my children and be deeply involved in the lives of my grandchildren. I'm hungry to read books I haven't read yet, go to every performance of Mahler I can find. I want to write more poetry. I want to continue to experience the love and trust of my marriage, because I'm lucky enough to be married to a man who accepts me, supports my dreams, and eases the way. I want more of our family vacations where we all gather in a big house by the water and eat and play and genuinely enjoy one another. I want more dinners with friends, complete

with heated, passionate discussions about politics, feminism, art. I don't see myself retiring. Slowing down, yes . . . but retiring? From what? I love the chaotic, contradictory, loving mess that has been my life. I love knowing that in the end, I too will be able to lift up my face to the sun and say, "The sun loves me."

I'm going to Africa to film a movie at the end of this year. I have a lecture schedule that will take me around the country to meet new women, make new friends. My editor even said to me the other day, "Olympia, I have the perfect idea for your next book." My next book? I'm not sure I have more to say, I told her, but then again . . . **ask me again tomorrow.**

Selected Reading

Following is a list of books that were amazing dis-
coveries for me—each one has been an important
resource in my search for identity and for mean-
ing in the world around me.

Biaggi, Cristina, and Marija Alseikaite Gimbutas.
Habitations of the Great Goddess. Man-
chester, Conn.: Knowledge, Ideas and Trends,
1994.

Christ, Carol B. **The Rebirth of the Goddess:
Finding Meaning in Feminist Spirituality.**
New York: Routledge, 1998.

Eisler, Riane. **The Chalice and the Blade: Our
History, Our Future.** San Francisco: Harper
SanFrancisco, 1998.

Gaydon, Elinor. **The Once and Future
Goddess: A Symbol for Our Times.** San

Francisco: Harper SanFrancisco, 1989; London: Thorsons, 1995.

Gimbutas, Marija Alseikaite. **The Gods and Goddesses of Old Europe, 7000–3500 B.C.: Myths, Legends, Cult Images.** London: Thames and Hudson, 1974. Revised edition, **The Goddesses and Gods of Old Europe, 6500–3500 B.C.: Myths and Cult Images.** London: Thames and Hudson, 1982; Berkeley-Los Angeles: University of California Press, 1982, 1990.

———. **The Language of the Goddess.** San Francisco: Harper SanFrancisco, 1989; London: Thames and Hudson, 2001.

———. **The Civilization of the Goddess: The World of Old Europe.** San Francisco: Harper SanFrancisco, 1991, 1994.

Lubell, Winifred Milius and Marija Alseikaite Gimbutas. **The Metamorphosis of Baubo: Myths of Woman's Sexual Energy.** Nashville: Vanderbilt University Press, 1994.

Meador, Betty De Shong. **Uncursing the Dark: Treasures from the Underworld.** Wilmette, Ill.: Chiron Publications, 1994.

Meador, Betty De Shong. **Inanna, Lady of Largest Heart: Poems of the Sumerian**

High. Austin, Tex.: University of Texas Press, 2001.

Perera, Sylvia Brinton. **Descent to the Goddess.** Toronto: Inner City Books, 1989.

Sjöö, Monica and Barbara Mor. **The Great Cosmic Mother: Rediscovering the Religion of the Earth.** San Francisco: Harper SanFrancisco, 1987, 1991.

Starbird, Margaret. **The Woman with the Alabaster Jar: Mary Magdalen and the Holy Grail.** Santa Fe, New Mexico: Bear, 1993.

Stone, Merlin. **When God Was a Woman.** San Diego: Harcourt Brace, 1976.

Walker, Barbara G. **Woman's Encyclopedia of Myths and Secrets.** San Francisco: Harper SanFrancisco, 1983.

Walker, Barbara G. **The Crone: Woman of Age, Wisdom, and Power.** San Francisco: Harper SanFrancisco, 1985, 1988.

Olympia Dukakis
Selected Credits

Stage debut—**Outward Bound,** Mrs. Cleveden-Brooks, Rangeley, ME, 1956.

New York debut—**The Breaking Wall,** Madelena, St. Mark's Playhouse, 1960.

Broadway debut—**Abraham Cochrane,** Anne Dowling, Belasco Theatre, 1964.

PRINCIPAL STAGE APPEARANCES

1960, **The New Tenant,** Royal Playhouse, NYC

1961, **The Opening of a Window,** Theatre Marquee, NYC

1961, **Othello,** Williamstown Theatre Festival

1962, **A Man's a Man,** Widow Leocadia Begbick, Masque Theatre, NYC

1962, **Night of the Iguana,** Maxine, Williamstown Theatre Festival

1962, **Long Day's Journey into Night,** Mary Tyrone, McCarter Theatre, Princeton, NJ

1963, **Crimes and Crimes,** Henriette, Cricket Theatre, NYC

1964, **Abraham Cochrane,** Belasco Theatre, NYC

1964, **Electra,** New York Shakespeare Festival, NYC

1964, **Six Characters in Search of an Author,** Charles Playhouse, Boston

1965, **The Rose Tattoo,** Serafina, Studio Arena Theatre, Buffalo, NY

1967, **The Balcony,** Madame Irma, Charles Street Playhouse, Boston

1967, **Hamlet,** Gertrude, Charles Street Playhouse, Boston

1967, **Mother Courage and Her Children,** Mother Courage, Charles Street Playhouse, Boston

1967, **Father Uxbridge Wants to Marry,** all the women, American Place Theatre, NYC

1968, **The Memorandum,** Public Theater, NYC

1968, **Iphigenia at Aulis,** Clytemnestra, Williamstown Theatre Festival

1968, **The Seagull,** Arkadina, Williamstown Theatre Festival

1968, **Camino Real,** Williamstown Theatre Festival

1969, **The Cherry Orchard,** Madame Ranevskaya, Williamstown Theatre Festival

1969, **Peer Gynt,** Troll Princess, Anitra, Delacorte Theatre, NYC

1970, **Three Sisters,** Olga, Williamstown Theatre Festival

1972, **Once in a Lifetime,** Williamstown Theatre Festival

1973, **Baba Goya,** Goya, American Place Theatre, NYC

1973, **Nourish the Beast,** Cherry Lane Theatre, NYC

1973, **The Good Woman of Setzuan,** Shen Te, Williamstown Theatre Festival

1974, **Who's Who in Hell,** Lunt-Fontanne Theatre, NYC

1976, **The Rose Tattoo,** Serafina, Whole Theatre

1978, **Curse of the Starving Class,** Ella, Public Theater, NYC

1981, **The Cherry Orchard,** Madame Ranevskaya, Whole Theatre

1982, **Enemies,** Actress, Williamstown Theatre Festival

1982, **Snow Orchid,** Filumena, Circle Repertory Company, NYC

1984, **Blithe Spirit,** Madame Arcati, Whole Theatre

1985, **Ghosts,** Mrs. Alving, Whole Theatre

1985, **The Marriage of Bette and Boo,** Soot Hudlocke, Public Theater, NYC

1986, **Social Security,** Sophie Greengrass, Barrymore Theatre, NYC

1986, **The Seagull,** Arkadina, Whole Theatre

1993, **The Rose Tattoo,** Serafina, Whole Theatre

1995 and 1997, **Hecuba,** American Conservatory Theater, San Francisco

1996, **The Hope Zone,** the Countess, Circle Repertory Company

1996, **The Milk Train Doesn't Stop Here Anymore,** Flora Goforth, Williamstown Theatre Festival

1996, **The Singer's Boy,** American Conservatory Theater, San Francisco

1998, **Lear and Her Daughters,** Lear, Shakespeare & Co., Lenox, Mass.

1999, **Rose,** Rose, Royal National Theatre, London (world premiere)

2000, **Rose,** Rose, Lyceum Theatre, NYC

2001, **Credible Witness,** Petra, Royal Court Theatre, London

2002, **For the Pleasure of Seeing Her Again,** Nana, American Conservatory Theater, San Francisco

2003, **Rose,** Rose, in concert version at venues throughout the United States

PRINCIPAL STAGE DIRECTING

Tally's Folly, Whole Theatre
U.S.A., Whole Theatre
Orpheus Descending, Whole Theatre
The House of Bernarda Alba, Whole Theatre
Arms and the Man, Whole Theatre
Uncle Vanya, Whole Theatre
Six Characters in Search of an Author, Williamstown Theatre Festival
A Touch of the Poet, Williamstown Theatre Festival
One Flew over the Cuckoo's Nest, Delaware Summer Festival
Kennedy's Children, Commonwealth Stages
The Seagull, Arizona Theatre Company
Do Not Disturb, TheatreFest at Montclair State University
Drop Dead, Charlotte Repertory
Last Lists of My Mad Mother, Luna Stage

MAJOR TOURS

1960, with the Phoenix Theatre Company, tri-state area, **Time of the Cuckoo, A View from the Bridge**

PRINCIPAL FILM WORK

Film Debut
1963, **Twice a Man**

Principal Film Appearances
1964, **Lilith**
1969, **John and Mary**
1971, **Made for Each Other**
1974, **The Rehearsal**
1979, **Rich Kids**
1979, **The Wanderers**
1980, **The Idolmaker**
1985, **Flanagan**
1988, **Moonstruck**
1988, **Working Girl**
1989, **Dad**
1989, **Look Who's Talking**
1989, **Steel Magnolias**
1990, **Look Who's Talking Too**
1991, **Over the Hill**
1993, **The Cemetery Club**
1993, **Look Who's Talking Now**

1994, **I Love Trouble**
1995, **Jeffrey**
1995, **Mr. Holland's Opus**
1995, **Mighty Aphrodite**
1995, **Jerusalem**
1997, **Picture Perfect**
1997, **Mafia!**
2000, **Better Living**
2003, **The Intended**
2003, **The Event**
2003, **Charlie's War**

PRINCIPAL TELEVISION CREDITS

Television Debut
CBS Workshop, CBS

Television Appearances
Series
1961, **Dr. Kildare**
1962, **The Nurses**
1983–84, **Search for Tomorrow**
1994, **Touched by an Angel**
2002, **The Simpsons** (guest voice)
2002, **Frasier** (guest voice)

Variety
The Ed Sullivan Show (two appearances in the early sixties)

TV Movies
1974, **Nicky's World**
1975, **The Seagull**
1982, **King of America**
1982, **The Neighborhood**
1991, **Fire in the Dark**
1991, **Lucky Day**
1991, **The Last Act Is a Solo**
1993, **Tales of the City**
1993, **Sinatra** (miniseries)
1994, **A Century of Women**
1995, **Young at Heart**
1997, **A Match Made in Heaven**
1998, **Scattering Dad**
1998, **A Life for a Life: The Stefan Kiscko Story** (U.K.)
1998, **Pentagon Wars**
1998, **More Tales of the City**
1999, **Joan of Arc**
2000, **Further Tales of the City**
2001, **Strange Relations**
2001, **Last of the Blond Bombshells** (U.K.)

2001, **And Never Let Her Go**
2001, **Ladies and the Champ**
2002, **Guilty Hearts**
2003, **Jesus, Mary and Joey**
2003, **Mafia Doctor**
2003, **Babycakes**

RELATED CAREER

Founding Member of the Following Theaters
Whole Theatre Company
Actors Company
Charles Playhouse
Buzzards Bay Summer Theatre
Edgartown Summer Theatre

Master Teacher
NYU

Visiting Acting Teacher
Yale University, Boston University, Brooklyn
College, Florida State University, Syracuse
University, Brandeis University, Stella Adler
Studio, Michael Howard Studio, Sarah
Lawrence

Regional and Summer Theaters

Whole Theatre
Williamstown Theatre Festival
American Conservatory Theater
Trinity Repertory Theatre
Arizona Theatre Company
Great Lakes Theatre Company
Pacific Repertory Theatre
Circle Repertory Company
Second City Company
Commonwealth Stage
Studio Arena Theatre
Olney Summer Theatre
Delaware Summer Festival
Rangeley Maine Summer Theatre
Saranac Lake Summer Theatre

Radio

BBC London, **Hecuba,** translated and adapted by Timberlake Wertenbaker and **Credible Witness,** by Timberlake Wertenbaker

Writings

Adaptor, **The House of Bernarda Alba, Edith Stein, Trojan Women**

Academy Award, Best Actress in a Supporting Role, **Moonstruck**

New York Film Critics Award, Best Actress in a Supporting Role, **Moonstruck**

Los Angeles Film Critics Award, Best Supporting Actress, **Moonstruck**

Golden Globe Award, Best Supporting Actress, **Moonstruck**

National Board of Review Award, Best Supporting Actress, **Moonstruck**

American Comedy Award, Funniest Supporting Female Performer, **Moonstruck**

BAFTA Film Award, Best Actress in a Supporting Role, **Moonstruck**

Cable Ace Award, Best Actress, **The Last Act Is a Solo**

OBIE Award, **The Marriage of Bette and Boo**

OBIE Award, **A Man's a Man**

Emmy nomination, **Joan of Arc**

BAFTA TV Award, Best Actress, **Tales of the City**

Emmy nomination, **More Tales of the City**

Screen Actors Guild Award nomination, **More Tales of the City**

Golden Satellite Award nomination, **More Tales
 of the City**
Golden Globe Award nomination, **Sinatra**
Emmy nomination, **Sinatra**
Emmy nomination, **Lucky Day**
BAFTA nomination, **More Tales of the City**
Jefferson Award, Chicago, **A View from the
 Bridge**
Walt Whitman Creative Arts Award, New Jersey
New England Fencing Champion

Honorary Degrees
Boston University
Bloomfield College, New Jersey

FAVORITE ROLES

Rose, Rose
Tales of the City, Anna Madrigal
Mother Courage and Her Children, Mother
 Courage
The Cherry Orchard, Madame Ranevskaya
Long Day's Journey into Night, Mary Tyrone
The Rose Tattoo, Serafina
For the Pleasure of Seeing Her Again, Nana
Hecuba, Hecuba
The Good Woman of Setzuan, Shen Te

Acknowledgments

Acknowledgments I've read in the past have always amazed me with what seemed like an excessive indebtedness. **Now I understand.** My deepest gratitude for the support, tenacity, and generosity of Liza Dawson, literary agent; Marjorie Braman, editor; Emily Heckman, Bonnie Low-Kramen, Kelly Bare, and Roberta Israeloff; and for their early support and generous comments, Ellen Burstyn, Cher, Phil Donahue, Richard Dreyfuss, Michael Dukakis, Brenda Fricker, Whoopi Goldberg, Peter Hunt, Norman Jewison, Diane Ladd, Frank Langella, Armistead Maupin, Austin Pendleton, Julia Roberts, Martin Sherman, and Gloria Steinem. Thanks also to the following people at HarperCollins: Cindy Achar, Roni Axelrod, Elliott Beard, Roberto de Vicq de Cumptich, and John Jusino.

My Family and Friends—for Your Honesty and Love, Always in My Heart

Alexandra and Constantine Dukakis, Louis Zorich, Christina Zorich, Peter and Elvy Zorich, granddaughters Isabella and Sofia, Stefan Zorich and Elda Rotor, Apollo, Maggie, and Damon Dukakis, Arthur and Patti Dukakis, Michael and Kitty Dukakis, Strat and Eva Dukakis, Ann Hollis, Claudia and Paul Hollis, Ann and Bill Hollis, Olga and Nick Kolivas, Bill Kanes, Alice Kaknes, Thanis Chakalis and family, Perry Mavrelis, Mildred, Harold, and Kathy Kocourek, Bonnie Low-Kramen, Leslie Ayvazian and Sam Anderson, Tom Brumberger, Roberta Campos, Austin Pendleton, Frank Langella, Madie Gerrish, Rayna Cooney, Rosemary and Al Iversen, Carey Perloff, Martin Sherman, Armistead Maupin, Timberlake Wertenbaker, Nancy Meckler, Joan MacIntosh, Judy Delgado, David Calicchio, Bernie Hiatt.

Mentors and Teachers—for Insisting I Proceed

Peter Kass, Nikos Psacharopoulos, Bill Hanson, Gerry Freedman, Norman Jewison, Steven

Whittaker, Gayatri Devi (Ma), Marija Gimbutas, Kitty La Perriere, Isa Bohn, Barbara Walker, Sam Chwat, Omar Shapli, Nora Dunphey.

At the Crossroads

Gene Parseghian, Joe Papp, Mike Nichols, Norman Jewison, Jenny Delaney, Scott Henderson, Angela Carbonetti, Howard Feuer, Gary David Goldberg, Michael Ritchie, Jaan Whitehead, Scott McVay, Gov. Thomas Kean, Sonja and Mike Gilligan, Rose and Pat Pakek of the Jewels of Charity Foundation.

So Many Great Memories

Actors Company: Jane Cronin, Roz Faber, Gloria DePiero, Rigmor Christiansen, Esther Small, Ed Zang, John (Ed) Heffernan, Charlie Auburn, John Cazale, Walter (Speedy) McGinn, Richard Galvin, Nick Smith, Jordan Hott, Michael Murray, Robert Foley.

Whole Theatre: Apollo Dukakis and Maggie Abeckerly, Judy Delgado, Jessica Allen, Remi Barclay Bosseau, Jason Bosseau, Tom Brennan, Lynn Martin, Bill Martin, Glenna and Stefan

Peters, Marge and Gerry Fierst, Judy and Paul Dorphley, Arnold Mittelman, Annie and Ron Abbott, Ernie Schenk, Sigrid Insul, Mary Orme, Cheryl Soper-Christensen, Micki Hobson, Loren Sherman, Jack Chandler, Dan DeRaey, Phil Polito, Harold deFelice, Mike Miller, Andrew Nikel, Jennifer Shaw, Tiffany Hendry.

Whole Theatre Board Members: Connie Sayre, Caroline Schumann, Bernard Berkowitz, Bill Michaelson, Rosemary Iversen, Warren Ross, Jerome Shelby, Barbara Malcolm, Rey Redding-ton, Corinne and Dan Gaby, Joe Starita, Helen Stein, Ruth Rosenblatt.

Williamstown Theatre Festival: Nikos Psacharopoulos, Bill Hansen, Austin Pendle-ton, Blythe Danner, Frank Langella, George Morfogen, Tom Brennan, Peter Hunt, Laurie Kennedy, Maria Tucci, James Naughton, Santo LoQuasto, John Conklin, Joyce Ebert, Jean Hackett, Carolyn Coates, James Noble, Bill Swetland, Franklin Keysar, Peggy Peterson, Juliet Flynt.

Photo Captions

1. My mother's family and friends in Lowell, Massachusetts (1921). My mother stands right behind the groom.

2. My mother with her four sisters. From left to right: my mother, Alec; Amelia; Gladys; Katherine; and Pota.

3. "The funeral of the century."

4. My aunt Marina's wedding. My father is second from left; then his brother George; his mother, Olympia; his brother Panos; the widow of his oldest brother; and the bride.

5. My parents' wedding, September 5, 1927.

6. I was two years old here, with my mother and grandmother Olympia. Seeing my mother's joy has always moved me.

7. My parents insisted we wear traditional dress for this picture. My brother and I endured the ordeal.

8. I'm sixteen years old in this picture, with my brother, and my beloved dog, Duke.

9. Fencing was the perfect outlet for my competitiveness and aggression.

10. With my mother on the beach in Cape Cod. My parents came to see me perform in Schnitzler's **La Ronde** (1957). My father was so shocked to see me play the role of a prostitute, he refused to be in the picture with us.

11. At age 26—starry-eyed and waiting for the magic to happen.

12. I met the actor Louis Zorich in 1962 and we were married in 1963. Three years later, the young husband and (expectant!) wife.

13. We moved to Montclair, New Jersey, in 1971.

14. My daughter, Christina, and sons Peter (left) and Stefan (right), playing to the camera.

15. Outside the Whole Theatre in Montclair, New Jersey. After years of hard work, our theater was known nationally because of the actors, designers, and directors who came to work with us.

16. With Bonnie Low-Kramen, the public relations director for the Whole Theatre, as well as my personal assistant and good friend—for seventeen years now!

17. My brother, Apollo, in Lanford Wilson's **Tally's Folly,** which I directed at the Whole Theatre. An extraordinarily versatile actor—a chameleon.

18. As Anitra in Ibsen's **Peer Gynt** directed by Gerry Freedman (1969). I was compared to Carol Burnett. Everyone said "big career jump!" . . . but the phone didn't ring. Carol Burnett was safe.

19. One of my favorite stage experiences, in Brecht's **Mother Courage,** directed by Gerry Freedman, with Christina in the role of the daughter. She amazed us all!

20. Here I am in Euripides' **Trojan Women** with my sister-in-law, Maggie, at the Whole Theatre. Her patrician beauty and emotional depths were ever-present!

21. Rehearsing Chekhov's **Three Sisters,** with Blythe Danner and Laurie Kennedy, directed by Nikos Psacharopoulos.

22. Brecht's **The Good Woman of Setzuan,** directed by Ted Cornell, transforming myself from a peasant girl to a male shopkeeper.

23. Playing the part of Luba in the Whole Theatre's production of Chekhov's **The Cherry Orchard,** with Louis (right) as Lophakin and Apollo (left) in the role of the brother, Gayev. They truly owned these parts.

24. As Rose Castorini with John Mahoney in **Moonstruck,** directed by Norman Jewison. I

had no idea how my life would change with this movie.

25. Oscar night, 1988. My mother was back in New Jersey. I love having this picture of her just as I was announced as the Best Supporting Actress.

26. Backstage. When I won, I yelled, "Let's go, Michael" from the stage, but afterwards all I could think was, what a miracle.

27. The week after my big Oscar night, cousin Michael wins the New York Democratic Primary. Our immigrant parents would have rejoiced at how far their children had come.

28. One of my favorite roles, Clairee, in **Steel Magnolias,** with all these amazing women— Dolly Parton, Sally Field, Shirley MacLaine, Julia Roberts, and Daryl Hannah.

29. In **Dad,** with Ted Danson and Jack Lemmon, directed by Gary David Goldberg. Aging me into my 80s took three hours every morning.

30. My mother, transported by **The Goddess Project.**

31. With Frank Sinatra on the set of **Young at Heart.** He was charmingly gracious with me. After our first take he whispered, "I've saved some money. Wanna run away with me?"

32. Christina Zorich—the actress! Her spirit, honesty, and loving heart shine through those beautiful brown eyes.

33. All grown up—family man Peter of the passionate political beliefs; big-hearted Stefan, the Renaissance man; and the beautiful, talented, and unpredictable Christina.

34. This is Gayatri Devi (Ma), who I met in 1987. Ma was one of the most important teachers and mentors I've been blessed to know.

35. Archaeologist and prehistorian Marija Gimbutas was a pioneer in exploring ancient matriarchal cultures. Her work introduced me to the civilization and language of the Goddess, and continues to inform my life.

36. The title role in Martin Sherman's **Rose,** at the National Theatre in London. This one-woman show was one of the most demanding—

and rewarding—parts I've ever played. Martin Sherman and Nancy Mechler (director) gave me the confidence and support I needed.

37. When **Rose** moved to Broadway (2000), Hirschfeld captured me, much to my delight.

38. Louis and I, together for 40 years! What a remarkable man! A brilliant actor, a loving and supportive husband, and a father who inspires loyalty and laughter, always.

39. Here's the cast back for Armistead Maupin's **More Tales of the City.** Anna Madrigal remains my favorite role in film. From left: Whip Hubley, Colin Ferguson, Laura Linney, Nina Siemaszko, Bill Campbell, Paul Hopkins, Barbara Garrick, and Thomas Gibson.

40. It's fun to look glamorous—at any age.